MODERN WATERCOLOR BOTANICALS

DEDICATION

To Jesus, who is the Giver of all these good gifts.

To my Colin, London, and Savannah.

To my family and friends, who always believed.

To all of you, the Creatives on this journey with me.

paige tate & CO.

Copyright Sarah Simon, TheMintGardener LLC, 2019

PUBLISHED BY PAIGE TATE & CO.
PAIGE TATE & CO. IS AN IMPRINT OF BLUE STAR PRESS
PO BOX 8835, BEND, OR 97708
contact@paigetate.com
www.paigetate.com

Art & Writing by Sarah Simon

Photography by Erin Schedler
@schedlerphoto

except those specifically listed below
The Crafter's Box: page 41, 70, 71, 196, and back cover author photo

Bianca Malone: page 179

Miranda Estes: page 192, 193

Design by Amy Sly

ISBN 978-1944515584

Printed in China

10 9 8 7 6 5 4 3 2 1

MODERN WATERCOLOR BOTANICALS

A Creative Workshop in Watercolor, Gouache & Ink

FROM THE MINT GARDENER
SARAH SIMON

CONTENTS

THE ARTIST'S DESK:
FOUNDATIONS OF WATERCOLOR

TOOLS

PREPPING TO PAINT

BASIC WATERCOLOR TECHNIQUES

COLOR EXPRESSION

COMPOSING A PAINTING

BOTANICAL LESSONS:
WATERCOLOR PROJECTS

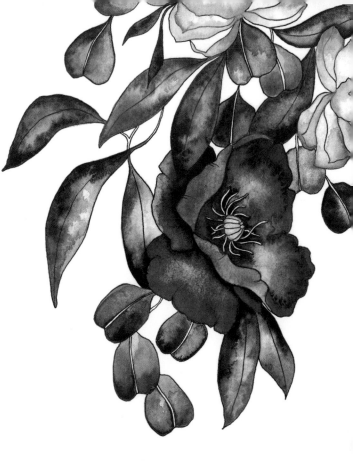

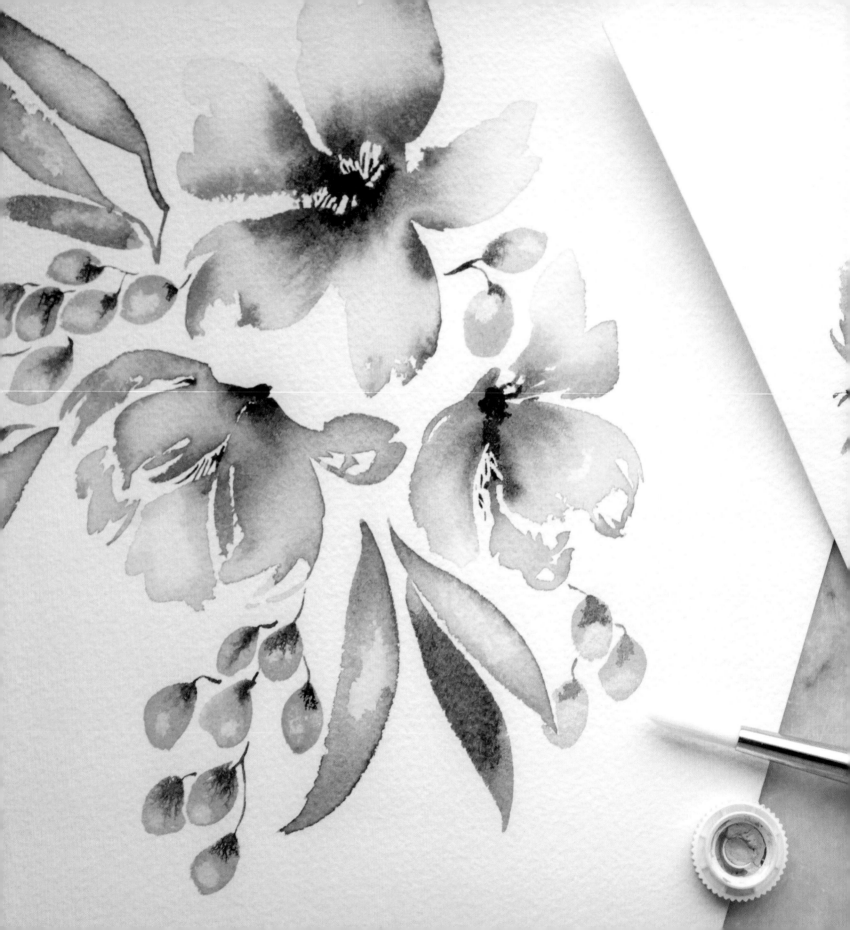

FOREWORD

WE WERE SITTING IN A CIRCLE, gathered in a living room, just as we did every other Wednesday. Each of us took turns sharing about our weeks, how the kids were driving us mad, our work was overwhelming, and how we were eager to find that magical, and let's be real, unattainable notion of balance, when Sarah mentioned that she wanted to start painting again.

I remember a flutter in my soul. Something happens inside me when a woman calls upon the courage to say out loud that they are ready to invest in their own creative lives. I get a rush of excitement and I can't help busting out my pom-poms to cheer them on. It's a scary and vulnerable task and I consider it an absolute honor that I got to be in the room and then subsequently follow along as Sarah followed her curiosity, passion, and talent to find her creative soul.

From the very beginning Sarah has shared her artistic journey for the purpose of inspiring others in their own creative pursuits. It's never just been about her own desire to paint to satisfy her creativity. For Sarah, it's always been about pursuing painting and bringing others into that process. Every image she shares, every post, every line she utters in her classes is created with the hope of inspiring others. And this book you hold in your hands is no different.

Sarah intimately knows how hard it is to carve out time for your creativity. When she courageously told us that she was going to start painting again she was a mother to one very young girl and pregnant with another. She had to carve out a few minutes here and there to appease her creative desires. Sarah persevered and we all got to witness magic. Through the process she continually inspired each one of us to pursue a relationship with our creativity no matter what obstacles stand in our way.

This book is your personal invitation from Sarah to become more intimately acquainted with your creativity. Sarah's voice is gentle and inviting as she reminds you that it's not about the tools, supplies and money needed to invest in the craft, but it's simply the belief that you are worth it. Sarah makes the art of watercolor approachable and deeply enjoyable. Whether you are a beginner or you've been painting for years I have no doubt that this book will bring a much-needed boost of inspiration and creative jolt to your artistic endeavor. ●

—ASHLEY RODRIGUEZ
James Beard Award Finalist
Author of *Date Night In and Let's Stay In*
Host of award-winning video series *Kitchen Unnecessary*

INTRODUCTION

CONGRATULATIONS ON OPENING THIS BOOK! You've taken a real step in investing in yourself as a creative. I am so excited you're here.

When I first pick up a new art book, I open it with feverish excitement to the beginning pages— and then often get bogged down in the minutiae of tools, theory, palettes, you name it. This is not what I want for you. I want you to be able to open this book, gather a few key materials, sit right down, and get your paintbrush on the paper while your Creative Muse is eager and willing. I want this book to challenge and inspire you. I want you to feel confident in modifying the lessons as you grow and learn. I want you to create *with* me, to combine these projects with your own ideas to make something totally fresh and unique.

But let's back up for a moment. What is this book anyway?

Modern Watercolor Botanicals is a project-based watercolor book of painting lessons that allow you to complete beautiful pieces while learning the skills to improve and grow your individual painting practice. It covers watercolor techniques and explores how to incorporate watercolor with gouache and ink for an immersive experience in modern botanicals. In the process, you will paint eucalyptus wreaths, shape olive branches, detail wildflowers, tint fine-lined blooms, shade tropical leaves, and find your unique voice in the world of modern watercolor artists.

We start out with some basics—affordable and easy-to-find tools, a deep dive into composition and color theory, and a basic overview of the core techniques you'll use as you work through the book and build your painterly skills. Creating washes, working with wet-in-wet and wet-on-dry, blotting, point-pressure-point, incorporating gouache—these techniques are all covered here to assist you however you need. If you're a beginner, you may find yourself coming back to this section often; if you're more experienced, you may just want to skim as a refresher. It's totally up to you.

In the second part of the book, I present the Botanical Lessons. Each lesson is a stand-alone project covering multiple skills and subjects. I present the lessons at three different skill levels—beginner, intermediate (all of the step-by-step instructions are at this intermediate level), and advanced—so you can choose your own adventure as you work. Each lesson builds on the skillset practiced in the previous lesson, so you will naturally build your skills as you move through the book. I provide you with traceable art at the end of the book so you can simply focus on learning to paint. For some of you, this will remove the burden of having to draw an object first, in all of its correct proportions, angles, shapes, and sides. For others, tracing will take away from the creative process, and you'll much rather create your own sketches—I get that. Do what feels right! After you're comfortable creating a piece with the techniques we've covered together, you can redesign the lesson using the best tool every artist is born with—your imagination. I've designed this book to help you grow—grow in skill, grow in technique, grow in knowledge, and most importantly, grow into your own artistic expression.

MY HOPE IS THAT THESE LESSONS WILL:

- Teach you watercolor technique in a relatable, instructive, and detailed manner.

- Foster the learning process, cheering you on to new heights in your watercolor pursuits, whether for your own personal enjoyment or to develop a creative voice you want to share with the world.

- Celebrate mindfulness and the joy of immersing yourself in the process of a well-learned skill.

- Explore the different ways you can use watercolor to play with the modern tools of ink and gouache.

- Enable you to make beautiful art!

In fact, if you're feeling that creative spark right now, skip to page 40 and just begin! Start those lessons while you have the excitement and the moments to invest. Later, when your energy has calmed, or you need a moment to savor, make yourself a cup of something tasty, and come back and join me for a leisurely stroll through the chapters

on composition and color harmony, or my humble thoughts on the art journey herself. If that moment to start painting isn't now, that is OK. Just promise me that if you start itching to paint, you won't use reading my book chapters as an excuse to delay and you'll run right along to the lessons and get started. Deal? Deal.

Now, one more thing: who am I to be telling you all this?

I guess now is the time to introduce myself and tell you why I wrote this book in the first place!

I've always been a beauty-seeker at heart. I grew up hungry for it, seeking joy in my parents' garden and the forests near our neighborhood. I spent summers playing hide-and-seek with my cousins in the sky-high sunflowers that my grandfather planted and treasured every year. And I loved to draw. To paint, to scrapbook, to create. To make something tactile with my hands, translating the beauty I saw all around me onto paper, a piece I could share with people I loved. My grandmother and my mother paint, and the tools I needed were always there at my fingertips, ready to bring my visions to life. I loved to document the world around me, from frogs in the marsh behind our house to the tiger lilies in my parents' garden, even recreating "Archie & Veronica" cartoons with my siblings, tirelessly coming up with new adventures for them. Drawing is one of my first memories. I even remember asking if I could get extra credit in my high school chemistry class if I drew the experiment we were assigned . . . beakers, Bunsen burners, and all. I enjoyed the process of seeing all of the individual pieces come together to make an end product that was dynamic and collaborative.

It felt very natural to begin and cultivate a garden of our own in Seattle, as my husband and I settled into the rhythm of everyday life. Tomatoes and squash, corn and beans—and, of course, flowers. Always flowers. Irises, peonies, a rosebush for every anniversary. A flowering magnolia tree for my birthday. The beauty of the garden consistently inspires me to pick up my pens and paintbrushes.

My passion for painting and sharing this beauty I seek has been the most natural way to express myself that I've ever found.

Watercolor is the way I share; others use words or hospitality, singing, music, or gifts. Painting pictures is the tool I was given to show people love. It's how I express the peace I find in small, joyful moments, and when I get to share my watercolor—my art and my process—it's like giving that small gift of love and peace to all it touches. Teaching others this passion of mine has become such a beautiful way to share and enjoy it again and again. It's the best kind of contagious there is! This book is for you—to fine-tune the tools you've been given, so you can express yourself creatively and use watercolor as your gift to others.

As you work through the lessons, I also want you to hear my core message for you on this journey: that we are not seeking perfection or competition, but rather community and our own voice of expression from our brush. That's why I've included little sections throughout the book called "Why Art?"—I want to share meaningful quotes and thoughts, since inspiration and reflection are so vital to the creative process. These are designed to be moments of pause and encouragement. It's my way of sitting down with you so we can connect as artists and as humans. As an artist, it's normal to occasionally feel alone in your process. I hope each story connects with you and reassures you that I'm here and we are in this together.

All in, I want this book to hand you the tools and skills to build a habit of mindful and sustainable creativity, one that can grow even beyond what you imagine for yourself. This book comes from my hands and my heart—it is my gift to you as you venture into your painting journey. I want your experience to be fulfilling and invigorating and inspiring, to both sustain you and encourage you to connect with the wider community of artists. I'm so excited to have you as part of our tribe. ●

—SARAH

the mint gardener
SARAH SIMON

THE ARTIST'S DESK
Foundations of Watercolor

OFTEN, THE ART WORLD CAN FEEL A bit unreachable—like a cool kid's club with a secret handshake. There are mystifying terms, inside phrases that are never really explained, and some intense emphasis on the best and most expensive tools. In this section, I break down all of those barriers.

I believe watercolor is accessible to anyone and really doesn't require a big investment (at least not at first). I will help you stock up on supplies, explore basic techniques, and discover inspiration through color and botanicals. I'll also walk you through composition and color harmony. My aim is to take any intimidation out of the process, so you can settle in and just create.

The truth is that watercolor is one of the most approachable ways to express yourself with paint, mainly because you only need a few materials to get started. And it's extremely portable, allowing you to play with paint wherever you can sit down with a good cup of coffee—no easel needed!

By keeping it simple, you'll be able to focus on learning the skills and experiencing the joy of exploring, trying new things, and expressing yourself through watercolor. That's what it's all about. ●

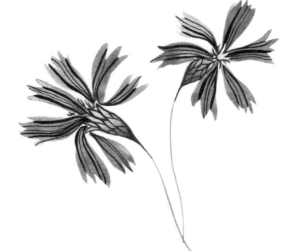

Watercolor is a negotiation between the artist & her tools.

TOOLS

Connection and accessibility are my two main considerations when it comes to teaching people how to paint. I want you to connect with yourself and your community, using art as a way of showing your love. By making cards or painting lovely pieces, you can give gifts from your heart and your hands. To be able to do this, all you need are some basic tools. No, you really don't need a twenty-dollar paintbrush—you can do it with a three-dollar paintbrush! Painting palettes? Meh. If you don't have one at home already, use a dinner plate. You just need a few keys tools, and you're off. I want you to enjoy the process and not fuss about the other stuff. I want you to see how much beauty you can create with minimum expense. I want you to feel the satisfaction of mixing some gorgeous colors with student-grade paints and brushes on a leftover dinner plate. I want you to experience the simple joys of painting.

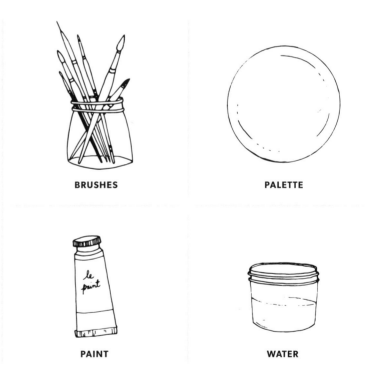

BRUSHES

PALETTE

PAINT

WATER

STOCKING UP

In this spirit, I've broken out the tools you need into two lists. First is a list of Essentials, followed by a list of Nice-to-Have items. The second list features some extra materials that I enjoy using, but they aren't necessary—especially if you're just beginning! Please know that the materials included here are based on my own trial-and-error process. The Nice-to-Have list is always evolving, and I'm sure you will discover a few items to add to your own. That's one of the best things about art: there is always something new to discover!

Review these lists and take stock of your current supplies. If you are missing any of the Essentials, go ahead and purchase them. That way, once you're ready to dive into the lessons, you'll have everything ready and waiting for you! If you're headed to the art supply store, you may want to read ahead to Lesson 2 (page 56) where we begin to mix some fantastic colors, so you can jot down some of the paint colors you'd like to purchase. If not, don't worry—you'll only need two colors of paint up until Lesson 2.

Once you've stocked up on the Essentials (and maybe a few Nice to Haves), you are ready to get started. But since paint, brushes, and paper are so crucial to the watercolor process, I go into more depth for each. Having a foundational understanding of these key materials will set you up for success as you continue to navigate your watercolor journey. For instance, knowing how different paper textures will affect the finished look of your work, or how to properly clean your brushes, will make a big difference in the quality of your practice over time.

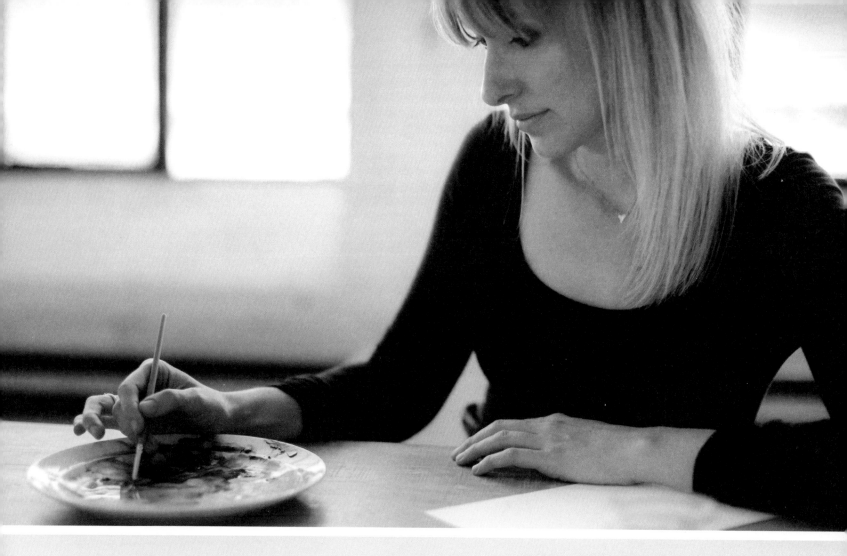

ESSENTIAL

- Student-Grade Watercolor Paint Set (Reeves tube paint set of 24)
- Student-Grade Round Brushes (Princeton, sizes 1 and 4)
- Student-Grade Watercolor Paper (Strathmore, minimum 140-lb. weight)
- Painting Palette (or a large white dinner plate)
- Micron Pens (sizes 01 and 02)
- Colored Pencils (blush/light pink and gray)
- HB pencil (any #2 graphite pencil works as well!)
- Pencil Sharpener
- Artgum Eraser (Prismacolor)
- Water (I use Mason jars filled with tap water; a clear jar works best, so you can see when the water needs changing.)
- Paper Towels (for blotting)
- Scrap Paper (for testing strokes and marks)

NICE TO HAVE

- Gouache Paint Set (Reeves tube paint set of 12, 18, or 24)
- Individual Gouache Tubes (specifically Winsor & Newton Flesh and Oxide of Chromium)
- Dr. Ph. Martin's Bleedproof White (for gouache)
- Micron Pen Set with Multiple Sizes (ideally 005, 01, 02, 03, 05, 08)
- Round Brushes in Multiple Sizes (specifically 20/0, 10/0, 5/0, 0, 1, 3, 4, 5, 6)
- Arches or Hahnemühle Cold Press Paper (140 lb. weight)
- Set of Colored Pencils
- Sakura Koi Coloring Brush Colorless Blender (for blending out splatters and mistakes)
- Light Box (for tracing)

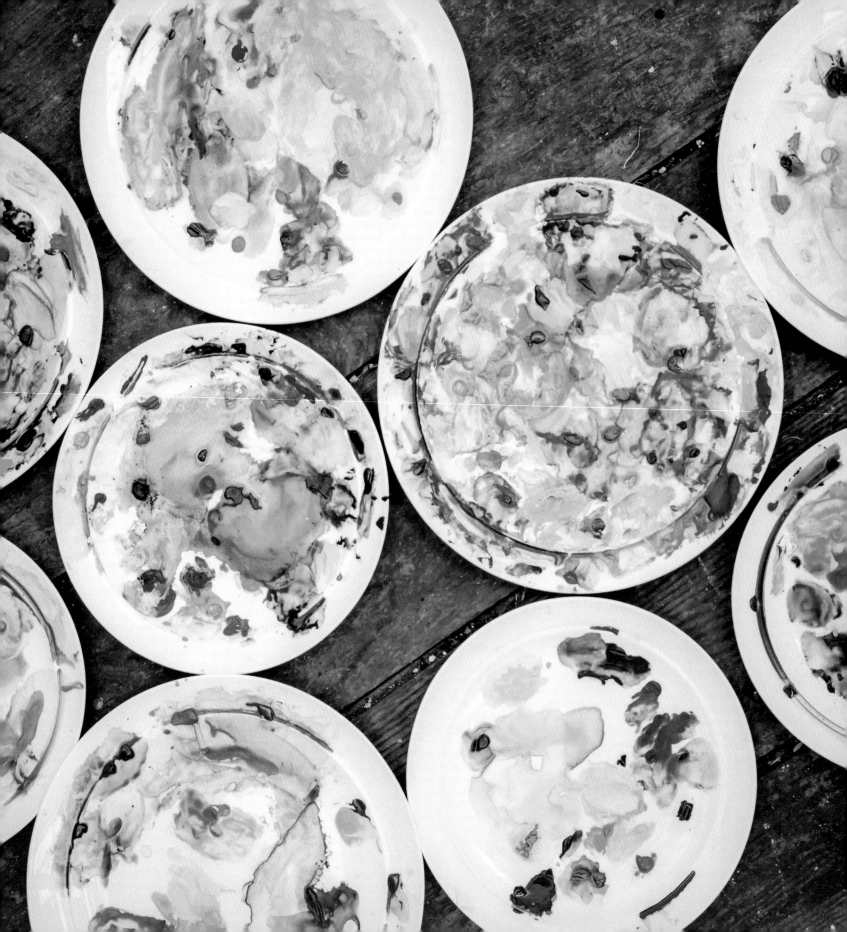

WATERCOLOR PAINT

I love the versatility of watercolor paint. You can smooth it onto paper in its most translucent form, using just a hint of color to suggest its presence. Or, you can layer it on thick, building in color and texture to make a bold statement. Watercolor paint is unique in its structure and is made of:

powdered pigment (to give it color)
+
gum arabic (a binder to hold it together and keep it on your paper)

Because of the unique binding agent of gum arabic, watercolor pigments are suspended and can be reanimated with water—meaning you can use it again after it dries just by adding more water. By contrast, acrylics and oils dry out; if any paint is leftover on your palette, it becomes useless, which can feel like such a waste. With watercolor, you can keep your palette of perfectly mixed colors and, by just adding water, pick up right where you left off with your favorite colors and mixtures ready to go.

Benefits of Tube Paints
I prefer working with paints in tubes over cake paints in pans. Here's why:

- **COLOR VIBRANCY:** Your ability to create a very saturated paint stroke is greater right out of the tube. Because of the pre-dried nature of cakes, you have to get them wet in order to get the color onto your page. This desaturates the color, so it takes a while to build up to the same intensity as a fresh dab of tube paint.

- **BLENDING:** As you will see as you begin to set up your palettes in Lesson 3 (see page 62), I enjoy blending different colors into color recipes, including the unpredictable colors that emerge when they naturally blend together on your paint palette. With pan watercolor, the colors are often separated into little cups. This holds the pure pigment nicely and prevents muddying of the color, which may be satisfying for some of you type-A painters. However, it also prevents the colors from running together in new ways on an open palette, which is part of the joy for me. True, sometimes my palettes can get a bit muddy, but they also become works of art themselves.

- **COLOR CONSISTENCY:** You can achieve fabulous color consistency directly from wet tube paint, which you simply cannot replicate in cake form since it requires you to add water, which leads to greater variance in tone within each color. For projects where consistency is key (say, working with a color that needs to stay very close to Yellow Mustard), fresh tube paint will serve your needs perfectly. The paint directly out of the tube is the same color every time.

Your Student-Grade Set
In terms of what to buy, I suggest a twenty-four-piece student-grade Reeves set of watercolors, which runs between ten and twenty dollars and includes an array of colors for ample mixing opportunities. Working with less expensive paint frees you up to play more! You can explore colors and textures without worrying about wasting paint. In fact, I discovered my favorite color, Payne's Gray, thanks to my twenty-four-piece Reeves set. Start with the basic kit and when your budget allows, supplement your collection with individual tube paint colors that you find exciting.

I refer to the colors in the Reeves twenty-four-tube kit throughout the book, so the easiest thing is to have this set on hand as you work through the lessons and projects. Many of you may already have a decent collection of watercolor paints, of all different grades and brands. This is fine—you'll just need to use your artist's eye to do some simple color swatch matching with the swatches of each Reeves color (see page 64) in order to substitute like colors from your paint set. More on this in Lesson 3.

Now, for all of my love for the Reeves set, of course, there are advantages to higher-grade watercolor paints. They tend to be more vibrant in color, more transparent in consistency, and more suitable for achieving fine-tuned results. It's fine to work your way up to a higher-grade collection over time. When you're ready, I recommend any paint by Winsor & Newton or Daniel Smith.

BRUSHES

As with paints, less expensive brushes free you up to play around and find your own personal preferences in, for example, brush shape. Trying multiple brush types and brands will allow you to discover your favorite types of marks and the types of handle and brush hair you prefer.

You don't have to own a lot of brushes. Having one small and one large brush is plenty, as long as they have good clean points. Individual brushes in the three- to seven-dollar range tend to function just fine. They hold a good quantity of water, are springy and return to their original shape, and keep their point well. And then you're not financially devastated if you accidentally ruin the point.

The only brushes you need to complete all of the lessons in this book are a Round 4 and a Round 1. The Princeton brand has never let me down! And if you're looking for a few other key brushes in the Nice-to-Have category, the smaller Rounds 0 and 00 are good picks.

However, it's often efficient (and a cost saver!) to find a pack of brushes with a wide range of rounds. This also gives you more versatility in your strokes. A basic pack of student-grade watercolor brushes is less than ten dollars. I have a seven-piece round set (Golden brand) that comes with rounds in sizes 0, 1, 2, 3, 4, 5, 6.

Why a Round?
Round watercolor brushes are the most versatile when it comes to mark making. Their shape makes them suitable for small details and delicate lines, but also for broader strokes and washes. Applying light pressure engages just the point of a round watercolor brush, which gives you control for making small details and delicate lines. Applying more pressure engages the full width and length of the

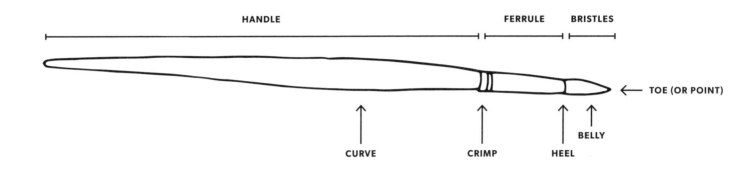

HANDLE FERRULE BRISTLES

TOE (OR POINT)

CURVE CRIMP HEEL BELLY

brush, allowing for broader strokes and larger deposits of water and paint on your paper. Rounds come in all different sizes; I work with the Round 6 all the way down to the tiny Round 20/0, which is practically a hair width! But it allows you to create the most delicate line you can imagine. Even a Round 4, which we use most often in this book, creates a very small line with light pressure and still has the ability to create broad strokes with heavy pressure. All of this dimension, in just one brush.

Why is it called a round? This simply refers to the shape of the connection point, where the bristles meet the ferrule. The *ferrule* is the metal cylinder that surrounds and encloses the hairs on a brush. If you turn your paintbrush with the bristles facing your nose and look directly down, you can observe the round connection point of bristle to ferrule.

Cleaning Your Brush

When I'm painting and need to switch to a very different color than the one currently on my brush, I use my wash water in my Mason jar to clean the brush before dipping in the new color. Just like priming my brush (see page 22), I press the brush side down against the bottom of the jar, first one side and then the other. Once the brush is clean, it's ready and primed to pick up the new paint color.

Note that you never want to store your brush— even for a few minutes! —bristles down in your water jar. The point of your brush is highly prized. You want to keep that point as straight as possible for as long as possible. Leaving your brush bristles down in your jar is the quickest way to destroy your bristle point.

To clean your brush once you're done painting for the day, clear it of excess paint in your wash water and then run it under running water, applying light pressure with your fingers to remove the more stubborn bits of paint. You can purchase specially designed soaps, but I don't use these very often. After rinsing the brush with clean water, use a paper towel to remove the excess water by pulling it

down the length of the brush, bristles last, defining the point as you finish. It's always a good idea to reshape your point with your paper towel or your fingers before storing your brush.

Storing Your Brush

I store my brushes on their sides, laid out on my desk. I will only store them vertically once I know all of the water has evaporated from the bristles (after about twenty-four hours).

Some people like to save the clear cylinder cases that come with brushes and slide them back on when storing. This is especially helpful if you are traveling and want to protect your points. Do this with caution, as you don't want to catch any bristles and bend them down the wrong way. It is best to wait until your bristles are cleaned of excess paint and dabbed dry with a paper towel before you put on the cylinder case.

PAPER WARPING & TAPING

A natural warping happens when a piece of watercolor paper gets wet. For this reason, many watercolorists tape their paper to their work surface in order avoid the buckling or warping that occurs as you paint and your piece dries. I'm personally not big on taping—I think the natural curving the paper takes adds interest to a piece. Certain sections pool and others rise up, affecting how and where the paint dries. I find the warping interesting and it's become a part of my process. I also avoid taping because I enjoy working on a mobile plane; I like to move my paper around and adjust it to my hand and the angles I need as I work.

If you prefer taping but want mobility, you can try using an artist's board as your surface. By taping paper to a mobile board, you will still be able to move your piece around, but your paper won't warp quite so much.

Pro tip: If you get a bit too much warping and it bothers you, squirt a few sprays of water from a spray bottle on the back of the completed piece, and then stick it between some heavy books for twenty-four hours or so. This should do the trick!

PAPER

Paper is another material on which you can splurge or start out with student grade and work your way up to the higher quality. Watercolorists use special paper, which comes in a variety of thicknesses and textures. Here are the top things to consider when choosing watercolor paper:

- **WEIGHT:** Thicker or heavier papers can handle the extra water and paint involved in watercolor without buckling or disintegrating. Papers are

KEEP IT SIMPLE

The bare minimum of what you need to watercolor is paint, paper, brushes, clear water, and a bit of light to see by. (And even that bit of light is negotiable—the Neolithic cave-dwelling women painted in the dark recesses of the earth. I marvel at their devotion!)

It's nice to have a little spot with all your supplies ready for when the desire to paint takes over. When I first began painting every day, I would leave my painting plates and Mason jars of water out and ready on the table. I made sure everything I needed—paint, water, brushes, and paper—were within reach when inspiration struck. It was really helpful to have everything readily accessible. It removed the excuse of "Oh well, it's too much work to gather all my supplies." I could dream in my mind all morning, tossing around creative ideas and working them out mentally, so when I finally had a few moments to sit down, the ideas were ready—and so were my materials.

My favorite place to paint is at my great-grandmother's timeworn roll top desk where I keep my favorite tools within arm's reach. The view of my iris garden is to my right, and light pours in all day. However, I am not always able to sit down and paint in these perfect conditions, and if I waited for only those moments, I wouldn't create as often as I need—or like! —to do.

To better adapt my painting practice to my real life, I also purchased a rolling cart from IKEA. This way, I can easily bring my watercolor supplies with me to whatever room of the house I need to be in. It's great because I don't have to dismantle my creative space every time I am done with a project, and I can pack all the loose bits of watercolor supplies in my cart and roll it into a closet to keep our small living space tidy. I also have a small traveling kit to take with me when we leave the house, so that wherever we go I can sit down and create a visual memory when the inspiration strikes. As long as you have a few paintbrushes, paper, and a few dabs of your favorite paints, you can paint anywhere.

Keep your watercolor practice simple by removing as many obstacles as you can, and you will find the time and freedom to create more and more!

measured by their weight in pounds of one ream, which is approximately 500 sheets. For watercolor, you never want to dip below the 140-lb. weight paper. (Some people try to coast by on the less expensive 90-lb. "watercolor" or "mixed media" papers, but in my experience, these do not hold watercolor well.) Someone could write an entire art thesis on the weights of papers and their relative uses and thickness. Feel free to research this to your heart's content—you won't believe how much info is out there on the topic! But to keep things simple: 140-lb. should be your minimum and is the perfect weight for completing the lessons in this book.

- **TEXTURE OR "FINISH":** Manufacturers usually produce three (or more) paper finishes, commonly labeled as "Rough," "Cold Press," and "Hot Press." If you run your hand over the surfaces of these finishes, you'll feel the most texture—that rough, "toothy" quality—with the rough and cold press finishes. These are ideal for watercolor work. The hot press finish is much smoother and works better for printmaking and drawing. For all of the lessons in this book, I suggest working with cold press, which has just enough toothy texture to add some interest to your piece and give your work a painterly effect.

 - **HOT PRESS:** This texture is even and smooth and makes a nice surface for painting if you want to scan your work and make prints of your art. It's also the easiest to work on when drawing fine lines and dries the fastest. Because it dries quickly, it's more difficult to make soft transitions when using this paper, so you may find that you have more hard edges in your work than you want. Also, it doesn't have any texture, so any scrubbing (side-to-side motions with your brush) will cause bits of your paper to come up and show within the texture of your dried watercolor painting.

 - **COLD PRESS:** The slightly bumpy texture of this finish, often referred to as "tooth," is the most popular texture for watercolorists. The texture allows paint to settle into the toothy pockets or sit on top and skip over the pockets, creating variety in color as the water evaporates and the paint dries. It adds a bit of extra visual interest to your piece with its textured and interesting surface. Cold press can also be labeled "Not Hot" or "Not," especially on paper brands manufactured outside of the United States.

 - **ROUGH:** Rough is similar to cold press, but it is even toothier and more textured. It's become of one my favorite textures to work on, as I love the added interest that the texture brings to my pieces.

- **FORMAT:** Watercolor paper is sold in many formats. The most common are blocks, pads, and large sheets.

 - **BLOCKS:** In this form, the individual sheets of watercolor paper are sealed together on all four sides. This allows you to paint on a firm surface (the paper beneath) and allows your piece to dry without the paper buckling while you paint, because the edges of the paper are sealed to a compact surface. Once your piece is dry, you can use a tool to remove the individual sheet from the block of paper.

- **PADS:** These are pages of watercolor paper that tear out easily at the top. They come in standard sizes like 9x12 inches or 11x14 inches.
- **LARGE SHEETS:** Large sheets of watercolor paper are the most economical way to purchase paper, as you can cut one large sheet into many different sizes and shapes depending on your needs.

■ **MAKE:** When you're shopping for your paper, be sure to purchase paper that's made for watercolor! The cover description should indicate that the paper is intended for watercolor use, as watercolor paper is treated with sizing, an ingredient that makes the paper water-resistant. This means the paper is treated to keep it from absorbing too much moisture and pigment all at once. As you can imagine, painting a watercolor masterpiece on tissue paper would be difficult, as it is highly absorbent and easily breaks apart. Sizing is what gives your watercolor paper just enough absorbency and resist to keep the paint on top of the paper and allow the white paper to show through transparent paint. The effect is brilliant, clear color.

The inexpensive watercolor papers are generally composed of wood pulp and don't hold water or move paint as gracefully as the more quality papers, which are composed of cotton fibers. Student-grade papers are often not made of 100% cotton like the professional- or artist-grade brands. However, my favorite brand of student-grade papers, Strathmore, produces papers that are acid-free and enable you to preserve the quality of your work. Like I said, I started on all student-grade supplies and worked my way up over time. I suggest starting with a pad of thirty sheets of 140-lb. acid-free Strathmore student-grade paper, which will cost you about ten dollars. If you want to try your hand on something a bit nicer, a pad of twelve sheets of 140-lb., acid-free Arches cold press paper will set you back about twenty dollars.

For each lesson in the book, I list the tools you need to complete the project. Some projects will truly benefit from using a higher-quality paper, and I call that out when necessary. Another thing to know ahead of time is that the higher-quality papers (100% cotton) can better withstand pencil erasing than the lower-quality (non-cotton) paper. So, if you're using student-grade paper, be sure to erase gently with your Artgum Eraser.

The final word on paper is that when it comes to watercolor, the higher the quality your paper, the better your paint will move, so the better your final product will be. You will get a feel for this over time, but here are a few examples from my own practice.

The examples at right were painted in the same sitting, and the only difference between them is the quality of paper used. Notice that student-grade paper dries faster, which makes a smooth wash harder to create. The pigments are a bit more vivid on the student-grade however, and it takes less paint to build up saturated color. The professional-grade dries slower, enabling its painter to make smoother washes, and slower more graded color blends.

STUDENT-GRADE WATERCOLOR PAPER

PROFESSIONAL-GRADE WATERCOLOR PAPER

PENS, PENCILS & ERASERS

These go-to tools are the unsung heroes of the watercolor process! My art compositions begin their process of becoming with my pencil, sketch pad, and an eraser. Every beautiful watercolor piece you see began as a sketched pencil idea, worked out and perfected before paint ever touched the palette. In this book, you will use your pencils to trace the project worksheets (or sketch freehand if you prefer), eraser to remove pencil lines from your finished piece, and pens to add fine ink work to your paintings for visual interest and dimension.

Micron Pens

Incorporating some ink with your watercolor paint can give your pieces a modern crispness. For these details, I like to use Micron pens. These pens create a thin, consistent, waterproof line that doesn't run or bleed when you paint over it. I often ink my lines before I add paint, so a waterproof Micron pen has become an essential part of my creative process.

Combining ink and watercolor mediums has become one of my most recognizable styles on social media. It's a great way to combine the precision and detail of drawing with the flowing freedom of watercolor paint. You'll practice doing this in Lessons 12, 13, and 15.

We also use ink in some lessons (such as Lesson 12, page 142) to create our boundary before painting, then bringing our paintbrush up to the edge of the ink to fill in the boundary.

Pencils & Colored Pencils

I keep HB pencils on hand at all times. "HB" refers to the lead consistency, and just means that the lead is soft and easy to erase. Any #2 pencil works in a similar way. Because I use pencils for sketching and conceptualizing ideas, I like the lead to be easy to remove, should I want to adjust lines.

Once I've sketched a new piece with my HB pencil, I usually use a water-soluble colored pencil to create the lines on my watercolor paper. HB pencil lines erase easily on sketchbook paper, but they do not erase once paint is added over them! If you're painting a piece in dark paint lines, like Payne's Gray, subtle HB pencil lines won't show up after you've painted over them. However, when you paint with light colors, and if subtle pencil lines showing up in your final piece bother you, you may want to opt to use water-soluble colored pencils, also called watercolor pencils, on your final surface. They allow you to draw illustrative guiding lines on watercolor paper, but the lines then dissolve when you paint over them. I like to select a light watercolor pencil (usually in a blush tone) and a dark watercolor pencil (usually in a gray tone) to use as my guiding lines. Since they dissolve into the watercolor paint, the color doesn't have to be perfectly matched.

Erasers

If you make a mistake with acrylic and oil painting, you can simply layer on another coat of paint and voila—the mistake is covered. But given its translucency, watercolor painting doesn't work that way; applying another layer will not fully

cover the out-of-place mark. Luckily, you have some tools at your disposal to help clean up mistakes.

I consider paper towels the watercolorist's eraser and always keep them within arm's reach while I'm painting. If you need to make changes to a piece, such as cleaning up an edge without disturbing the surrounding paints, a paper towel and a bit of water go a long way. You'll practice using paper towels as an eraser and blotting tool throughout the lessons in the book.

Another tool I regularly use is the Sakura Koi Colorless Blender, a clear brush pen. Its intended use is to blend watercolor colors together smoothly, but I've found that using it as an eraser is extremely effective. To do so, wet the point of the blender in clean water and gently stroke a stubborn, out-of-place splatter; this usually removes the offending mark without pulling up the texture of the paper. Unexpected red pigment splatters on your clean white watercolor paper are generally the hardest to remove, but the Sakura Koi blender can even erase these! You don't specifically need this tool for the lessons, but it is handy to have.

And, of course, I also use an Artgum Eraser for all of my sketching, before I ever paint. Artgum Erasers are designed to absorb graphite, so they are a wonderful tool to have as you trace and sketch in pencil. These can also pick up some colored pencil lines.

GOUACHE & WATERCOLOR

Gouache: What is it? And how do I pronounce it?

For starters, it's pronounced "guh-wash." Throw this one into casual conversation and people will be very impressed.

The traditional way to create white space in a watercolor painting is called "reserving," which means leaving the paper free of paint where you want light space to appear. Another, more modern way to create light in your piece is incorporating white pigment into your watercolor palette.

When you combine white pigment with watercolor paint, you're officially using gouache. Gouache paints are essentially an opaque version of watercolors. A paint color is *opaque* when it hides what's underneath—when it lacks translucency. White pigment slowly lightens a watercolor pigment, fading it out by reducing its translucent quality and increasing its opacity. I like to think that adding gouache paint to watercolor paint is like adding cream to black coffee. Gouache works beautifully to add highlights or create light in a dark space. It's also super useful if you would like to add a light layer on top of a dark-toned watercolor piece.

Most watercolor kits come with a white color called Chinese White. It is only semi-opaque, but when combined with other tubes of paint in your watercolor kit it will get you close to gouache. You can also purchase a tube of white gouache, which will enable you to create your own gouache on your palettes.

Gouache is unique because its opacity is like that of oil or acrylic paint, yet it is pliable and water-soluble like watercolors. Gouache is also commonly known as "opaque watercolor." Prized for its versatility, gouache dries quickly but can be reactivated with water and altered after it dries. However, unlike watercolor, gouache allows you to add color and actually cover up what's underneath. It's the best of both worlds. One thing to remember is that gouache usually dries to a slightly different shade because of its increased opacity: in most cases, lighter tones will dry lighter and darker tones, darker.

You can use all sorts of techniques, from drybrush to translucent washes, with gouache. All of the watercolor techniques we cover in the book are applicable to your gouache painting journey as well. Just like in watercolor, you don't want to layer gouache too thickly, as it may crack if it becomes too heavy. I water mine down considerably and treat it just like watercolor, as far as the paint-to-water ratio I load onto my brush. A little gouache goes a long way!

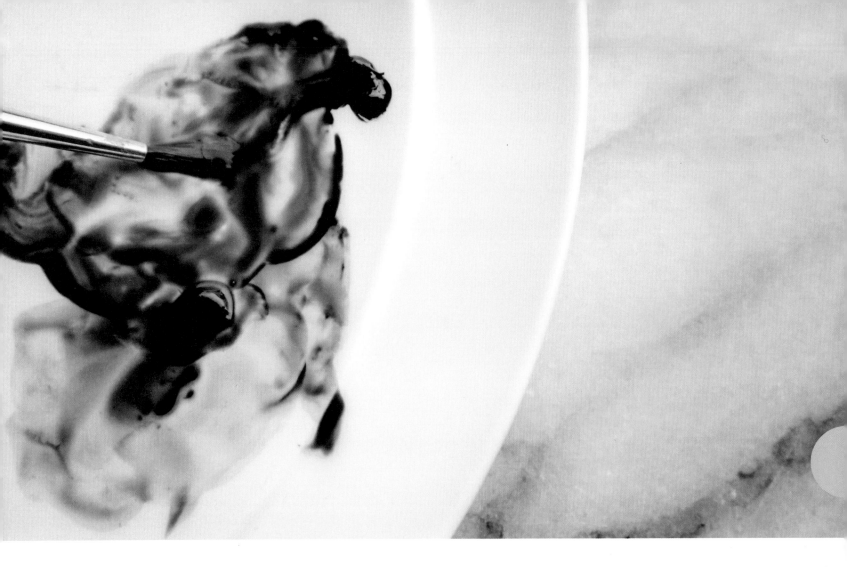

PREPPING TO PAINT

Let's start at the beginning and chat about how to prep your supplies to paint. Here are the fundamentals that I use daily. We are going to talk about creating movement and shine on your palette and your paper, and why that magic sauce is what watercolor is all about.

WATER SOURCE

When it comes to your water source, any clear container that's short in comparison to the length of your brushes works wonderfully. It's easier to rinse your brushes in a short jar, and you want to be able to see when your water needs changing. I like to use short 6-oz clear Mason jars.

You can maximize your painting time by having two jars of water nearby when you sit down to paint: one for washing your brush clear of light-colored paint, and one for washing out dark-colored paints. It's also good to have a clean water source nearby in case of accidental spills and splatters. Plus, you can dampen your paper towel to quickly tend to mistakes (see page 99).

When it comes to changing the water, some say that you want your rinse water to remain clean enough that you would let your goldfish swim in it. If I used this barometer, I'm afraid my fishies wouldn't fare very well. I always start out with lovely, clear room-temperature water, but it muddies up pretty quickly. As you begin to paint and develop your style, you can see if you prefer to follow the goldfish rule for your rinse water, or to simply refill your water when you feel like its muddiness is affecting the coloring of your paint.

> "The spontaneous and fluid look in watercolor painting only occurs when one mixes the colors like a sauce, then paints without looking back!"
>
> —JOSEPH GYURCSAK

PRIMING YOUR BRUSH

You'll see instructions to "prime your brush" many times throughout this book. This means getting your brush bristles ready to accept water and paint.

If your brush is new, it may come in a clear cylinder protector for transporting the brush. Feel free to recycle this or save it to use for protecting your brushes on the go. The clear cylinder keeps your brush point intact and protects the sensitive bristles from bending.

Once you're ready to paint, bring your brush to your water jar, and press the brush side down against the bottom of the jar, first on one side and then the other. Repeating this motion in the jar allows the bristles to relax and soak in water. Swirl your brush in a figure-eight motion a couple of times. This motion fills the bristles with water, making them ready to accept paint.

The secret of watercolor is that you actually don't use much paint—you use mostly water! Getting familiar with your brush and how to prime it is the beginning of a healthy relationship with watercolor as a medium.

Prime your brush whenever you sit down to begin a painting—it is the first step—and then as often as needed while you paint. This motion of the bristles in the water against the bottom of your jar clears away the excess pigment from the bristles so that when you bring your brush back to your palette, you can pick up a new color without any remnants of the previous pigment. [A]

One of the reasons people love to look at watercolor pieces, or enjoy watching the painting process, is that this medium seems to move with a life of its own. This is all thanks to water! When combined with water, the paint swirls and moves, independent of its creator's brush. The only way to achieve this free-flowing dance is by giving the paint enough water with which to move. Streaking and hard lines only appear when there isn't enough water used on a brush or in a palette in the beginning.

A

BRISTLES FLATTENED
COMPLETELY TO
THE FERRULE

THE BOTTOM OF WATER JAR

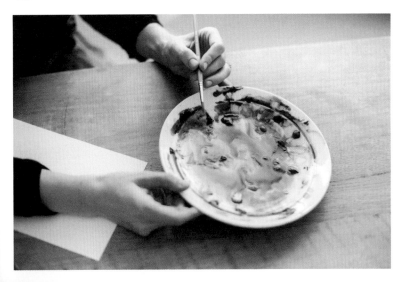

CREATING YOUR PAINT PALETTE

When I sit down to paint, I squeeze small dabs of my tube watercolor paint onto my palette of choice, which is usually a large white dinner plate. Depending on how many colors I want to use, and how much space I have available, I usually like to place the dabs a few inches apart to leave some room to blend colors. I tend to place the pure pigment dabs near the edges of the palette and then mix the colors and water closer to the center of the palette.

I use my brush to bring clear water from my Mason jar to my painting palette to create a mixture of water and paint. This mixture—the ratio of water to paint—is the key to watercolor painting! (More on this in The Magic Sauce, page 24). I enjoy using the slanted edges of my white dinner plate for the paint dabs, as the water runs through, in, and around each of the dabs of pure pigmented paint. The slant of the plate allows the pure pigment to sit slightly above the pools of the paint-water mixtures I create. This way I can easily access the mixtures and, because there are other paint mixtures flowing on the broad mixing area of my plate, new colors and shades are created as I continue to add water and paint. I can also still dab into my pure pigmented paint as needed because it stays in place on the lip of the plate. So convenient! The pure dabs of paint come in handy, in case I want to quickly add more pigment to a paint-water mixture or carry some over to another area of the plate to create a different color mixture.

Some of my favorite color discoveries have happened because of the unintentional blending that happens on my palettes. After I'm done painting for the day, I save my palettes. They dry, and when I return to paint the next day (or hour), I reanimate the same blends just by adding water. This way, all my favorite colors are waiting for me and I can pick up right where I left off.

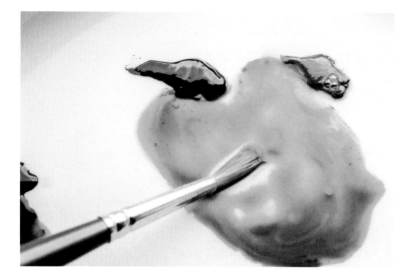
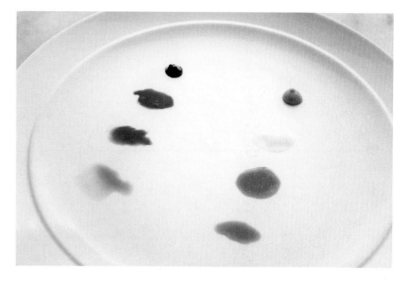

THE MAGIC SAUCE: WATER-TO-PAINT RATIOS

Finding the right balance of water and paint is the key to enjoying watercolor and creating lovely pieces, and it starts right on your palette. Before the paint *ever touches your paper*, it needs to be mixed on your palette and have both movement and shine.

People often ask me: How much water am I supposed to use? How much on my paper? How much on my brush? How much on my palette? Many videos and classes suggest "just a touch more water here" or "maybe a little more water to make that paint really move," but how do you know if you've added enough? This all takes some practice, but I'll try to keep things really simple to help you use water-to-paint ratios for the best outcome.

In teaching my students, I've found that it helps to explain paint consistencies using food analogies. I like to compare the consistencies of paint and water with well-known sauce textures. Throughout the book I refer to these as the "magic sauces," and they should be easy for you to remember. If you get the hang of them now, you'll have an easy time mixing your "sauces" for the lessons that follow.

To make your sauce, you'll use your brush to bring water from your Mason jar to your palette. You can take your brush back to your water source as many times as you need in order to create your sauce so the paint mixtures on your palette begin to have movement.

To see if you've added enough water, pick up your palette and tilt it vertically, shifting it this way and that. If you see small raindrops of your paint and water mixture beginning to form, like the picture of my palette on page 23, you're on the right track. You're after both movement—the small drops moving on the surface—and shine—the surface of the mixture shining and reflecting the light. Movement and shine! Once you see this, be sure to maintain it on your palette for the entire time you are painting—otherwise, your paint mixtures won't bring the desired effects to your watercolor paper.

Of course, there is a very wide range of paint-to-water ratios that people use to create their watercolor pieces. To keep things simple, and to share what works best for me, I will break down four go-to water-to-paint ratios—four magic sauces—that we'll use throughout the book. Each of these consistencies creates different looking washes. As you'll see, some are better for painting one thing and some are better for painting another.

Note: If you aren't familiar with these food sauces in everyday life, you can easily find them at your local market. I suggest building your familiarity with these sauces, as they really are great comparisons as you learn to build your palette and work with water and paint. Above is a picture of Payne's Gray watercolor paint in the four ratios laid out below, next to their corresponding real-life food sauce consistencies.

CONSISTENCY RATIO	CONSISTENCY COMPARISON
Water / Paint	**Magic Sauce**
10w/90p	Mustard (with wet tube paint)
50w/50p	Heavy Cream
80w/20p	Soy Sauce with Wasabi
90w/10p	Soy Sauce

To explain how to create a magic sauce, let's use the 80w/20p "soy sauce with wasabi" consistency as an example.

If your water is your soy sauce, and your dab of tube paint is your dab of spicy wasabi, use your brush to bring water to the dab of concentrated paint and draw out a bit of the pigment into your water. Continue to add water with your brush until you have a mixture of about 80 percent water and 20 percent paint—80w/20p. The food analogy continues here, as wasabi is incredibly potent, and a little goes a long way—same as a fresh dab of tube paint, which is extremely concentrated. By using your brush to carefully draw just a bit of the pure pigment away from the dab and into your water mixture, you stretch the contents of your paint tube and only use what you need. Keep adding water as needed, diluting and creating your "soy sauce with wasabi" consistency.

This method applies to all four of our sauces, each consistency requiring a different ratio of water to paint—from the most concentrated paint mixture of "mustard" (only 10 percent water and 90 percent paint) to the least concentrated, highly diluted "soy sauce" (90 percent water and only 10 percent paint).

Once your palette has dried after a painting session, reanimating the paint dabs and the mixes you've already made on your palette follows a similar process. Use your brush to add water to the color mixtures to recreate your desired consistency. The dried paint dabs of the concentrated color can be reanimated slowly with water to get them back to their tacky, interactive form, so you can draw more paint pigment into your mixtures as needed.

MOVEMENT & SHINE: WATERCOLOR ON PAPER

Your brush is a guide: it deposits the paint and water mixture on your paper and creates boundaries for the paint. Where the water stops, the paint stops. With your wet brush, you suggest the shape and area for the paint to land, but the paint and water will move on their own within that wet boundary as they mix, dry, and blend. This is the magic of watercolor.

How do you achieve the right amount of movement for your paint on paper?

It begins with mixing that magic sauce on the palette first. Once you've created your desired consistency on the palette, you use your paintbrush to bring that sauce over to your paper to begin painting.

If you were to pick up your paper from your desk, as shown, your paint would stay within the wet boundary you've created. You know you have the correct ratio of paint to water if you can move your paper all the way around, and the wet boundary you've just painted doesn't run. This means the mixture on your paper should form a small bead of water that moves around the boundary you've painted but doesn't quite run out of the boundary.

In addition, you also want to see a layer of "fine shine" on your paper, whether it's just a clear water wash before the paint is added, or a water/paint mixture. This is where the wet boundary catches and reflects the light as you tilt your paper this way and that.

Movement and shine—that's what you want to see every time your paint colors touch your watercolor paper.

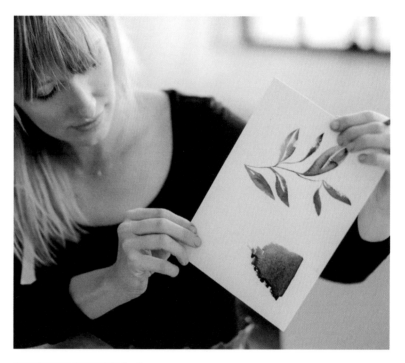

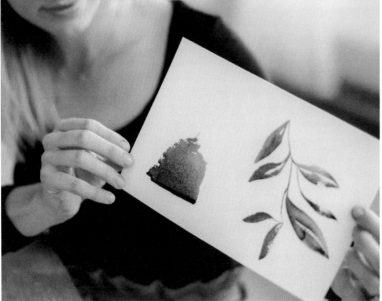

A NOTE ON PRE-WETTING YOUR PAPER

I've been asked often if I pre-wet my paper before I begin to paint. "Pre-wetting" simply means covering your entire paper with water, essentially creating a surface that will not have any hard lines: the entire paper is wet at the same time, allowing paint to move over the entire piece.

The key to understand pre-wetting comes down to understanding what paint does on wet paper. Paint moves into any part of the paper that is wet. When you pre-wet an entire page, you're declaring your entire sheet as the wet boundary so your paint can move into any space it desires, provided it gets there before the water evaporates. With pre-wetting, it is difficult to create hard lines or intentional white space. It offers less control once your brush touches paper.

I don't pre-wet my papers; I bring water to my paper in the form of my magic sauces and create a wet boundary within the small area I'm painting.

BASIC WATERCOLOR TECHNIQUES

Spending time learning watercolor technique is so important. Even if you've been watercoloring for a while, when you take the time to practice, develop, and hone a technique, you will only get better. Even the techniques you use all the time are really not so basic—they are fine skills that only improve as you use them. Plus, practicing technique can be relaxing and meditative, a way to paint without the pressure of finishing a piece. I designed Lessons 1 through 6 with this in mind: to teach technique while allowing you to enjoy the process of painting and also help you create some pretty, abstract designs on your paper. Following is a quick primer on the key techniques. You will practice them, step-by-step, in Lessons 1 through 6.

By taking your time and learning to practice the basics of watercolor with the correct technique, you are training your brain in procedural memory. Often referred to as "muscle memory," this involves consolidating a specific task into memory through practice. Certain skills, like bicycling, might require the strengthening of certain physical muscles, but the processes that are important for learning and memory of new skills occur mainly in the brain. The more you practice, the better you will be. And the better your skills are, the more beautiful your final products will be.

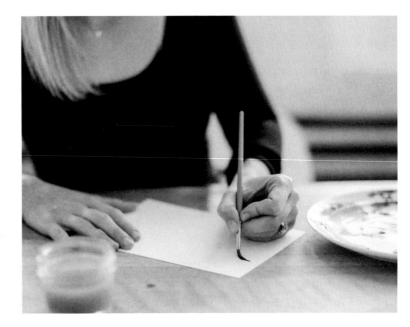

HOLDING YOUR BRUSH

How you hold your brush is an important watercolor technique!

I want you to get used to the classic hold for a watercolor brush. This grip is similar to how most people hold a pen or pencil for writing. Pick up your brush and grip the thickest part of the handle, above the ferrule, and hold it like you

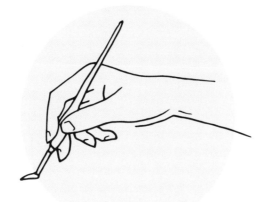

are getting ready to write a letter. Think of the point of your brush like the tip of your pen.

Feel the weight of the brush in your hand, roll it with your fingers, find the balance of the brush in your grip. The classic hold gives you linear control. It works wonderfully for detail painting and blending, creating flowing lines, and drawing with paint.

As you begin to make marks with your brush, keep in mind that you have the most control if you use your brush to pull the paint down or move it from side to side, as opposed to "pushing" the paint upward.

Where you hold the brush makes a difference in the type of mark you're making. Holding the brush closer to the bristles (on the metal ferrule) gives you more control in finer strokes, like the details of a leaf.

Holding it further back gives you more agility in your movement and works well for making looser strokes for a wash.

The amount of pressure you use as you touch your paintbrush to paper will also affect the shape and style of the mark you create. We will play with pressure and mark making more in Lesson 5 (page 78).

> # "Watercolor offers us, as artists, an inspired approach to the age-old process of making paintings sing."
>
> —JEFFREY J. WATKINS

WATERCOLOR WASH

A watercolor wash is a transparent layer of color brushed onto your watercolor paper. From painting a small flower to an immense seascape, the wash begins the process for almost every watercolor piece.

When you create a wash, you use your brush to apply your water/paint consistency to your paper smoothly and evenly across the surface in a side-to-side motion. A wash can be flat (one consistent color throughout) or graded (meaning the wash color moves gradually from darker to lighter through layering). We cover both washes in the upcoming lessons.

You'll use the wash technique in every project you create in this book. It is the most common way for a watercolorist to bring color to paper.

A watercolor wash can also just begin with clear water, or simply wash water. I like to create with a clear wash, getting that movement and shine with just water, when I want the overall dried piece to be lighter. A light blush watercolor flower begins with a wet wash that starts clear, or almost clear. We get to play with this in Lesson 6 when we explore the light florals!

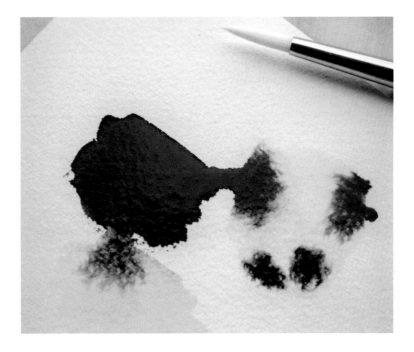

BOUNDARIES

One amazing thing about watercolor is its ability to form a crisp, clean edge where the water meets the paper. Where the water stops, the paint will stop. Throughout this book, I refer to this edge as the boundary. Paint moves within the watercolor boundary as long as the area remains wet.

You can direct where the paint should go with your brush by creating a wet boundary. Every time you bring your loaded paintbrush to your watercolor paper to make a wash, you create a wet boundary. By creating movement and shine with your paint consistency within that boundary, you give yourself time to add more color to your wash using the wet-in-wet method (see page 28) or to remove color from your wash by blotting (see page 29).

You can also blend boundaries as long as both boundaries are still wet. See in this example, how when the boundary of one wet wash touches the boundaries of other wet washes, the colors begin to move and blend into one

another—because paint moves where there is a wet boundary. This is one of the unexpected beauties of watercolor. By guiding your paint washes to overlap their wet boundaries, lovely blending can happen. Boundaries are also a great thing to be aware of when you do not want two areas to blend. If you want defined, separate boundaries, make sure your wet boundaries don't touch!

As a boundary begins to dry, your ability to change the coloring within that wet boundary lessens. Once the boundary is dry, the paint is set and formed. Adding water or another layer of watercolor to a dry boundary can leave you with new lines, edges, or unexpected effects, like watercolor blooms (see page 29). If you aren't looking for these types of effects, avoid disturbing a boundary that is already drying.

WET-IN-WET

Painting wet-in-wet means using your brush to drop wet paint onto a wet boundary. The result is that your colors will blend into one another, bleeding and veining into the boundary you have created on your paper. Be prepared: once you drop the color into the wet boundary, the way the paint moves will be unpredictable and mostly out of your control. And this is a good thing!

With wet-in-wet, your paint makes beautiful effects that you could not achieve with a brush. In many ways, you are not really "painting" in wet-in-wet; you are merely releasing the paint from your brush and letting it do its thing. Watercolorists use this technique to create shadow, high/low contrast, and interesting movement within their washes. It's a beautiful way to create clouds, oceans, flower petals, and more, providing more color in a base wash that lends itself to natural movement and shading. You'll do this in many of the lessons that follow.

Be mindful that this technique relies on a bit of speed. A successful wet-in-wet application is dropped in when the base wash boundary is still wet, enabling a smooth blending of colors without hard lines or blooms. You will add your wet-in-wet application soon after painting your wash, so you want to have all of your paint mixtures ready to go.

WET-ON-DRY

Most people think of watercolor as a transparent, dewy medium with a smooth and fast-drying application. While this is true most of the time, you can also achieve bolder effects with your watercolor paints.

One way to do this is with the wet-on-dry technique, which involves waiting for the first layer of your wash to completely dry and then applying new paint to

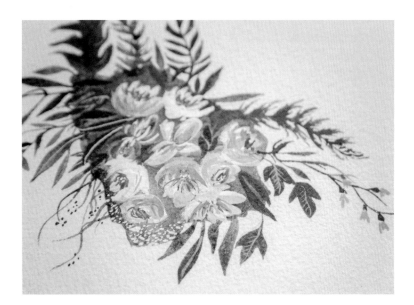

the dry surface. This method works great for layering color, adding fine lines and details, and elevating the definition of your pieces.

It's best to use a smaller brush (such as your Round 1) to apply new wet paint to dry paint on your piece. Darker colors or white-based gouaches work best on top of a dry wash. You'll use this technique in the last four lessons of the book. For the wet-on-dry method, the wet paint you're adding is used for detail work and produces hard, clear lines.

How can you tell if your paint is dry? Make a flat palm and hover your hand a quarter inch above the boundary. If you feel any coolness coming up from the paper, your paint is still wet! Wait another thirty minutes and try the test again.

GLAZING

Glazing is another fundamental watercolor technique that you've most likely used before, without even realizing it. "Glazing" is just the fancy term for laying a wet layer of watercolor on a dry layer of watercolor. Because watercolor is known for its transparency, you can create depth in your pieces by slowly building up color, overlaying your washes and building the color slowly. To glaze is to layer your transparent washes, one on top of the other, after the first has dried. A

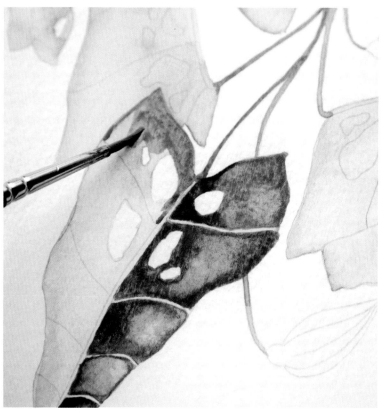

washed boundary, once dry, can be darkened, adding contrast and interest, by painting another layer of transparent color on top. It is similar to the wet-on-dry method, because we use glazing to add wet watercolor on a dried watercolor wash. However, I primarily use wet-on-dry to provide intense accents of color, or color "pops," that cover very small surface areas, whereas I use glazing to cover larger boundaries. In Lesson 11, we will use the glazing technique to build up the transparent saturation of green colors as we paint green leaves in segments. Watercolor tends to dry lighter in appearance than when applied in its wet and water-saturated form. Glazing, or layering your paint on, allows you to deepen your piece with contrast.

WATERCOLOR BLOOMS

Watercolor blooms, also known as blossoms, appear when new wet paint spreads on and into a drying (but not yet completely dry) boundary. When you add a new layer of wet paint (or water) onto a drying wash, the new wetter liquid forces the pigment of the original wash out, creating irregular shapes that resemble blooms. Areas of greater wetness will flow and spread into areas of lesser wetness, causing these watercolor blooms, which are granulated dark and light. You can see in this portion of my painting that the first wash had already begun to dry once I dropped in a bit more paint and water. This shows the drying line of a wet boundary meeting a dry boundary. [A]

In the second example, the paint was dropped into a boundary that was already dry, so there was no movement into a bloom. The pigment simply dried where placed. [B]

Blooms are one of the magical effects of watercolor, and one reason why it's so fun to play and let the paint, water, and paper do their thing. Without overworking the wet boundary with a brush or paper towel, your paintings will change as they dry. This is often when you'll see the most beautiful effects emerge.

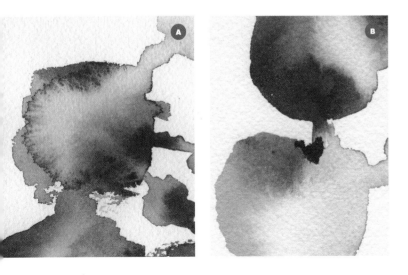

POINT-PRESSURE-POINT

I use the point-pressure-point technique to add a full brushful of color to my pieces. Because I prefer to use round brushes, this fun little stroke has become one of the most useful techniques as I paint. Not only does it create the most lovely little leaf shapes in one simple stroke (we will play with these in Lesson 6), it's also a wonderful stroke to learn to use because of its ability to distribute a full brushful of paint onto your paper. Round brushes are pointed at the "toe" of the bristles and begin to widen throughout the "belly," coming to a round fullness at the "heel," where the hairs then connect into the ferrule. With bristles fully saturated in your magic sauce from your palette, begin a stroke on your paper by accessing just the point, or "toe," of your brush, gently pulling down and creating a very delicate line. Then, continuing your fluid motion as you pull your brush, increase the pressure on your bristles to expand your stroke, enabling your bristles to broaden to their full capacity, distributing more paint. To finish off your stroke, again decrease the amount of pressure you apply on your handle, enabling the bristles to again access the thin, pointed "toe." You have created a leaf shape in one fluid stroke that is wet and ready to be added to a wreath. I've found this brushstroke to be one of the most mindful exercises I can practice as I begin to paint. There's nothing like a few point-pressure-point strokes to warm up your hand, quiet your mind, and get your creativity twirling.

BLOTTING

Blotting is the act of using an absorbent material, such as a paper towel or a wrung-out, damp brush, to pick up pigment or water in order to lighten a wet or damp area of your painting.

You can press the paper towel into your wet paint boundary to soak up paint splatters and areas with too much water or too much paint. Using heavy pressure will pull all of the pigment and water out of the area. It acts as a "watercolor eraser" of sorts, completely removing all of the wet paint and water. Using light pressure has more of a dabbing effect, or what I like to think of as a "watercolor vacuum." Lighter pressure usually pulls out paint, but not all of the water, allowing movement to still continue within the area.

You can also use a damp or "thirsty" brush to "sweep" color away from a spot within your wet boundary to create a lighter area. This is the subtlest way to remove color, while blotting with a paper towel removes more color and paint and has a more dramatic effect.

As a general rule, keep paper towels on hand at all times while you're painting. In addition to creating wonderful contrasting light spots within your wet boundaries, they are handy for absorbing unwanted puddles of water or cleaning up accidental paint splashes.

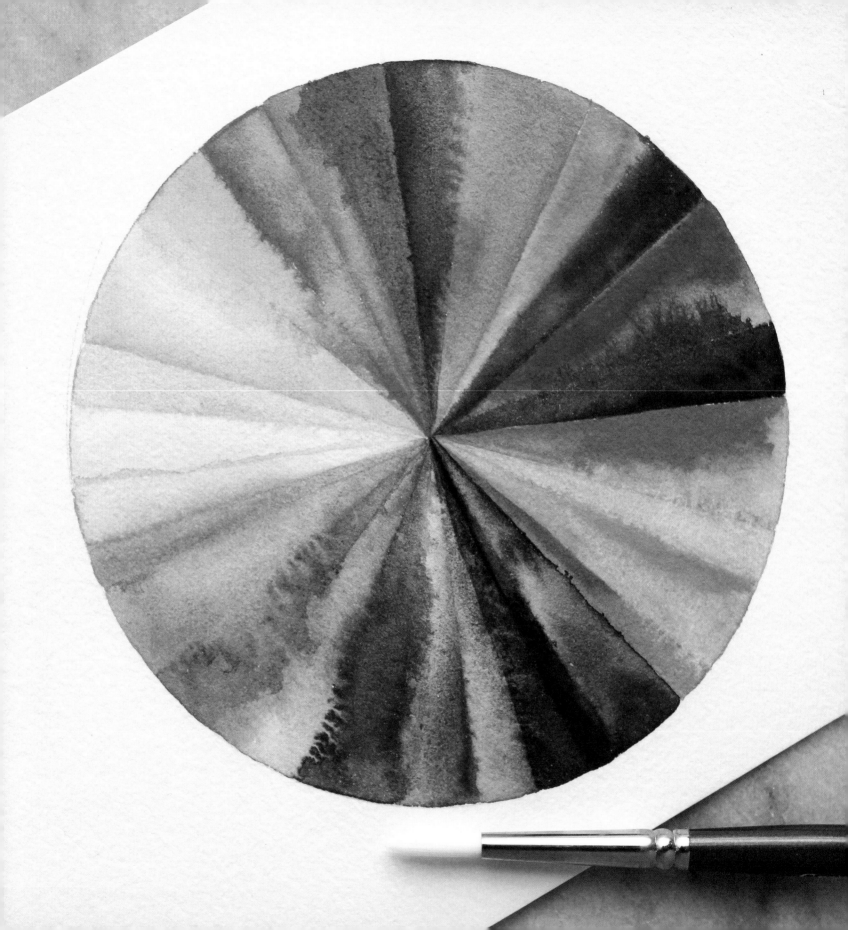

COLOR EXPRESSION

Color preference is very personal. With practice and time, as you develop on your painting journey, you will begin to see similarities across your palettes and painted pieces. These similarities represent your personal style and are your unique expression in the world of color.

You can learn a lot about your color preferences and personal aesthetic simply by observing the colors you've surrounded yourself with. We are strongly influenced by the visuals we have all around us. Take a moment to lift your eye from the page and take in your surroundings right now, be it your garden, your mother's kitchen, or on the train riding into work. Ask yourself: What colors am I drawn to? What colors make me feel calm and at ease, or energized and excited? What colors do I think look good together? If I were to recreate them in paint, and put them together on my page, do I feel excited about how that would look? Pause and take a moment to think about the colors in a favorite room in your house or a favorite place you've visited. When you think of the colors in that place, what do you feel? Whatever comes up for you now is telling you a lot about your color preferences, which will guide your color expression as you paint!

I began my own painting journey with intuitive color choices, soaking in color from my experiences, the treasures lining my bookcases, and my garden in every season. As I've grown and developed in my craft, I've learned that many of my intuitive choices can be expressed through age-old artistic terms. What a joy this was to discover! For instance, I realized that several of my pieces were already reflecting complementary triad color schemes, and only then did I intellectually understand why they worked so well together. While I firmly believe in using your intuition, it can also be helpful to have a few guidelines as you hone your eye and preferences.

In this section, I provide a quick review of color relationships and some practical color guidelines that have helped me. Mixing colors to make a satisfying and original composition is a skill that takes time and practice to learn. If you're interested in a deep-dive look at color theory and how different color combinations relate to one another, I suggest getting a book dedicated to the subject. *Color Choices* by Stephen Quiller or *Interaction of Color* by Josef Albers are good places to start.

THE COLOR WHEEL

The color wheel is a circle of colors that shows the relationship of colors to one another. When you're looking at the color wheel, you're essentially seeing a color rainbow. The natural order of colors is the same one you've known since elementary school: red, orange, yellow, green, blue, indigo, violet. When the two ends of the rainbow are connected, the traditional color wheel is created. An orderly circle of lovely color!

But the color wheel isn't just a pretty rainbow circle—it actually teaches us a lot about color theory.

HERE'S WHAT YOU CAN IDENTIFY IN THE WHEEL:

Primary Colors: These are the three colors that cannot be created from any other colors: Red, Yellow, and Blue—often referred to by artists as "**RYB**."

Secondary Colors: These colors are created by combining two primary colors and are commonly referred to as "**OGP**."

RED + YELLOW = ORANGE
YELLOW + BLUE = GREEN
BLUE + RED = PURPLE

Tertiary Colors: These are the colors you can create by combining a primary color with a secondary color. For example:

YELLOW-GREEN
YELLOW-ORANGE
RED-PURPLE
BLUE-PURPLE

Warm Colors: Yellow, orange, and red are generally in the warm spectrum of colors. But like Michael Crespo says, it's all relative. A red can be considered cooler as it blends and approaches violet.

Cool Colors: Blue, violet, and green are considered part of the cooler color spectrum, but green can move up in warmth as it approaches yellow.

Neutral Colors: These include blacks, whites, grays, and browns. Neutral browns, grays, and blacks can be created by mixing primary colors in the wheel. Some people consider these neutrals "muddy." I often see the color of bark, leaves, and compost in these colors and enjoy them on my palette.

Each color in this wheel can be stretched to produce many values within that one color.

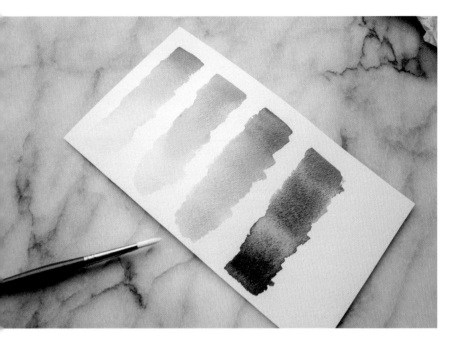

COLOR HARMONY

When you are painting an art piece, keep in mind that, aesthetically, colors work best when they are in harmony with one another. But what does that mean? Of course, there are multitudinous color harmonies to explore—and tons of opinions and information out there about this topic. But in the spirit of keeping things simple and fun, here are the four harmonies that inform my color work and will help guide you in your color exploration. When in doubt about color combinations, come back to these harmonies and the color wheel for inspiration.

RANGE OF INDIVIDUAL COLORS

When speaking of color, color theory, color harmony, hues, tones, and tints, it's easy to get lost in terminology. I find a good visual makes all of the difference.

Let's take a look at the paint color Oxide of Chromium by Winsor & Newton—commonly referred to as OoC. By observing the chart shown above, you can see all of the ways to adjust a single color in order to discover the full range of its potential. Here are some helpful terms to remember as you begin to work with color:

Hue: Pure color, pure pigment; a color without tint or shade. The terms "color" and "hue" are interchangeable.

Tint: A color lightened by mixing with water or white pigment.

Tone: A color altered by mixing with gray pigment.

Shade: A color darkened by mixing with black pigment.

Value: A color's value refers to the range of color expression from tinting to tone to shade. You can continue to increase a color's light value by tinting with water or white paint or increase the dark value by adding gray or black paint.

Saturation: Value encompasses the term "saturation," which refers to the color's singular expression. To saturate a color, you add more of the same pigment to increase the color expression in the same hue, without tinting or shading.

Similarly, you can desaturate a color by toning (adding gray pigment).

Monochromatic

The term "monochromatic" refers to shades of a single color as it moves through a value range. For instance, in the example above, we took OoC and moved it through a value range of tint, tone, and shade. This value range of one color provides a monochromatic harmony that is lovely when used in a piece. For this example, I painted an entire branch of outlined leaves in one color, using monochromatic harmony.

Analogous

When three colors are side by side on the color wheel, they are known as analogous colors. For example, red, orange, and yellow are analogous. These colors work well together because they naturally blend into one another. In the example below, you can see the blending of these three colors in the flowers: red, orange, and yellow. And just like on the color wheel, analogous colors are often found next to one another in nature. Think about the coloring of fall leaves as they change to bright reds, oranges, and yellows, or in the summer, when leaves are rich in nutrients with their deep greens, blues, and purples. The word "analogous" is defined as "similar or comparable." A grouping of colors in this theme feels calm and natural because of both their similarity and subtle differences.

Complementary

Some of the best colors to pair together are shades that are "complementary." In the world of color, this actually means colors that are opposites and sit across from one another on the color wheel. Basic complementary colors include red and green, violet and yellow, and blue and orange. For the example above, I've used a deep Payne's Gray blue to color the seashells and flowers, and I've accented the piece with complementary orange tones, found on the opposite side of the color wheel.

"Of all the elements that define painting, color is by far the most complex, abstract, spiritual and forceful. The colors that we paint most often, the ones we wear, the colors in our dwellings, the ones we cherish most, those that identify us like fingerprints, are apt to change many times as our experience accumulates."

—**MICHAEL CRESPO,** *WATERCOLOR CLASS*

Triadic

The term "triadic" refers to three shades on the color wheel that are an equal distance apart from each other. For instance, pink, blue, and orange are triadic. If you were to draw straight lines connecting these three colors, you would form a triangle in your wheel. When you choose three colors that are spaced evenly around the color wheel for your piece, it creates a harmony that then translates to your audience as they see your piece.

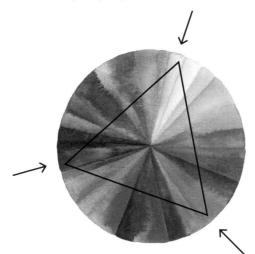

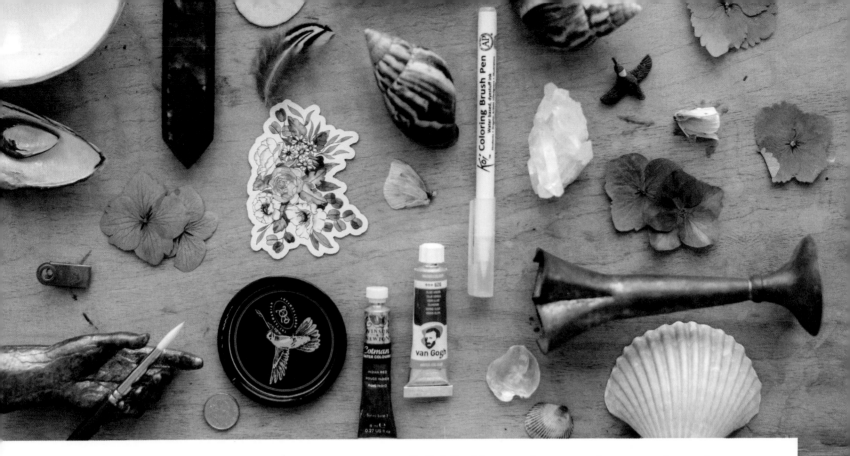

COLOR PSYCHOLOGY

When I am preparing a palette for a new art piece, more often than not, I avoid using pure pigment, or the hue that comes directly out of my tube of paint. I like to use toning, tinting, and shading, as well as mixing multiple pigments, until I get the feel I want. You will practice doing this in Lesson 3 (page 62).

Another thing to consider when choosing your colors is what each color and its values and combinations can say to the viewer.

For example, my visual journey of sharing my art on Instagram has repeatedly drawn the comments: "Your art makes me feel so peaceful when I see it." "Your art is so clean and soothing." It's fascinating that across cultures and time zones, all over the world people tend to feel this way about my work. I am fascinated by this. When I paint, I am often in a very peaceful space, both mentally and physically. Every afternoon, I sit at my great-grandmother's writing desk with a paintbrush, and I reconnect with myself and recharge as a human being. So often, the calming meditation of painting for me IS peaceful. I was overjoyed to hear that this was being communicated through my work. Did I pick the colors and palette that have become my signature because I am feeling so peaceful? Or am I just naturally drawn to these colors because of how they make me feel?

Following is some basic color psychology you can keep in mind as you work and paint and view the art of others. As you look at these colors, and read their word association, how do you feel? Do you think they are accurate?

- **Red.** Confidence, youth, power, passion, anger, and aggression.
- **Orange.** Friendliness, warmth, energy, and adventure. Often associated with Red's power and Yellow's friendliness.
- **Yellow.** Happiness, friendliness, optimism, warmth, and inspiration. If used too much: anxiety or fear.
- **Green.** Peace, growth, and health. Calming.
- **Blue.** Trust, security, and stability. Calming.
- **Purple.** Luxury, creativity, and wisdom.
- **Pink.** Hope, sensitivity, romance. Youthful femininity.
- **Black.** Reliability, sophistication, and experience.
- **White.** Simplicity and cleanliness. Calming.

My color palette is often a mix of tinted, toned, and shaded greens, blues, blushes (created on a palette by combining pink, orange, and yellow), and sometimes a touch of purple. I paint on white paper and tend to edit the photos I share of my art to increase the brightness of the white paper. According to color psychology, the qualities of my color palette are: peaceful, calm, creative, feminine, clean—all descriptors I've heard over and over again from people from all over the globe as they take in my visual images. Pretty fantastic.

What do you think? What do the different colors make you feel? What combinations have you tried, and what do they say about you and your work, based on the color psychology shared here?

COMPOSING A PAINTING

For me, composing a piece often begins with an inspiring element. Something will catch my eye and set off the internal process. Suddenly my heart, my previous experiences, and other things I've noticed around me all come into play. My mind starts swirling and making connections:

"This peony! Look at the movement of her petals. And the slowly fading blush color in each one . . . I need to paint her! Look how this one overlaps here, and this other one folds in. Look at that knobby center and her coloring. I think I could mix Oxide of Chromium with Yellow Ochre to find just that shade for the center. This peony would look so lovely with a leaf placed near her. I saw some leaves yesterday that are just the right shape—I'll add those! Would this be a better piece if I incorporate ink so I can really capture the definition and movement of each petal? Or should I lay a base layer of watercolor, and add wet-on-dry details with gouache to add the definition?"

When this happens, I know I've caught a spark of inspiration and I literally cannot wait to start painting.

The coolest thing about the artistic process is that each person's internal approach will look different—even if we are working from the same visual cue or prompt. There's a deeply internal element that makes artistic expression unique. From that place, it flows out from our hands, our brushes, our colors, and our choices to come alive on the paper or canvas.

When I teach a class, I get to see this creative process in every student. In the beginning, I typically provide a pre-traced art piece and give every student the same instructions. They're all using the same color palette, the same brand of paints, the same reference piece. They're experiencing everything within the same environment. But what emerges on every page is different. It's unique for each person. Every time, I'm amazed as I watch these results unfold! I can't wait for you to experience this in your own work as well.

FINDING INSPIRATION

What are you passionate about? What activities are you drawn to, besides painting? As you can tell, I love flowers and being in the garden. It was a very natural thing for me to take one inspiration and blend it with another . . . flowers and painting. Painting themes or subjects we are passionate about can provide the best subject material. Our pets, friends, chocolate, or even listening to our favorite band, and painting a visual of how it makes us feel. Inspiration is all around us, and many of us have hobbies and bright lights of inspiration just waiting to be captured in watercolor.

Because my watercolor book focuses on botanicals, you will see pictures of me arranging real life flowers through this book. In the last lessons, we will actually create watercolor pieces from this arrangement, so you can see the full progression from inspired idea to a fully designed watercolor masterpiece.

COMPOSITION

The term "composition" literally means putting together and applies to any work of art that is arranged using intention—from music to writing to painting. It refers to how the elements of the subject matter work together to create a satisfying whole.

For this book, as you work with the colors, shapes, textures, tones, and lines of botanicals, I want you to think of composition in eight elements: unity, balance, movement, rhythm, focus, pattern, contrast, and proportion. To help illustrate these elements, I've created the example floral arrangement on the next page and will walk you through how I applied each individual element of composition to this piece. Later, in Lessons 15 and 16, you will create a palette and your own art piece based on this same floral arrangement.

Unity

To assess the unity of a composition, I ask myself: do the pieces I'm adding occupy the space in harmony? Every element and color introduced asks something of its audience, so you don't want to add something that detracts from the natural unity of the overall piece. In the example of the floral arrangement, showcasing a focal point composed of a unifying color allows the piece to continue fluidly. The soft pinks, blushes, and coral colors of the peonies and iris flower harmonize in color and texture, adding to the sense of unity. As I slowly added pieces to the existing structure, I continued to ask myself: do all the parts of the piece (color, texture, lines) feel as if they belong together, or does something feel stuck on, or awkwardly out of place? For this particular arrangement, I kept trying to place a leafy branch in one spot, stepped back to take in that decision, and then plucked it out and moved it to a more unifying spot. Playing around and pausing to reflect on unity is the greatest way to achieve the best overall effect.

Balance

Balance is the sense that the piece "feels right." Is it too heavy on this side? Is there too much going on texturally here and not enough there? Often, a symmetrical arrangement adds a sense of calm, whereas an asymmetrical arrangement may create a more energizing or dynamic feeling for its viewers. In the photo on the next page, the brightness of the peonies, iris, and arugula flower are

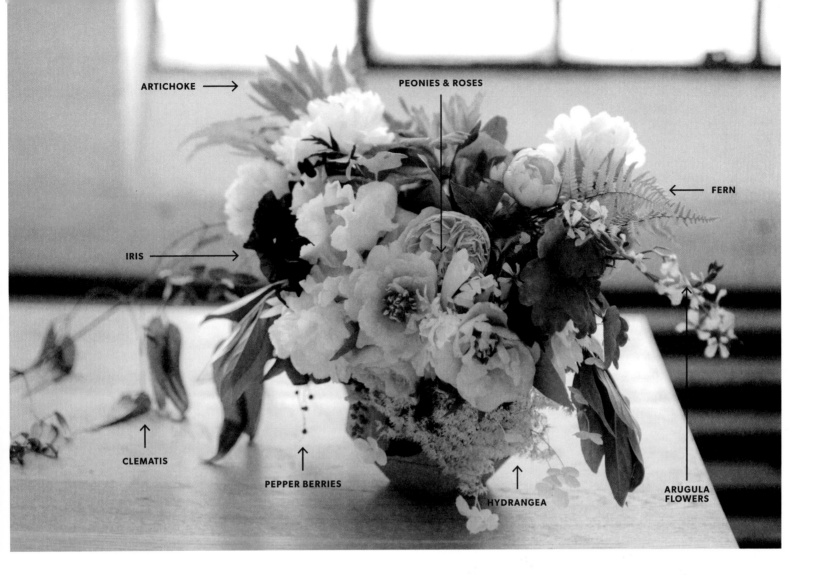

ARTICHOKE →

PEONIES & ROSES

← FERN

IRIS →

CLEMATIS ↑

PEPPER BERRIES ↑

HYDRANGEA ↑

ARUGULA FLOWERS

answered by the deep purple-black color of their iris neighbor. The focal point of the piece is balanced in color with this high-low contrast, and is also balanced in texture, echoing the light iris ruffles with the dark iris ruffles.

Movement

There are many ways to bring a sense of movement to a piece, such as the arrangement or angled positions of objects. In working with botanicals, I often create movement by coordinating the shapes of leaves and curves of flowers with any strong lines I've used to define the structure of my piece.

In this arrangement, you'll see I created two predominant lines with the ferns and arugula blooms. These lines guide your eye to the focal point of the piece, which is the center of the flowers. There is an interesting asymmetrical line that follows the left lead line and accentuates its placement with its length, creating a dynamic feeling with the clematis. In this arrangement, I'm suggesting movement when a branch goes off to one side. Also, notice that the leaves are not all pointing the same direction, and neither are the flowers. This is how you would find them in the garden and painting them this way is how you create movement

and mimic nature. Creating a painting from a floral arrangement is essentially making a two-dimensional snapshot of a three-dimensional moving subject. It's important to show different sides of leaves and blooms and the different angles of objects in order to capture natural motion and movement.

Rhythm

In much the same way as music, a piece of art can have a rhythm or underlying beat that leads your eye around a piece, encouraging you to view it at a certain pace. In my art, I often achieve rhythm with repeating color. In this example, I've chosen a few colors and then repeated them throughout the arrangement. For instance, each creamy-white pop of color guides your eye around the piece.

I've also created rhythm in the leaves: I've used a few different leaf species throughout, and placed them to interact with one another, gently leading the eye around the perimeter and out to the asymmetrical edges, and then back in toward the focal point. This intentional use of color brings rhythm to the piece. Too many green colors, just like too many textural elements, would confuse the eye and throw off the rhythm of the piece.

Pattern

Pattern refers to a regular repetition of lines, shapes, colors, or values in a composition. Patterns take the rhythm of your piece to another level, allowing you to create with similar elements throughout. Pattern is different than rhythm because it is more about regular repetition. For instance, in the bouquet in this photo, after I added one peony, I added another and another in order to form a pattern. Repeating shapes and colors help bring more unity to your piece as well, giving your composition a feeling of completion. Patterns can be as busy or as simple as your aesthetic prefers!

Contrast

Paintings and pieces with high contrast—strong differences between light and dark, for example—have a different feel than paintings with minimal contrast. In addition to light and dark, contrast can be achieved with differences in shape, size, and texture.

In the example in this photo, I've contrasted the sharp, edgy lines of a fern with the round, draping petite shapes of pepper berries. The small blooms and buds of a lace-leaf hydrangea tucked in near the soft rounds of a peony contrast only in size, but repeat the rhythm of color, making these elements bond cohesively.

Proportion

Proportion is how things fit together and relate to each other in terms of size and scale, whether big or small, nearby or distant. For this element, you consider the shape and scale of the objects in relation to one another.

Proportionally, the focal of this bouquet is bold. I create movement around and within the focal point with small variations in the color pattern of creams, blushes, and coral. This slight variance in textures between the peonies and iris adds proportional interest for the eye; there is a lacy, loose fluidness to the center focal point. I suggest rhythm in size proportion with the contrasting elements of the dense hydrangea, peonies, and irises, compared to the more sparsely adorned pepper berries, eucalyptus, and clematis branches. The luxurious round proportions of the florals contrast in proportion with the leggy, thin arugula—yet both have that repetition of a creamy color to create movement from one to the other.

Exploring the different ways to play with compositional elements can affect how your art is experienced and how it makes people feel as they take it in.

Focus (or Emphasis)

The viewer's eye ultimately wants to rest on the "most important" thing in the piece—this is called the focal point. If the focus of a creation is not clearly identified, the eye can grow tired, or feel lost, a bit like it is wandering around in space, as it takes in the piece. Focus is the emphasis—the point where you give the viewer a place to rest their eyes.

Texturally, this piece has the softest, roundest shapes in the center, with sharper, interesting concave and convex shapes surrounding, encircling, and creating dimension, and ultimately pointing you in, leading your eye into the soft center. The exaggerated length of the left lead line in the clematis invites the viewer in, drawing the observer's interest slowly, and then delivering in the focal point with a punch of contrast and color.

WORKING IN BOTANICALS

I have always loved botanicals.

Soaking in the flowers and leaves around me—whether in a trusty house-plant or bountiful floral arrangement, out in my garden or nature, or depicted in a larger-than-life floral pattern—has been a passion of mine since I was very small. My mom introduced me to the softness and texture of botanicals from a very young age. Now, with a little family of my own, I find sanctuary in our small urban garden in Seattle. My husband is the mastermind behind the ed-ibles in our green space, and I love finding heirloom flowers to plant in our beds. I surround his carefully laid rows of kale, corn, collard greens, snap peas, and beets with my wild patches of sunflowers, roses, lavender, beauty berry, chamomile, peonies, bearded irises, lilies, and dahlias. Our two small daugh-ters know where to find the homegrown snacks and love munching fennel, strawberries, and carrots as they come into season. We spend time together every year combing through seed catalogs, selecting which plants to grow, and talking about our favorites from previous seasons. Friends visit and dig in the dirt with us, constructing "Fairy Huts" from fallen tree branches and lend-ing a helping hand to tie back unruly raspberry bushes. Time in the garden rejuvenates my spirit and creates wonderful memories. It also provides endless inspiration for my art.

From spending all this time in my garden, I've learned that there is nuance in every movement and detail within each individual plant. Leaf shapes and their veins are a plant's thumbprint. How a leaf connects to its stem, the angle at which the leaves grow, the lines or shapes that repeat and reveal patterns, the plant's natural shape—whether it curves toward the earth or defies gravi-ty and reaches for the light—I like to just sit and notice the flawless design of nature, one branch, one flower, one leaf at a time.

As you observe with this eye for detail, the world will open up to you. You will just start to see more. Leaves are no longer "green"—they are composed of Sage, Viridian, and Terre Verte; they are textured, detailed, and dynamic. When examining a leaf or flower, I ask myself: if I were to paint this, what col-ors would I use? For instance, the sky is not just blue—it's Payne's Gray with glowing clouds of white gouache, streaks of Lavender, and hints of Orange, Lemon Yellow, and Yellow Ochre. This is how I interpret the world now. And soon, with practice, you will, too.

I know it's not realistic to assume that everyone, on any given day, can go out and pick flowers and arrange an aesthetically pleasing flower bouquet as inspiration. Luckily, photography works just as well. There are so many incredible florists sharing their work on social media—scroll through and find your favorites. Let the beauty of the image wash over you, examine the details up close, and feel that connection to whatever makes the botanicals special. These images have become sources of endless delight for me as a painter, allowing me to render plants and flowers I never would have laid eyes on in my own little corner of the world.

BOTANICAL LESSONS
Watercolor Projects

WELCOME TO THE WATERCOLOR LESSONS! I am so happy you're here. I created all of these lessons to help you refine your skills while simultaneously absorbing the meditative and restorative process of watercolor and painting gorgeous works of art. Wash by wash, a creative piece will blossom beneath your hand as you grow more comfortable in the medium. By allowing yourself to play with techniques in various ways with the following projects, you're not only refusing to be intimidated to begin, you are learning and growing every time you sit down and pick up your paintbrush. Let's look at a quick roadmap for the lessons ahead.

The first set of lessons (Lessons 1–6) incorporates the fundamental techniques we explore in Basic Watercolor Techniques (page 26)—techniques you will use over and over as you watercolor your way through this book and beyond. Don't be fooled by the word "fundamental!" These lessons aren't boring or basic—they're meant to shape the foundation of your knowledge in this art, which applies even if you already have a watercolor practice. The better you become at creating a lovely wet-in-wet, blended boundary, the more beautiful your finished piece will be at the end. These beginning lessons are fun and low-pressure. They invite you to mix, blend, and dab your way into the lovely swirling flow of the watercolor art. They are my favorite exercises to warm up with, or to use as a mindfulness practice when the creative ideas are not quite flowing.

The second set of lessons (Lessons 7–11) integrates the fundamentals, encouraging you to practice your skill set in new and challenging ways. These projects are all watercolor-based and are organized progressively, with each lesson building on the techniques used in the one before.

The third set of lessons (Lessons 12–16) introduces creative ways to combine your watercolor skills with gouache and ink. These lessons build on the skills from the first eleven lessons and stretch your creativity to combine these mediums in new and exciting ways.

Beginning with the second set of lessons, I provide suggestions for how to make each lesson simpler or more challenging. I know you all come to this book with different levels of experience, so I want to be sure to include something for everyone! For lessons 7–16, take a look at both the "beginner" and "advanced" tracks and follow what feels best for you. You may want to work through all of the lessons taking the beginner suggestions first, then do the lessons a second time, following the intermediate path that I laid out, step by step for each chapter. Then you can return for another layer of difficulty, and challenge yourself with the advanced prompts, and observe how your skills have evolved. If you are more advanced in your practice, rest assured that I include enough detail and variation in the lessons to keep you stimulated and inspired—and if you're anything like me, you may want to try some lessons at the beginner level for ease of practice, or to get back to that beginner state of mind. Again—it's all up to you and may change just based on your mood or energy level that day. Go with what feels best! ■

BUILD YOUR SKILLS
TECHNIQUE BOXES

AS YOU LEARNED IN THE MAGIC SAUCE (PAGE 24), THE beginning of all good watercolor lies not on the paper or in your brush—but on your palette! Creating that magic sauce on your palette is where it all begins. Having the right amount of water and paint on the palette allows you to create movement and shine, and then transfer this magic sauce to your paper with your brush. Watercolor is all about time; the more water you have, the more time you have to make changes to your piece while the paint is still wet. The free-flowing and transparent beauty of watercolor is achieved with good water management, which mostly happens right on your palette.

WASH	WET-IN-WET	GRADED WASH	BLOTTING—PAPER TOWEL

BLOTTING—DAMP BRUSH	WATER DROP	WET-ON-DRY

TOOLS

- Round watercolor brushes, sizes 4 and 1
- 140-lb. watercolor paper
- HB pencil
- Paper towels
- Watercolor Technique Grid (above)
- 2 Mason jars of water

PAINT PALETTE

(or one dark pigment and one light of your choosing)

PAYNE'S GRAY

PEACH

Your palette for this lesson will have one dab of dark paint and one dab of light paint. Leave space between them so you can add and play with water near each paint dab.

TECHNIQUES

Watercolor wash Blotting

Wet-in-wet Wet-on-dry

AS YOU BEGIN

- Using your HB pencil, draw the "Watercolor Technique Grid" above onto your watercolor paper. Label each box to match the box titles.

- Set out two Mason jars of clear water (one jar for the dark pigment and one for the light) and prime your brush with water.

- Use your brush as your water transportation vehicle. Dip your brush in your Mason jar of water, bring that water to your palette, and begin to mix the water into the side of your paint dab.

- Take your brush back to your Mason jar and add more water to this mixture on your palette. You want to create an 80w/20p consistency of "soy sauce with wasabi" on your palette (see page 24). I encourage you to repeat these steps four to five times, until there is that desired movement and shine on the surface of your palette.

- Remember, if you were to lift your palette and tip it vertically, you would begin to see small paint-saturated raindrops moving along the surface of your palette.

ANIMATING YOUR PALETTE

In order to get that smooth, flowing beauty on your completed water-color piece, it is essential to begin with movement and shine on the palette before the paint ever touches the paper. "Animating your palette" is essentially keeping the colors you are painting wet enough to work with the entire time you are creating. You will be consistently revisiting your palette, adding water to ensure there is movement and shine before you bring the paint and water mixtures to your paper. When I first sit down to create a piece, I'm often working off of a dinner-plate palette, covered in dried paint dabs and color mixes from the last few times I've painted. I don't add water, or animate, every color every time. I only bring water to the colors I'm going to be working with in the first few stages of the piece, knowing that as I go, the water on my palette evaporates just like the water on my paper, so I will be consistently adding more water to my palette as I paint.

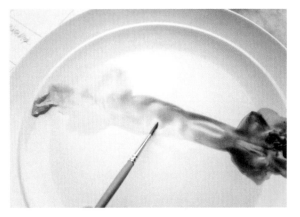

ADDING WATER TO FRESH PAINT VS. DRIED PAINT

If the paint dabs on your palette are fresh, remember the analogy of the wasabi—fresh tube paint is more potent, and a little goes a long way. When you begin to add water to your fresh paint, by using your brush to pull some of the concentrated paint dab away, you can dilute just a portion of the concentrated paint and make your magic sauce to the side of the paint dab. This gives you a bit more control.

If you already have dried paint on your palette, or you're using cake pans, you will need to use a bit more water to wake up the paint. Use your brush in a side-to-side motion along the dried surface of the cake or dried paint to engage the paint. Once it's dried, it requires a bit more effort to get the same pigment saturation as paint fresh from the tube.

BRUSH:
Round 4

PAINT CONSISTENCY:
Wash, 80w/20p "soy sauce with wasabi"

A flat watercolor wash is a translucent layer of color on your paper. The goal is to produce a flat surface of color without any hard lines or variation in color within. This technique is the foundation to watercolor painting, so we will be practicing it again and again.

WASH

1 Once your palette is animated with water, and your Payne's Gray paint-and-water mixture resembles soy sauce with a touch of wasabi, gently place your primed wet brush into your wet palette mixture of Payne's Gray, soaking it into your brush bristles. [A]

2 Take your filled brush to your watercolor paper, and stroke your brush from left to right, right to left, left to right, along the top of the box labeled "Wash" to create a wet pigmented boundary. [B, C, D]

3 Once you've completed a few strokes along the top of your wash box, you'll notice the texture of the paper beginning to show through your strokes. That's your cue to return to your paint and fill your brush with the paint-and-water mixture again.

4 For your second stroke, bring your paint to your paper again and make several back-and-forth brushstrokes to enlarge your wet pigmented boundary. You are looking for the right balance of water to paint to fill the boundary, creating MOVEMENT and SHINE. [E]

5 To make the final strokes to complete your wash, you will use only water! Take your paintbrush to your dark palette Mason jar, rinse your brush, and bring water to your watercolor paper. Brush

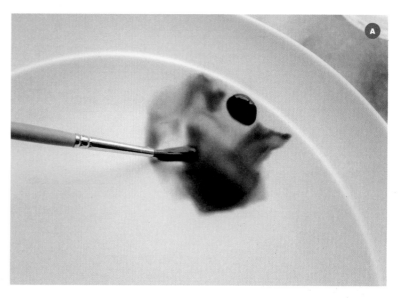

within the strokes you have already painted with pigment. Then, using the water-only brush, continue to draw the paint down, letting the pigment follow the water as you define its boundary, filling the rest of your wash box. Feel free to move your paper around as needed in order to smooth the outside edges of your wash. [F]

6 As you draw the pigment down, notice that the paint only moves into the spaces where your brush has provided a water pathway. This is why wet boundaries are such powerful tools in watercoloring. Paint moves where the water is!

7 To test the consistency of your wash, tilt your paper and shift it around—you should see a shine of the wet boundary reflecting the light as you tilt the page.

continues on next page

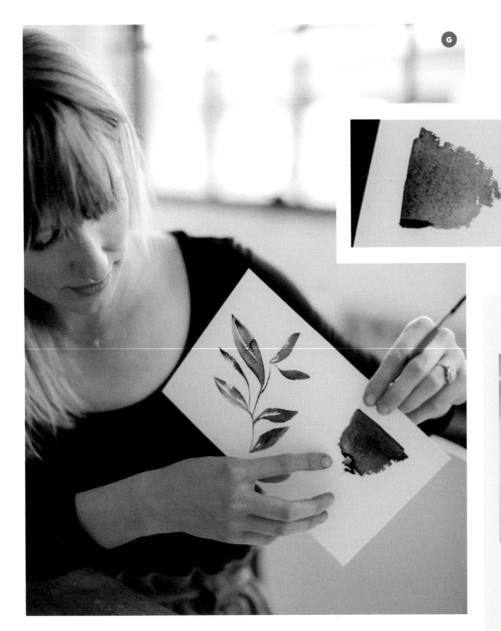

MOVEMENT & SHINE

When creating a wash, always ask yourself these two questions:

■ Can I see a nice wet SHINE? Does the boundary reflect the light as I shift my paper?

■ Do I see MOVEMENT in the boundary, with a small bead (or raindrop) of water forming when I tilt the paper vertically?

8 To make sure you have enough movement within the boundary you've just created, look for a bead of water and paint forming as you tilt your paper down. Rotate your paper all the way around, watching as the bead travels along the wet boundary. If you don't see a bead form, use your brush to bring a bit more water to the boundary, and blend it into the pigment. You need to move quickly here, because if you wait too long, the paint marks you've made will start to dry. If you add more water to an already-drying wash, you will get watercolor blooms (see page 29), or hard lines, rather than a nice flat wash.

9 Create the movement and shine in your wash boundary and enjoy that tiny raindrop traveling around the edges of your wash. [G, H]

BRUSH:	PAINT CONSISTENCY:
Round 4	Peach base wash, 80w/20p "soy sauce with wasabi;" Payne's Gray for wet-in-wet, 50w/50p "heavy cream"

Wet-in-wet simply means adding wet paint into wet paint. You can use this technique to create shadows, contrast, and interesting movement in your watercolor paintings. Note that you will increase the paint-to-water ratio for your darker pigment. The goal is to introduce a higher concentration of paint into the wet boundary's more diluted base wash. This will allow the new paint to bleed, vein, or bloom into the existing wet boundary for an interesting effect.

WET-IN-WET

1 Dip your brush in your Mason jar of water and use your brush to bring water to your palette to create an 80w/20p consistency of Peach.

2 Load your brush with your Peach mixture and bring the loaded brush to your watercolor paper, this time to the box labeled "Wet-in-Wet."

3 Follow the wash instructions on page 45 to create a Peach wash in this box. Define the square boundary of the box by filling it with your 80w/20p Peach mixture. **[A]**

4 Once your wash is painted, and you've made sure there is a raindrop of water that moves around your square boundary, it's time to

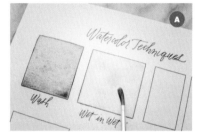

add in your Payne's Gray. Remember to work relatively quickly, because this step must be done while the boundary is still wet.

5 Dip your brush in your light palette Mason jar of water to clear it of excess light pigment. Use your brush to bring water to your palette, creating a 50w/50p consistency of Payne's Gray.

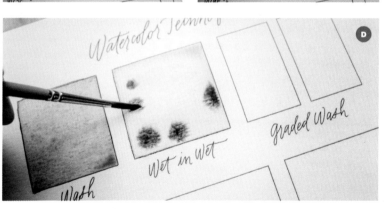

NO FIREWORKS? NO PROBLEM.

If your dab of dark color simply stays put, without bleeding or creating fireworks, it's because your light wash boundary has already begun to dry. Not to worry. Just rinse your brush, dab it in your 80w/20p Peach mixture and cover the entire boundary with another fine sheen of a light wash.

Once you've rewashed the entire boundary, ensuring movement and shine within your wet boundary, dab your brush in your 50w/50p mixture of Payne's Gray, dab the paint into the light wash, and celebrate your fireworks!

Observe the difference of how the paint moves within a wet boundary versus a drying boundary. Dropping a moving magic sauce into a dried boundary simply stagnates. Whether you're creating a wet-in-wet wash or a flat wash, remember that changes must be made while the boundary is still wet.

6 Scoop up the magic sauce with your brush and bring it to your watercolor paper, to the box labeled "Wet-in-Wet." Using the lightest pressure, dab the brush into the wet boundary of the light wash you just created.

7 As you lift your brush from the wet surface, the dark color should bleed and "vein out" like a mini firecracker. Dab a few more times to see what happens. Dab the

same spot with more pigment—do you notice how it gets darker and more concentrated in the spot as you lift and add? **[B, C, D]**

8 Try painting a line with the dark pigment in the wet boundary and see how it bleeds. As you paint the line, lift your brush at points where you would like the paint to bleed. Paint will be the darkest at the points where you lift the brush.

BRUSH:
Round 4

PAINT CONSISTENCY:
80w/20p "soy sauce with wasabi"

This technique combines the two skills you just learned. A graded wash in its most simple form is three washes, layered one after the other while everything is still wet. The effect is a slow "graded" fade of one color into another and then another. How smoothly the colors blend is completely dependent on the wetness of your base wash.

GRADED WASH

You will use two colors to make three washes:

- The first wash is **Peach**.
- The second wash is a combination of **Peach and Payne's Gray**.
- The third wash is **Payne's Gray**.

1 Dip your brush in your Mason jar of water and use your brush to bring water to your palette, creating an 80w/20p consistency of both Peach and Payne's Gray colors. Make sure there is movement and shine on your palette in both your light and dark colors, since we will be using both of these colors to create a graded wash.

2 Gently place your primed wet brush into your 80w/20p mixture of Peach, soaking it in.

3 Take your loaded brush to your watercolor paper, this time to the box labeled "Graded Wash." Follow the wash instructions to create your first layer of Peach wash in this box. (Do you see movement? Do you see the raindrop when you turn your paper?) [A]

4 To make your second wash layer, bring your brush to your palette and mix together a bit of your Peach sauce with your Payne's Gray sauce to make a nice blend of these two colors. The blend should be the 80w/20p consistency of soy sauce with wasabi. Feel free to add a bit more water to the sauce if needed.

5 Load your brush with this blended sauce and bring it to the wet boundary of your Peach base wash. Use a side-to-side motion to gently paint this new sauce in, but don't paint the entire box! Stop and lift your brush about two-thirds of the way down the painted box. You should see a soft blending beginning where you lift your brush. You want this slightly darker shade to smoothly blend into the light first layer wash. You should not see a hard line, because your first wash is still wet. [B, C]

6 To create your third wash layer, return your brush your palette and pick up a bit of 80w/20p consistency of Payne's Gray. Bring your loaded brush to your watercolor paper and apply a dark wash to just the top third of the "Graded Wash" box. When you lift your brush at the one-third mark, you should see a soft blending of the third layer into the second layer wash. [D, E]

7 Now you can see each of the three layers of washes before they begin to dry. There are no hard lines, and the movement of water in the first wash enables the entire boundary to stay wet long enough for each added layer to blend in smoothly. Once the three layers are dry, the three colors will be successfully blended into a soft gradient without any hard lines. And this is all because you were working in a wet boundary the entire time! You defined your boundary with your first wash, telling your paint where you'd like it to go. With your two successive washes, you were able to add in a subtle gradation of color, building interest in the wet boundary. [F]

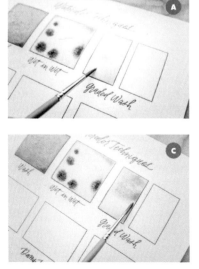
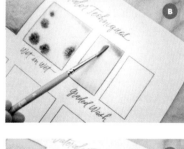
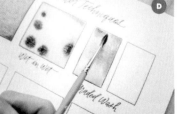
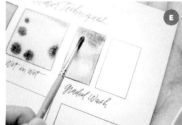
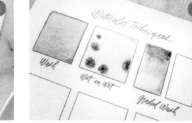

WHY AM I GETTING HARD LINES?

At this point, you may be thinking: "WOW, we use a lot of water!" In watercolor, we use more water than people tend to realize. But this is how seamless, smooth watercolor creations begin. You may notice some puddles forming in the corners of your wash boundaries. These bother some folks more than others and are part of learning water management as you paint.

I encourage you to create your washes and let the puddles dry, just to see what happens and if you like the effect (hint: these puddles are one way to create watercolor blooms!). Basically, there are two common problems to keep in mind when it comes to water management: not enough water and too much water.

If you don't use enough water when you lay down the wash, you will see hard lines from your paintbrush when the wash dries—it will not be smooth. In this example, you can see the dried first wash with a dried second wash on top, with hard lines delineating the two washes. This first wash dried too fast, so when more color was applied, the boundaries did not move and blend with one another. The way to make sure it will dry flat and smooth is by creating the movement and shine on your palette and transferring it to your paper as you paint. As you move your brush on your paper, notice how water smooths any hard lines and breaks down the pigment of the paint so it absorbs nicely into the texture of the paper.

On the flip side, if you put too much water on the paper for a wash, you'll end up with what I call the "biodome" effect. If you're using too much water, a bubble of water begins to pool or form in a half-circle above your wet boundary. As an over-watered boundary begins to dry, it may develop water blooms (see page 29), and your paint will bleed over the wet boundary, giving you jagged edges when it dries. You can eliminate puddles or biodomes by gently blotting with a paper towel (see Blotting, page 29).

I'll tell you that using too much water in the beginning is better than not using enough! The longer your boundaries are wet on your paper the more time you have—more time to add color with the wet-in-wet method or, as we will learn in the next section, more time to take color away with blotting. The more time you have while your boundary is wet, the more you can play and make interesting changes to your piece.

So, don't worry too much about those puddles for now.

BRUSH:
Round 4

PAINT CONSISTENCY:
80w/20p "soy sauce with wasabi"

Blotting is the process of removing pigment from a wash. Using different blotting methods allows you to create points of light within a boundary. You can use a paper towel in multiple ways or a damp brush (cleaned in clear water) to do this. In this exercise, you will create a dark wash so you can see the full effects of the different blotting techniques.

BLOTTING

1 Gently place your primed wet brush into your 80w/20p mixture of Payne's Gray, soaking it in.

2 Take your loaded brush to your watercolor paper, this time to the box labeled "Blotting – Paper Towel." Follow the wash instructions to create a Payne's Gray wash in this box. **[A]**

3 Roll the edge of your paper towel to get a fine point (since you're working in a smaller blotting area). Press the paper towel down into your wet wash using firm pressure, and then lift it straight up. You will see the white of your paper (and perhaps a slight hue left from the color of your wash). I love this effect—I use it all the time to create points of light on small leaves or petals. **[B, C]**

4 When you use a paper towel with firm pressure, you remove a considerable amount of the paint pigment you just applied—to the point where the white of your paper shows through. For a subtler effect, try gently dipping (not pressing) a folded paper towel into a very saturated area in your wet boundary, like the edges, to seep up excess water. It's like a water vacuum. This is a great solution to any biodome or puddle problems you may encounter as you create your washes.

5 Play with both techniques. Notice how when you apply pressure to the paper towel, it takes all the pigment, and when you just dip the paper towel into the edge of the wet boundary, it gently soaks up any excess pigment or water. **[D, E]**

6 Another way to remove pigment from a wet boundary is to use a "thirsty" or damp-brush technique. To try this, gently place your primed wet brush into your 80w/20p mixture of Payne's Gray, soaking it in.

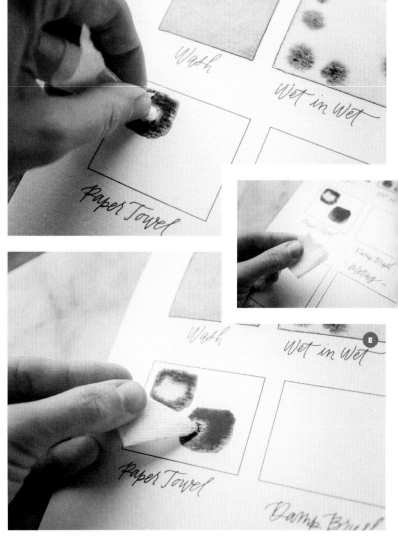

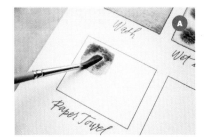

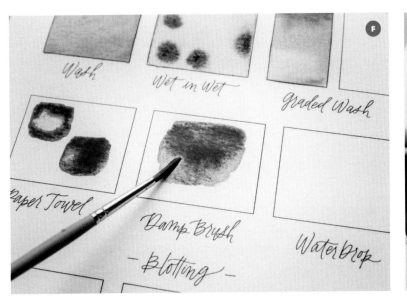

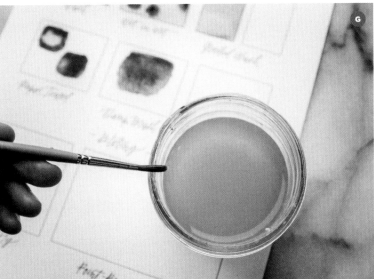

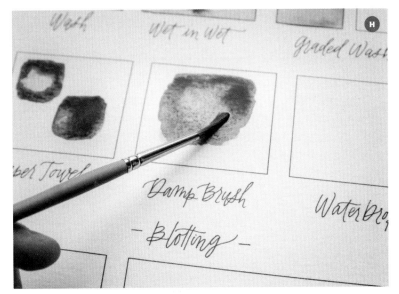

7 Take your filled brush to your watercolor paper, this time to the box labeled "Blotting – Damp Brush." Follow the wash instructions to create a dark-colored wash in this box. [F]

8 Next, clean your brush in your Mason jar of clear water. Wring out your brush by running it along the edges of your jar, essentially making it "thirsty" so it will pull water out of your wet wash boundary. [G]

9 Touch your damp brush to the wet paint of your dark wash to lift the color off the paper. The brush absorbs more water than it releases, so it will quickly pick up the wet color from your boundary.

10 You can also use your damp brush to move the paint around in your wet wash box, creating points of light wherever you sweep the paint away. Whereas a paper towel merely lifts color or pulls out excess water, a damp brush enables you to sweep and gently suggest to your wet boundary where you'd like color concentration or a light point to be. [H]

BRUSH:
Round 4

PAINT CONSISTENCY:
80w/20p "soy sauce with wasabi"

The waterdrop technique is similar to wet-in-wet but involves dropping clear water rather than paint into your wet boundary. It can also be considered another form of blotting, as it dilutes the area and removes color, adding interest and light. In order to get a seamless transition of light to dark, like all techniques in watercolor, the waterdrop must be done while the base wash is still wet. I use this method regularly, as it seems to make washes glow with an inner light. It is how I've created some of my all-time favorite leaves!

WATERDROP

1 Gently bring your primed wet brush to your wet palette and soak in your 80w/20p mixture of Payne's Gray.

2 Bring your loaded brush to your watercolor paper, this time to the box labeled "Waterdrop." Follow the wash instructions to create a Payne's Gray wash in this box.

3 Once your wash is painted, and you have ensured there is enough water to see a shine of wet movement on the surface, it's time to add your waterdrop.

4 Dip your brush in your Mason jar of water and use your brush to gently dab a drop of clear wash water into the wet boundary of the Payne's Gray wash. [A, B]

5 After the water is dropped in, wring out your brush by running it along the edges of your water jar, making it "thirsty." You will use the damp-brush blotting technique (page 51), moving your brush in a scrubbing motion on the wash, brushing and sweeping from side to side to shove the paint away from the area you want cleared. [C]

6 To complete the effect, press a folded paper towel firmly into the lightened area where you first added your waterdrop, increasing the light spot within your wet wash. [D]

7 You just used all three blotting techniques together: waterdrop, damp brush, and paper towel!

Combined, they create a seamless transition of color removal. [E]

8 You can repeat these three blotting motions (waterdrop, damp brush, paper towel) as many times as you would like to get the desired glowing effect in your wash. As long as the boundary is wet, you can keep making changes! [F, G]

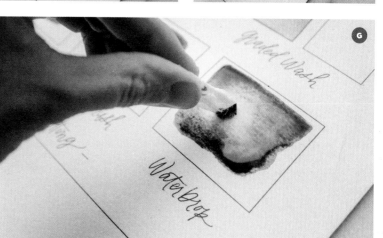

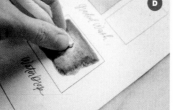

BRUSH:
Round 4, Round 1

PAINT CONSISTENCY: Peach base wash, 80w/20p "soy sauce with wasabi;" Payne's Gray for wet-on-dry, 10w/90p "mustard"

Wet-on-dry simply means adding wet paint to dry paint. This technique is another way to add interest to your piece, but it can be done without the time constraint of working while everything is still wet. It gives you a bit more control, allowing you to create sharp and defined lines. I use this method when I want to add small brushstrokes of contrasting color or defined details.

WET-ON-DRY

1. Dip your Round 4 brush in your Mason jar of water and use your brush to bring water to your palette, creating an 80w/20p consistency of Peach. Gently place your primed wet brush into your 80w/20p mixture of Peach, soaking it in.

2. Take your loaded brush to your watercolor paper, this time to the box labeled "Wet-on-Dry." Follow the wash instructions to create a Peach wash in this box.

3. Allow the wash to dry completely. Wait at least a few hours, maybe more; hover your hand a quarter inch above the wet boundary to see if you feel any coldness seeping up from the paper—the coldness means it is still wet. In order to achieve strong, defined lines with a wet-on-dry technique, your base wash must be dry before you apply the second layer of paint. If you paint it too soon, your new wet paint will bleed into any area of the underlying wash that's still wet. The flowers and shells above were painted using the Wet-on-Dry method, waiting until the first wash layer was completely dry so the successive layers of wet paint remained clear and crisp.

4. Once your base wash is completely dry, you're ready to begin your wet-on-dry marks. You will switch to a Round 1 brush for the second part of this technique, because it's easier to make smaller marks with a smaller brush. Plus, the bristles of smaller brushes hold less water, which works better with the thicker paint consistency you will use for your wet-on-dry marks.

5. Dip your Round 1 brush in your Mason jar of water and use your brush to bring a small amount of water to the Payne's Gray on your palette. Mix water with pigment to create the thicker 10w/90p "mustard" consistency of Payne's Gray.

6. Gently place your primed wet Round 1 brush into your Payne's Gray mixture, soaking it in.

7. Take your loaded brush to the dried Peach wash in the "Wet-on-Dry" box. Using the lightest pressure, touch the point of your brush to your paper and make different marks and stampings. You will practice mark making more in Lesson 5, so don't worry about creating any specific shapes for now. Just play and observe how the paint feels as you layer details on top of a dry wash. [A]

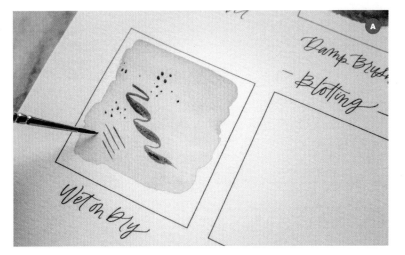

TROUBLESHOOTING

What's up with granulation and what do I do about it?

If you have been painting a wash and happen to notice that a certain color seems to deposit little dots or leave behind granulations of color or pigment that cannot seem to be dissolved away, you are not alone.

This is called *granulation*, and there are multiple factors contributing to this phenomenon in your piece. Granulation occurs in all types of painting where pigment is concerned, but it is most readily observed in watercolor painting, because watercolor is known for its transparent qualities. When you are painting a nice smooth wash, it can be confusing to see little dots of darker pigment where you intended a smooth finish.

Remember that all watercolor is made of a pigment (color in dry form, made of particles) and a binder (the liquid vehicle, gum arabic, that "binds" or holds these color particles together). You see granulation in watercolor paint when the color pigment separates from the binder.

WHY THIS IS HAPPENING

THE TYPE OF PIGMENT: Certain pigments are made from actual minerals and materials from the earth. These colors granulate easier because the natural materials have larger particles, and because of this, they separate more readily from the binder. When this happens, they leave behind the sediment of their color particles as the water dries and evaporates from the paint and paper. They essentially fall into the crevices of the paper and stick there because of their size and weight. In comparison, pigments made from manmade synthetic particles, which are smaller and blend more readily with the gum arabic, tend to more smoothly bind and blend in water. For example, the color Ultramarine is mostly made from natural minerals and is more likely to separate, leaving behind a grainy substance, compared to the synthetically composed colors of Indigo, Yellow Ochre, and Phthalo Blue.

THE AMOUNT OF WATER: The more water you use in your wash, the more likely you will have separation of the pigment and binder, and the more likely you will see granulation.

THE BRAND, QUALITY, AND COMPOSITION OF YOUR PAINT: Student-grade paints often have a lower pigment-to-binder ratio, compared with professional-grade paints. Pigment is more expensive, so using less in the student-grade lines allows the tubes to be more affordable. This means you're actually LESS likely to have granulation with student-grade paints, since less pigment means more binder, and thus a lower chance of granulation. Professional-grade paints have a higher pigment-to-binder ratio, giving you more vibrant and quality color, but an increased chance of granulation. Different brands produce professional-grade paints, and brands vary in sensitivity to granulating properties, so if granulation bothers you, make some observations across brands.

THE QUALITY OF YOUR PAPER: Your paper is also a factor in granulating paint. Student-quality paper is often not 100% cotton, and because of its wood fiber, textures can "catch" the granules of the pigment more easily. Using professional-grade paper can help resolve this factor, as the cotton paper is higher-quality and allows the pigment to be absorbed as the water absorbs and evaporates, leaving the pigment smooth.

MY SOLUTION

If granulating paint bothers you, use student-grade paints and high-quality paper, keep your colors bold—using a lower water-to-paint ratio—and research synthetic vs. natural colors to determine which colors are more prone to separating so you can leave them off your palette.

But! Before you write it off completely, I encourage you to play with granulation. While you may not appreciate the granulating effect on a rose petal or a smooth sky, many landscape painters seek out granulating colors specifically for their texturizing effects and properties. Think of the texture granulation could add while painting sand, a forest canopy, tree bark . . . there are some exciting possibilities. Some artists truly enjoy granulation. You can even purchase a granulation medium to increase the granulating abilities of a color!

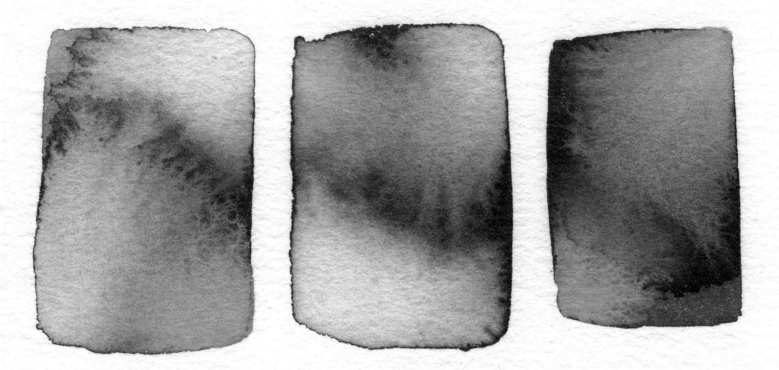

WATERCOLOR BLOOMS

Whether accidental or on purpose, watercolor blooms can be a lovely outcome of playing with watercolor. Learning to embrace them is a lesson in letting go of perfection—and a reminder that what we're doing is, after all, art. There is no perfect way to paint. There is no perfect art. As you practice watercolor more and more, you will come to understand the drying times of your wet boundaries, and exactly how much water causes puddles or biodomes and, eventually, watercolor blooms. Here, in this little practice section, I'll show you how to create these unpredictable beauties on purpose.

Gently place your primed wet brush into your 80w/20p mixture of Payne's Gray or any darker pigment, soaking it in.

Take your loaded brush to your watercolor paper to create a rectangular wash.

Pause and allow the wet wash to dry a little. You still want to see the shine of the wet water/paint mixture but wait until movement is no longer happening within the boundary.

Then, dip your brush in your Mason jar and bring it to your watercolor paper. Touch it lightly to a corner inside the boundary of your drying wash. The new drop of water will spread and create a sharply defined "bloom" as the water wash dries within the paint wash. Play around, adding more waterdrops to your wash layer.

Keep in mind that in order for this to work, the underlying wash needs to be wet, but on its way to drying.

You can also use this technique to create colorful blooms by dropping another paint color into an already-drying wash.

PLAY WITH TECHNIQUE
ABSTRACT SQUARES

IN THIS LESSON, WE ARE GOING TO PLAY AND CREATE WHILE WE learn. I love creating beautiful things while still practicing. As opposed to the boxes used in Lesson 1, this exercise is more freeform, and at the end, you will have a completed watercolor painting that is both a lovely abstract creation and a helpful reference. This project is great to come back to at any time and is really fun when you are sampling new colors to see what they can DO. You will learn how to use the different techniques you practiced in Lesson 1, understand why your paint is drying in different ways, and improve your skills as you work in small abstract squares. This is one of my favorite exercises to mindlessly paint when I don't have a particular vision for a piece but want to create something lovely and simply relax and enjoy the process. It never gets old!

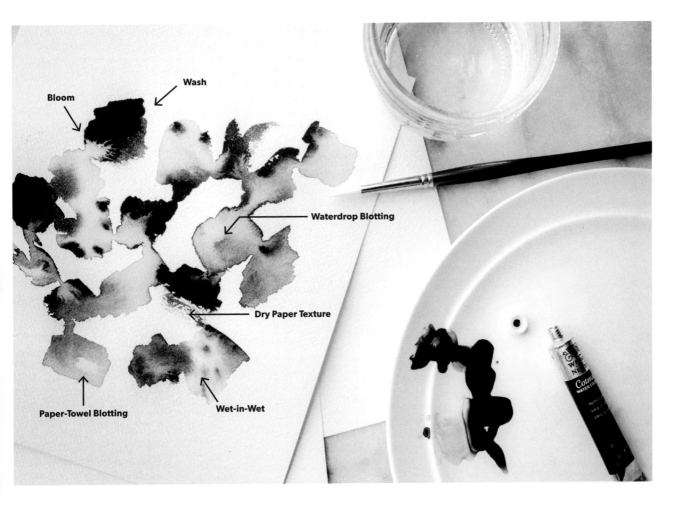

- **Bloom**
- **Wash**
- **Waterdrop Blotting**
- **Dry Paper Texture**
- **Paper-Towel Blotting**
- **Wet-in-Wet**

TOOLS

- Round watercolor brushes, sizes 4 and 1
- 140-lb. watercolor paper
- HB pencil
- Paper towels
- 2 Mason jars of water

PAINT PALETTE

PAYNE'S GRAY

Challenge

If you want to take this one up a notch, select three or four colors and create a lovely cohesive piece with several colors instead of just one!

TECHNIQUES

Wash	Waterdrop blotting
Paper-towel blotting	Wet-in-wet
Bloom	

TIPS FOR THIS PROJECT

- Cut a full sheet of watercolor paper in half. Since this is just for practice, you can conserve your paper and create two pieces this way.

AS YOU BEGIN

- Ready your Mason jars of water and prime your brush.

- Prime your painting palette with paint and water. Use your brush to transfer water from the Mason jar to the palette, creating the magic sauce of soy sauce with wasabi, 80w/20p consistency, of your Payne's Gray paint.

SQUARE 1

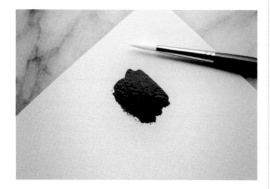

WASH

BRUSH: Round 4
PAINT CONSISTENCY: 80w/20p "soy sauce with wasabi"

1 Dip your brush into your Mason jar, then back into your 80w/20p consistency of Payne's Gray. Bring your loaded brush to your water-color paper.

2 With enough pressure to access the bold-er and full round dimension of your brush, stroke your brush from left to right four to five times, creating an uneven square boundary. Because this is a wash, ask yourself: Is there enough water so I can see a nice wet shine? Do I see movement in this boundary with a small bead of water forming when I tilt my paper? If not, use your brush to bring a bit more water to the boundary, and blend it into the pigment with your paintbrush.

SQUARE 2

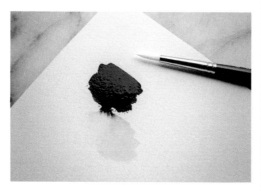

CLEAR WASH, CROSSING BOUNDARIES

BRUSH: Round 4
PAINT CONSISTENCY: wash water only!

1 Clean your brush by dipping it first into your already muddied wash water, and then into a jar of clean water to get the bristles primed in clear water. You will create another small square boundary near the first, but this time using only water.

2 Again, using enough pressure to access the bolder round dimension of your brush, stroke your brush from left to right a few times, creating an uneven square boundary. You want to cross the first square's boundary with this square, causing a blended boundary where the color from your first box moves into the clear box. This is called "crossing boundaries." Because both wash boxes are wet, the paint and water can now move freely between the two.

SQUARE 3

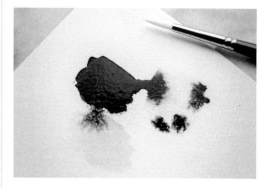

ADDING WET-IN-WET

BRUSH: Round 4
PAINT CONSISTENCY: 50w/50p "heavy cream"

1 We are going to prep our palette now, and create a thicker sauce of Payne's Gray, in a 50w/50p consistency. Using your brush on your palette, pull more paint into your sauce to create that thicker consistency like heavy cream. You will use this sauce to drop into your third square, us-ing the wet-in-wet technique.

2 To create your third square boundary, re-peat all of the steps for Square 2, starting with cleaning your brush and creating a clear wash with movement and shine.

3 Once your third square clear wash is on your paper, cross the boundaries between Square 1 and Square 3. Square 1's pigment will begin to bleed into Square 1's clear wash boundary.

4 It's time to bring your brush back to your palette and pick up that thicker 50w/50p consistency of Payne's Gray. For a bold, wet-in-wet effect, take your full brush to your wa-tercolor paper and with the lightest pressure of your brush, gently dab your bristles into the clear wash of Square 3. Watch and enjoy as the small dabs of paint begin to bleed and create small fire-works of color within your square.

SQUARE 4

ANOTHER WASH

BRUSH: Round 4
PAINT CONSISTENCY: 80w/20p "soy sauce with wasabi"

1 To create the next square, bring your paint-filled brush to your watercolor paper and, with enough pressure to access the bolder round dimension of your brush, stroke your brush from left to right four to five times, creating an uneven square boundary. You want to create a bold wash here, letting the boundary cross over into Square 2. This will create another bleed, since the boundary of Square 2 is still wet.

2 For the last brushstroke of this square, once your brush is running out of water, let it scratch along the natural pebbles of your cold press paper to create a nice textured effect.

SQUARE 5

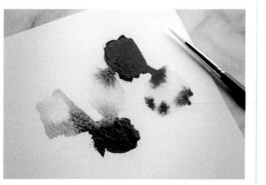

WASH-WATER WASH, PAPER-TOWEL BLOTTING

BRUSH: Round 4
PAINT CONSISTENCY: 50w/50p "heavy cream"

1 To create Square 5, dip your brush into the Payne's Gray-tinted wash water to create a new wet boundary with movement and shine. You will notice the coloring of this box is tinted; not quite as dark as when you started a wash with sauce from your palette, but not clear like Squares 2 and 3.

2 With your brush, cross the boundaries of Square 4 with your new Square 5, letting the more pigment-saturated wash from Square 4 bleed into Square 5.

3 Take a paper towel and, pressing down with your thumb, remove the water and pigment from a small area of Square 5. This will give you a small point of light in this square.

> Notice my brush bristles are so white and clean here? That's because I haven't used them. Once you paint with white-bristled brushes, they take on the color of the paints you've used. I like to keep a 'styling brush' for photos because it makes my photos pop, and draws the viewers' eye to the painting.

SQUARE 6

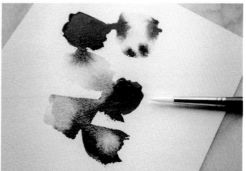

WASH, DAMP-BRUSH BLOTTING

BRUSH: Round 4
PAINT CONSISTENCY: 80w/20p "soy sauce with wasabi"

1 To create Square 6, follow the steps for Square 1, creating a wash with movement and shine.

2 With your brush, cross the boundaries of Square 5 with your new Square 6.

3 Next, use the damp-brush blotting technique (page 51) to sweep the paint and water out of a spot within the wet boundary of Square 6. Remember to dry the brush along the rim of your water jar to create a "thirsty" brush, and then sweep the color into Square 5 to create a nice light point in Square 6.

4 From here, continue to play, making more squares and repeating the different techniques. Dab, sweep, drop, press, and wash, in whatever order feels good! Continue to blend boundaries and watch what happens as some boundaries begin to dry. For an added challenge, you can even introduce a new color and see what happens with the different bleeds and washes.

LIVING THE UNLIVED LIFE

AS ARTISTS, WE ARE USUALLY AWARE OF THE DESIRE TO CREATE EVEN IF IT IS something we have buried deep inside. It may be a voracious need or a quiet hunger, but we know it's there. We long to feel the freedom of the creative life and yet we often argue against it. We may talk or dream about it more than we actually sit down and do it.

There are different reasons for everyone: not enough time, none of our own ideas, not enough skills to match the pictures we imagine in our minds. It can lead to a fair amount of discouragement and if we don't give up outright, we at least push it to the side . . . day after day.

Growing up, I always loved creating—drawing, painting, sketching. Even more, I had no problem thinking of myself as an artist.

Then I became an "adult," with very "important" grown-up responsibilities and concerns. I headed to college to pursue a practical "dollars and cents" degree, one that would guarantee a career after graduation. There was logic in this: I would be able to pay my bills and survive on my own in the world—a world that measured success in financial terms. Although I dabbled with artistic side jobs as I worked my way through school (my favorite was one where I soldered kaleidoscopes), I mostly stuffed my creative urges down deep inside and worked my way along a safer path. I graduated with a degree in economics and had some fantastic adventures as a young adult. I traveled, began a successful career at a Seattle tech firm, and was "doing well."

And then one day, I broke my foot.

Confession: I tripped while wearing flip-flops. The most frustrating part of having a broken foot was having to slow down and sit still—definitely not my style. It was during this time that my best friend, Lauren (who had an art degree) insisted that I take advantage of this forced period of rest. "You have to sit still, so you will paint!" she cheered.

Suddenly, I was face-to-face with my resistance and forced to examine the real reason why I fought my artistic urges. Now that I had no reasonable excuses left, why shouldn't I paint? The truth was that I was afraid. I felt more like an imposter than an artist. What could I say or contribute that hadn't been said or done before? What if what I created wasn't good enough—for me? For everyone else?

Lauren simply wouldn't listen to my excuses. She drove me to the art store and piled supplies in the cart as I crutched along behind her. She added a big tube of white paint. "An artist always needs a good white," she said. I gulped and confessed that I didn't know what to paint—I

"Most of us have two lives. The life we live, and the unlived life within us."

—STEVEN PRESSFIELD

didn't even know what my style was. She suggested that I paint something for my fiancé, Colin, because at least I knew what he liked.

Colin and I often traveled together and visiting art museums was one of our favorite things to do. We loved to wander through rooms of incredible art, soaking up the atmosphere, standing in awe of the Greats—van Gogh, Picasso, John Singer Sargent, or Rembrandt. I knew that one of Colin's favorite paintings was *The Great Wave* by Katsushika Hokusai, the Japanese woodblock master and legend. I thought perhaps I could embark on my new painting journey like many before me, by copying a master and hopefully learning a few things in the process.

I dove in, bolstered by Lauren's belief in me, spending every Saturday on a secret "mystery project." I didn't tell anyone that I was painting, just in case it was a total failure. The unveiling happened on Christmas Eve at Colin's grandparents' home. Both of our families were there. My heart was beating out of my chest. Colin opened the framed canvas and exclaimed, "Oh my gosh—I love Hokusai! It has all the texture of a real painting—where did you buy this?"

I proudly told him that I painted it; my journey back to art had begun. ●

COLOR RECIPE
SWATCH CHARTS

NOW IT'S TIME TO PLAY WITH COLOR! IN THIS LESSON, YOU WILL create a color swatch chart of your tube paints, as well as a swatch chart of fun "color recipes"—colors created by mixing pigments in your Reeves 24 set (or whichever brand you're using), which we'll use throughout the book. As you create these charts, you will practice your wash skills and get accustomed to mixing paint recipes and creating palettes. I am going to teach you to become a master blender, creating colors you didn't know were possible with simple sets of paint. Your finished swatch charts will be a great reference as you continue to choose colors for the rest of your projects. Plus, making them is methodical, fun, and relaxing!

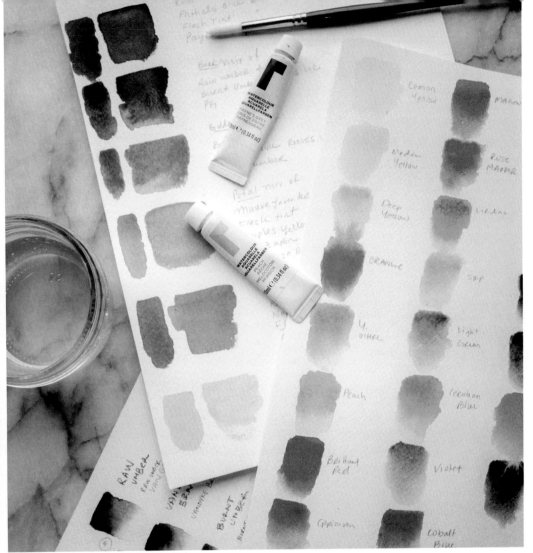

TOOLS

- Your tubes of paint (You can also do this exercise with pan or dried watercolor.)

- Round watercolor brush, size 4

- 140-lb. watercolor paper

- 2 Mason jars of clean wash water (Refresh your water often in order to capture the true color of the paints.)

- Paper towels

- Scrap paper (for testing color recipes before you create the swatch)

- You can use similar or like colors from other watercolor brands if you don't have the exact Reeves paint. Once you have your pure pigment tubes swatched, just substitute them for like colors on these pages.

PAINT PALETTE

| VIOLET | PEACH | PAYNE'S GRAY |

To create these palettes, pour small concentrated dabs of paint directly from your tubes onto your palette or dinner plate. You will blend from these concentrated dabs, creating color recipes from different combinations of the pure pigments.

TECHNIQUES

Graded washes

TIPS FOR THIS PROJECT

- I strongly suggest keeping your paints in the order shown on the following page in their set, and then keeping the paint dabs on your palette in the same order. This way, you'll always have clarity about which colors are which.

- Since we are working on white paper, we'll skip creating color swatches of the white paint in your set. Whites are wonderful to experiment with when you are playing with gouache, as you will explore in Lessons 13–16. Different brands and grades of white pigment have different consistencies, staying power, and opacities, so I suggest playing around with white paints when you can, and discovering what you enjoy using in combination with your favorite colors.

- For each swatch in these charts, you will essentially create a graded wash of color. A graded wash swatch allows you to see the range of possibility of the color more completely, from a clear wash with color blending in at the lightest point, all the way to a more concentrated consistency of the heavier paint ratio. As a reminder, the layers for a graded wash are:

FIRST LAYER: clear water only

SECOND LAYER: "soy sauce with wasabi" 80w/20p consistency, washed two-thirds of the way down

THIRD LAYER: "heavy cream" 50w/50p consistency, washed one-third of the way down

AS YOU BEGIN

- Prepare your light and dark palettes.

- Ready your Mason jars of water and prime your brush.

- Label two separate sheets of watercolor paper— one should read "Color Swatch Chart" and the other "Color Recipe Swatch Chart."

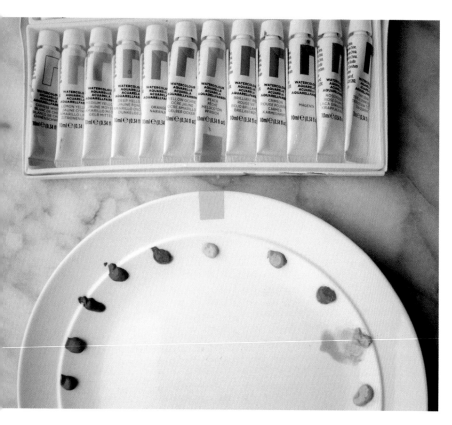
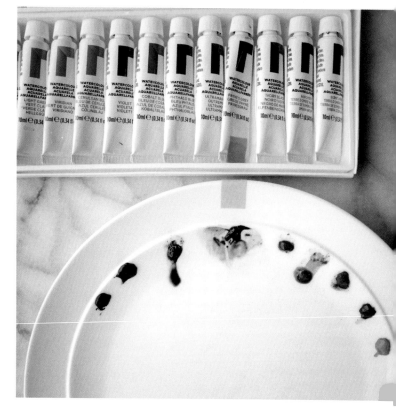

LIGHT PALETTE

LEMON YELLOW	MEDIUM YELLOW	DEEP YELLOW	ORANGE	YELLOW OCHRE
PEACH*	BRILLIANT RED	CRIMSON	MAGENTA	ROSE MADDER
BURNT SIENNA	VIOLET*	PAYNE'S GRAY*	CHINESE WHITE	

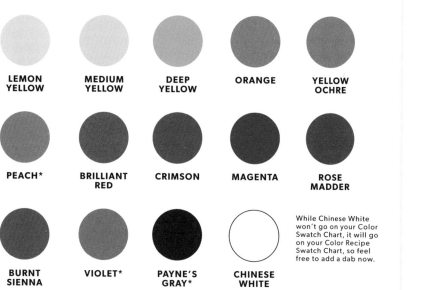

While Chinese White won't go on your Color Swatch Chart, it will go on your Color Recipe Swatch Chart, so feel free to add a dab now.

DARK PALETTE

BURNT UMBER	RAW UMBER	IVORY BLACK	PAYNE'S GRAY*	ULTRAMARIN
PHTHALO BLUE	COBALT BLUE	VIOLET*	CERULEAN BLUE	VIRIDIAN
LIGHT GREEN	SAP GREEN	PEACH*		

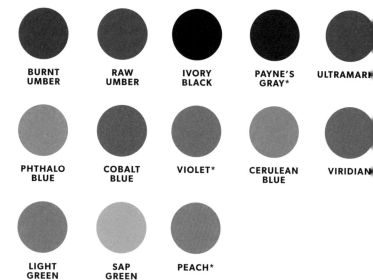

These are colors I like to include on both palettes: light and dark. I use all three to mix so regularly, that I like to include a dab on both.

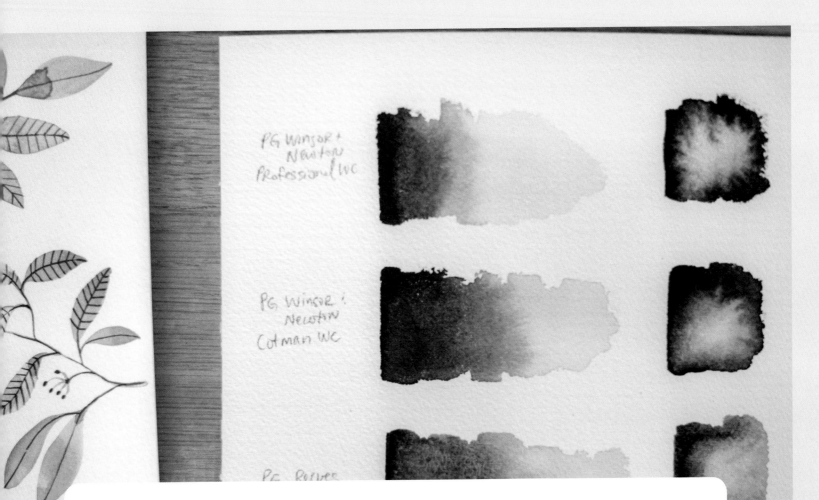

Handwritten labels on swatches:
- PG Winsor + Newton Professional WC
- PG Winsor + Newton Cotman WC
- PG Reeves

COLOR VARIATION

As you make your swatch charts, be sure to note the brand and color of the paint to the right of your swatch. Pigments vary slightly depending on the brand and the quality of the paint, so it's important to know exactly which paint you used when you reference the swatch again down the line. We can see this variation in color in this example, with Payne's Gray—check out the difference within grades and brands.

The first row is Winsor & Newton Professional-Grade Payne's Gray. The second row is Winsor & Newton Student-Grade Cotman Series Payne's Gray. The third row is Reeves Student-Grade Payne's Gray.

You'll see that the professional-grade Winsor & Newton Payne's Gray has more gray undertones, while the Winsor & Newton student-grade Cotman Payne's Gray has more black pigmenting, with an almost cobalt blue color hiding beneath the surface. The Reeves Payne's Gray seems to be a blend the two Winsor & Newton colors, with a very strong cobalt blue coming through when we blot the pigment. Not all colors have such strong difference among brands, but some do! It's important to know this when seeking consistency across your work. It can also be exciting to find a favorite color and explore all its pigmenting possibilities across brands and grades.

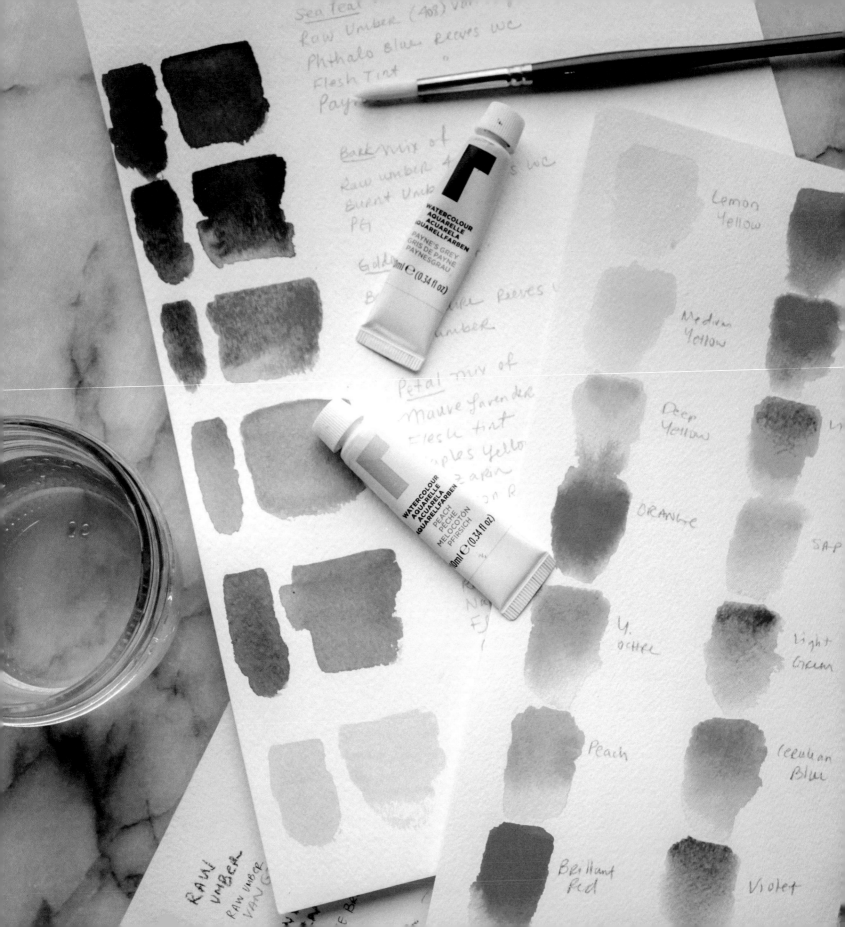

Sea Teal
Raw Umber (408) Van...
Phthalo Blue Reeves WC
Flesh Tint
Payne...

Bark mix of
Raw Umber 4...s WC
Burnt Umb...
Pt...

Gold...ml Ⓔ(0.34 fl oz)
B...re Reeves...
...mber

Petal mix of
Mauve Lavender
Flesh tint
...mples Yello...
...zarin
...on R

Na...
F...

WATERCOLOUR
AQUARELLE
ACUARELA
AQUARELLFARBEN
PAYNE'S GREY
GRIS DE PAYNE
PAYNESGRAU
...0ml Ⓔ(0.34 fl oz)

WATERCOLOUR
AQUARELLE
ACUARELA
AQUARELLFARBEN
PEACH
PECHE
MELOCOTON
PFIRSICH
...0ml Ⓔ(0.34 fl oz)

Lemon
Yellow

Medium
Yellow

Deep
Yellow

ORANGE

SAP

Y.
OCHRE

Light
Green

Peach

Cerulean
Blue

Brilliant
Red

Violet

RAW
UMBER
RAW UMBER
VAN G...
...E B...

BRUSH: Round 4

PAINT CONSISTENCY: For each color swatch, you will use the 80w/20p "soy sauce with wasabi" magic sauce for one wash layer, and the 50w/50p "heavy cream" magic sauce for the next wash layer.

COLOR SWATCH CHART

1 To begin, label the top of your watercolor paper "Color Swatch Chart."

2 Select the first color, which will be Lemon Yellow if you're using the order laid out on page 64.

3 Dip your brush into your Mason jar of water. Bring the brush to the upper left corner of your watercolor paper and create a clear water wash by stroking your brush left to right four to five times. Remember to look for movement and shine in a clear water wash as well, and that small raindrop forming in the corner of your water-only boundary.

4 Next, dip your wet brush into the 80w/20p consistency of Lemon Yellow on your palette, and bring it to your wet wash box. Lightly stroke the top of your wet wash box from left to right four to five times, keeping your strokes within the top two-thirds of the wash (similar to the Graded Wash technique, page 48).

5 Bring your brush back to your palette and select a mixture of Lemon Yellow that has slightly more paint for a 50w/50p "heavy cream" consistency. Soak this mixture in your brush, bring the brush to your wet wash box, and lightly stroke the top of your wet wash box from left to right, keeping your strokes within the top one-third of the wash.

6 Because the base layer water wash is wet and initially clear, it will draw the color down subtly, and you will be able to enjoy Lemon Yellow in all its individual graded-color glory.

7 Label this color swatch with the exact color, grade, and brand of paint you used.

8 Rinse your brush and prepare your paper for the next swatch of pure color by creating a wash of clear water under your Lemon Yellow swatch. Select your second color, Medium Yellow, and repeat the previous steps to create your next graded color swatch.

9 Continue moving through all the colors until you have a completed color swatch chart for both your light and dark palettes.

10 As you move through your colors, keep an eye on the color of your wash water. As long as it's still appearing clear for your wet washes on your watercolor paper, it's fine to continue. As soon as any residual color begins to build, replace the water in your jar with fresh clear water. This goes for your brush as well! Make sure your bristles are well-rinsed in your wash jar between each color to avoid blending any colors on your swatch chart.

BRUSH: Round 4

PAINT CONSISTENCY: For each color swatch, you will use the 80w/20p "soy sauce with wasabi" magic sauce for one wash layer, and the 50w/50p "heavy cream" magic sauce for the next wash layer.

COLOR RECIPE SWATCH CHART

Now that you have your handy Color Swatch Chart of colors right from the tube, it's time to begin blending these colors to create some interesting combinations, which I like to call my Color Recipes. I prefer to blend the color recipes directly on my palette, getting the correct consistencies before I ever touch my paper with them. I pour small dabs of paint onto my palette and use water to bring the colors together.

BLUSH (LESSONS 6, 9, 10, 11, 14, 15)
Crimson + Yellow Ochre + Peach

SAGE (LESSONS 6, 7, 8, 11, 16)
Viridian + Cerulean Blue + Yellow Ochre

PINE (LESSON 6, 7, 8, 10, 11, 12, 13, 15, 16)
Viridian + Cerulean Blue + Yellow Ochre + Lemon Yellow

MAUVE (LESSON 4, 10)
Yellow Ochre + Peach + Violet

PAPAYA (LESSON 12)
Peach + Yellow Ochre + Crimson

MONSTERA (LESSON 6, 11, 13, 15, 16)
Viridian + Payne's Gray

DUSK (LESSON 14)
Chinese White + Peach + Payne's Gray

APRICOT (LESSON 5, 16)
Chinese White + Peach

ROSE (LESSON 14)
Chinese White + Peach + Rose Madder

SANDY (LESSON 15)
Peach + Yellow Ochre + White + Payne's Gray (the tiniest touch!)

STORM (LESSON 16)
Paynes Gray + Ultramarine

RASPBERRY (LESSON 16)
Magenta + Crimson White + a touch of Payne's Gray

IRIS (LESSON 16)
Magenta + Crimson White + Payne's Gray

GOUACHE SAGE (LESSON 4)
Sage Recipe + White

GOUACHE BLUSH (LESSON 4)
Crimson + Yellow Ochre + Peach + White

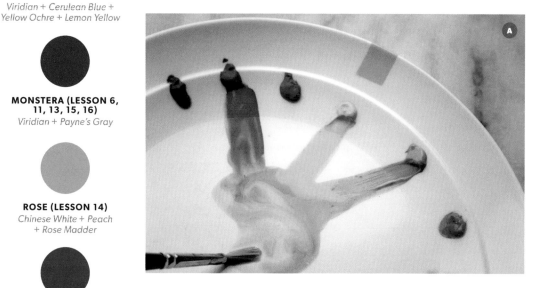

Over time, the palette begins to take on a life of its own—and often becomes a masterpiece of abstract beauty! As you add more colors, water knows no bounds, and will blend colors together you may never have considered. This is how some of my favorite colors have been made, so I encourage you to experiment and play. I've been known to save a palette for many months (or years!) if I happen to love the colors on it.

We use all of the following recipes in the lessons for this book, so be sure to clearly label your chart so you can reference the swatches later!

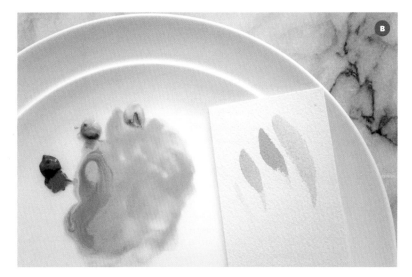

1 To begin, label the top of your watercolor paper "Color Recipes Swatch Chart."

2 You will begin with the first color recipe shown on page 68, which is Blush, and continue creating the recipes listed, straight on down the line.

3 Prime your brush with clean water. Use your brush to bring water to your painting palette, animating the individual colors for your Blush recipe: Crimson + Yellow Ochre + Peach.

4 Use your brush to pull a small amount of each pigment into the water on your palette to create the blended recipe. Start off slow and build up as you learn the strength of the pigments. Use a swirling motion to help blend the pigments and water together on your palette until you have an 80w/20p mixture of Blush. [A]

5 Once you have the color recipe for Blush on your palette, you're ready to test it on paper. Use your brush to pick up your Blush mixture and make a mark on your scrap paper. Compare the color of your scrap paper markings to the color shown for Blush on page 68. [B]

6 This is where you begin to develop your eye for color by trial and error. Does your Blush need more pigment from one of the colors? If so, pull in a bit more from one of the "wasabi" paint dabs on your palette, test it again, and see what happens. Don't be too hard on yourself. Remember that this can become a relaxing meditation as you play and try.

7 Once your recipe color is where you want it, dip your brush into your water and bring it to your watercolor paper to create a clear water wash on the upper left corner by stroking your brush left to right four to five times. Remember to look for the shine of reflection, and the movement of the waterdrop within your boundary.

8 Next, dip your wet brush into the 80w/20p consistency of your Blush color recipe on your palette, and bring it to your wet wash box. Lightly stroke the top of your wet wash box from left to right four to five times, keeping your strokes within the top two-thirds of the wash.

9 Bring your brush back to your palette and select a mixture of Blush that has slightly more paint for a 50w/50p "heavy cream" consistency. Soak this mixture into your brush, bring the brush to your wet wash box, and lightly stroke the top of your wet wash box from left to right, keeping your strokes within the top one-third of the wash.

10 Because the base layer water wash is wet and initially clear, it will draw the color down, and you will be able to enjoy Blush in all its individual graded-color glory.

11 Label this color swatch with the exact colors, grades, and brands of paint you used for your Blush recipe.

12 Rinse your brush and create a wash of clear water under your Blush swatch.

13 Begin to create the next color recipe, which should be Sage, on your palette. Repeat all the previous steps to create your Sage color recipe swatch.

14 Continue moving through all the colors until you have a completed Color Recipe Swatch chart for all the recipes.

15 As you move through your colors, keep an eye on the color of your wash water. As long as it's still appearing clear for your wet washes on your watercolor paper, it's fine to continue. As soon any residual color begins to build, replace the water in your jar with fresh clear water. This goes for your brush as well! Make sure your bristles are well-rinsed in your wash jar between each color to avoid blending any colors on your swatch chart.

SUBTLETIES OF COLOR

As you try your recipes, notice how the final color changes with only the slightest increase of just one of the colors. This is why I like to think of creating colors like a recipe—as we all know, when preparing a dish, the slightest difference in measurement or ingredient can alter the entire outcome. There are so many amazing color possibilities with each combination of only a few paints! Also keep in mind, watercolor tends to dry about 10-20 percent lighter than when it was painted, so your colors will change slightly as the water fully evaporates and leaves only color behind. A subtle difference in pigment choice can transform your painting and, like I shared in Color Harmony (see page 32), each color will begin to reflect you, your experiences, your preferences, and your personality. Listen and tune in to your thoughts and feelings as you create these color swatches. Create them as directed so you can learn the recipes, but as you continue to explore, feel free to alter them as appeals to you. Add your unique recipes to your Color Recipe Swatch Chart and remember to write down what you did so you can revisit them again and again.

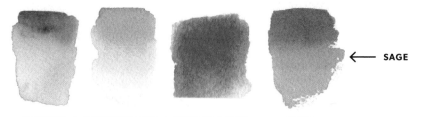

← SAGE

VIRIDIAN + CERULEAN BLUE + YELLOW OCHRE = SAGE

THE BEGINNING DAYS OF
THEMINTGARDENER

I **KEPT PAINTING, MOSTLY EXPERIMENTING** with acrylics. Others saw the joy that painting gave me, and I received a few commissions from family and friends. I was learning and growing as an artist. Then, my first daughter was born. My days were full of sweet smiles and tiny fingers and toes, but my time was not my own. Painting was on the back burner; I told myself that I would turn back to art when life slowed down a bit. And then we were blessed with a second daughter. I was completely swallowed up in motherhood and all that is entailed in caring for a family and home. I collapsed into bed each night. I never found time for myself.

My husband saw my exhaustion—and he recognized my restlessness. He reminded me that my happiest days were those I spent painting. Cue the excuses—and I had plenty of them. How could I justify spending money on a craft? How could I spend time painting when I didn't even get enough sleep? Where would I find time between laundry, dishes, diapers? But Colin didn't let me off the hook that easily, thank goodness. Again, he reminded me that I was happiest when I was creating.

I began @TheMintGardener—an Etsy shop and Instagram account— in 2014. My name, TheMintGardener, has a funny story behind it. My favorite thing to do in the garden was to throw seeds in the general direction of dirt, and then see what came up in a few months. Mint was

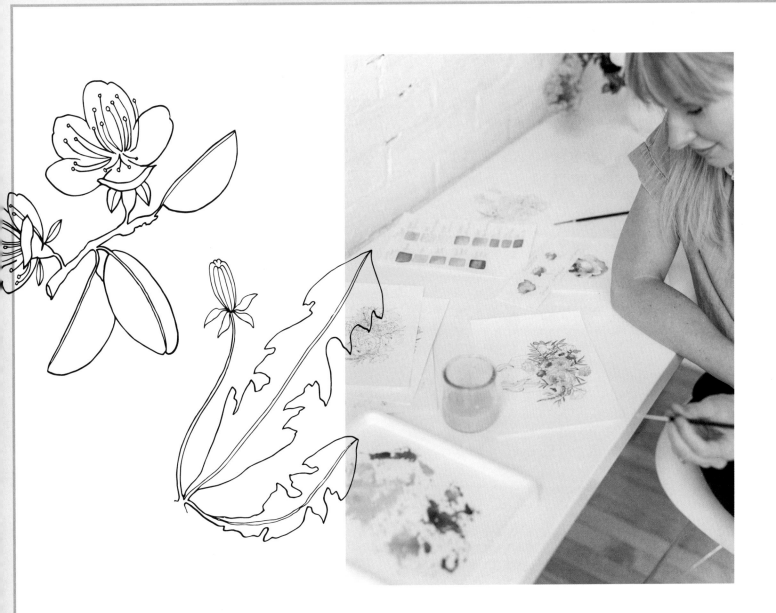

a favorite of mine because it was vibrantly successful. It flourished wherever it landed: in shade or sun, with little need for water and no need for fertilizing. Being a "Mint Gardener" was a bit of a laugh between my husband and I, since it didn't take much in the way of my effort to make a successful mint bed. I felt more confident sharing plants and flowers . . . and maybe one day I would post some of my art pieces. Maybe.

So, I began slowly, sharing simple posts about our garden. It was a way for me to tap into the outside world, a place where I could be Sarah—not someone's wife or mother. As time passed, I received encouragement from so many family members and friends. They believed in me—that I was indeed an artist, both in my garden and with my brush.

It's hard to express in words the joy that I have experienced because I chose to paint and share my art. And I still feel vulnerable, with flickering feelings of fear when I share a new post or do a show or pop-up shop. But still, I show up, because my goodness, feeling uncomfortable is well worth the reward of sharing what I love to do. ●

BOUNDARIES & BLENDING

WATERCOLOR BLOCKS

IN THIS LESSON, YOU WILL PLAY WITH THE COLOR RECIPES YOU JUST created and do some exploring with boundaries, seeing how watercolor paint moves from one color to the next depending on how dry or wet a boundary is. I like to think of this blending between boundaries as the paints talking to each other. With the right amount of water, the colors begin to blend and hang out, making some beautiful friendships that you started with your very own brush! Color in abstract play allows you to learn technique without worrying about creating a recognizable botanical shape yet. I love removing obstacles so you can just enjoy the beauty of watercolor! At the end of this lesson, you will have a lovely piece that will also serve as a reference.

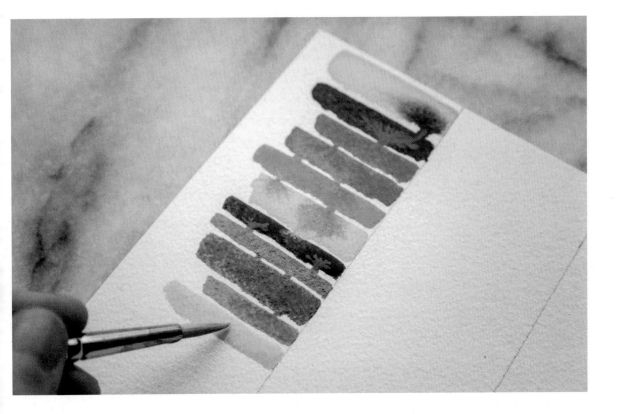

TOOLS

- Round watercolor brush, size 4

- 140-lb. watercolor paper (I like to use the very best watercolor paper I have for this lesson, as it shows off all the amazing bleeding and veining properties that make watercolor so lovely. Hahnemühle 140-lb. rough or cold press is my favorite. If you opt for nicer paper, cut the paper in half, since you won't need all of it.)

- Paper towels

- 2 Mason jars of water

- Ruler

- HB pencil

TECHNIQUES

Wash Boundaries

Wet-in-wet

TIPS FOR THIS PROJECT

- You will paint small rectangular boundaries, one right next to another, with thin lines of dry watercolor paper between each rectangle. This is excellent practice for your hand, as you learn control of your brush and its capabilities to bring paint and water to your paper.

- Notice that the first line I paint is straight, and the rest of the box is rather jagged. Don't worry about making a perfect rectangle; the point is to see the effect of one color on another, and what happens when one wet boundary bleeds into another. We will do the first row together, but please, fill an entire page (or half a page . . . or four pages) if you're in the groove. I find this to be one of those meditative, calming lessons I return to again and again for testing out new colors or just as an act of creativity for the day.

- This is also an excellent way to play with mixing gouache and watercolors, learning how they communicate with one another and how they differ in opacity and texture.

AS YOU BEGIN

- Using an HB pencil and ruler, lightly draw two lines across the width of your watercolor paper, roughly 2 inches apart, like you see in the picture.

- You will create rectangle boxes in similar widths along the right-hand pencil line.

- Ready your Mason jars of water and prime your brush.

- Use your brush to bring water to your palette to reanimate the following colors, adding more water until you have an 80w/20p "soy sauce with wasabi" consistency of each of these colors on your palette:

 · Gouache Blush (recipe on page 68)

 · Payne's Gray (pure pigment color)

 · Gouache Sage (recipe on page 68)

 · Mauve (recipe on page 68)

 · Yellow Ochre (pure pigment color)

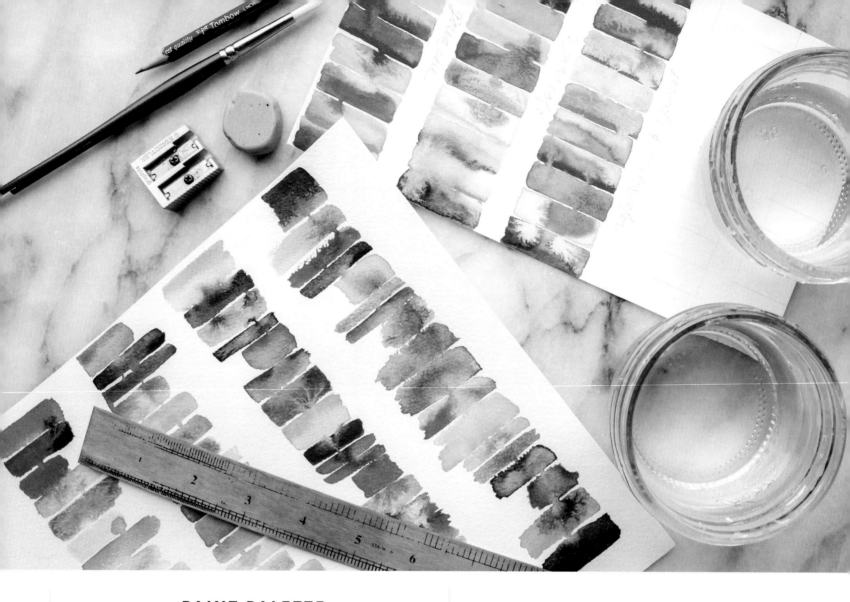

PAINT PALETTE

PAYNE'S GRAY **YELLOW OCHRE**

COLOR RECIPES

MAUVE
Yellow Ochre + Peach + Violet

GOUACHE BLUSH
Crimson + Yellow Ochre + Peach + White

GOUACHE SAGE
Sage Recipe + White

REANIMATING YOUR COLORS

To return to a palette that has dried from a previous painting session, just add water to reanimate your colors. You'll notice a difference in the vibrancy of your colors when working with reanimated paint versus paint directly from a wet tube. Reanimated paint, compared with wet tube paint, is more like working from cake watercolors. To get a thicker consistency of paint, and thus more saturated pigment, you need to brush water directly on the dried dab of paint. Don't be shy—pile that water on so you can get the same raindrops of movement on your palette. Your colors will activate and eventually be true to color.

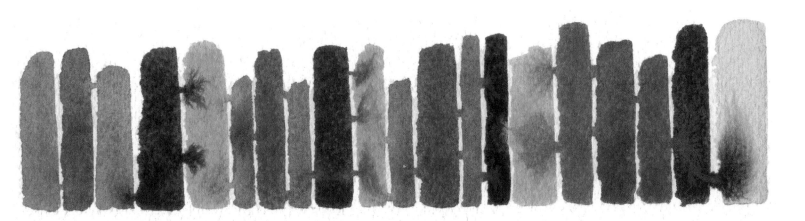

GOUACHE & WATERCOLOR

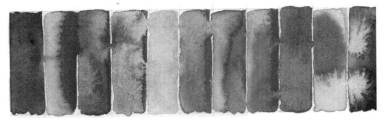

WATERCOLOR

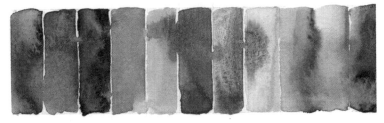

GOUACHE

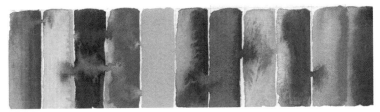

CHALLENGE YOURSELF

- Try adding in a few new colors using the wet-in-wet technique. For example, introduce Crimson by dropping it into a wet boundary to see how it moves and bleeds. Observe what this does to the coloring of your rectangles.

- Once the washes have begun to dry, drop in a new color (or pure water) to create some lovely watercolor blooms!

- Try this lesson with new color palettes, arranging different color combinations to see how they look.

- Play with color patterns: analogous only, monochromatic only, complementary next to each other only, or make up your own!

WATERCOLOR BLOCKS

1 Use your brush to pick up the 80w/20p Gouache Blush mixture on your palette and bring to your watercolor paper.

2 With your brush, create a rectangle boundary of the Gouache Blush, stroking your brush from left to right.

3 Because this is a narrow boundary, your second stroke can be all water. Dip your brush in your Mason jar and bring it back to your watercolor paper. Apply a water stroke to complete the boundary of your first rectangle, squaring off the bottom neatly. [A, B, C]

4 To create the second rectangle, bring your brush to your palette and pick up the 80w/20p consistency of Payne's Gray. Bring your loaded brush to your watercolor paper and stroke your brush from left to right to create your next rectangle.

5 Once your second rectangle of color is created, it's time to blend your boundaries. Using the lightest pressure, and just the point of your brush, gently drag your brush from the dark Payne's Gray rectangle into the light Blush rectangle. Since both of these boundaries are very wet, let them do their magical watercolor blending! Let them blend and move on their own as they dry. I call these small lines between boundaries "bridges." [D]

6 Try adding a bit more Payne's Gray with the tip of your brush to the bridge point to watch the bleeding increase. [E]

7 Continue down the line following this color pattern: Gouache Blush, Payne's Gray, Gouache Sage, Mauve, Yellow Ochre, and then back to Gouache Blush. Remember to leave thin lines between your wet watercolor rectangle boundaries as you paint, and only create small bridges where the boundaries collide. Too many bridges, and the colors may muddy too much. [F]

8 Feel free to alternate the heights and widths of your rectangles. This makes the collection of boxes appear abstract but balanced, adding more visual interest and helping improve your brush control skills. [G–P]

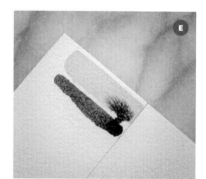

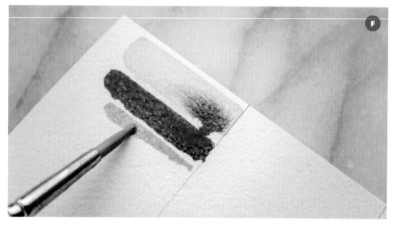

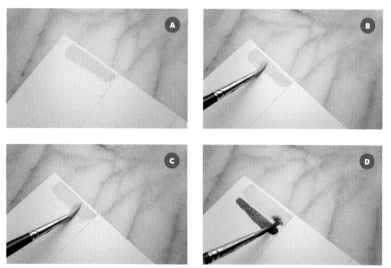

PROBLEM SOLVE

Colors not blending? Don't worry! Your washes just need more water. Try adding a bit more water to your second wash and see if that does the trick.

Are you dealing with some crazy biodomes from too much water? Because these are small boundaries, it's easy to get a bit overzealous with the water. I encourage you to leave these and see how they dry and settle. But if they are really wet and look like they might spill over your boundary, use the corner of your paper towel to blot and lightly remove excess water from the corners of your boundary (see page 50). Try not to over-blot! Resist the urge to continually touch your wet or drying boundaries, and just MOVE ON to the next rectangle and see what happens as things dry. Watercolor done right is full of sure strokes, left alone to mingle and swirl. If you're blotting and fretting constantly, not only are you killing your joy with worry, but you're stopping the paint from its full artistic expression.

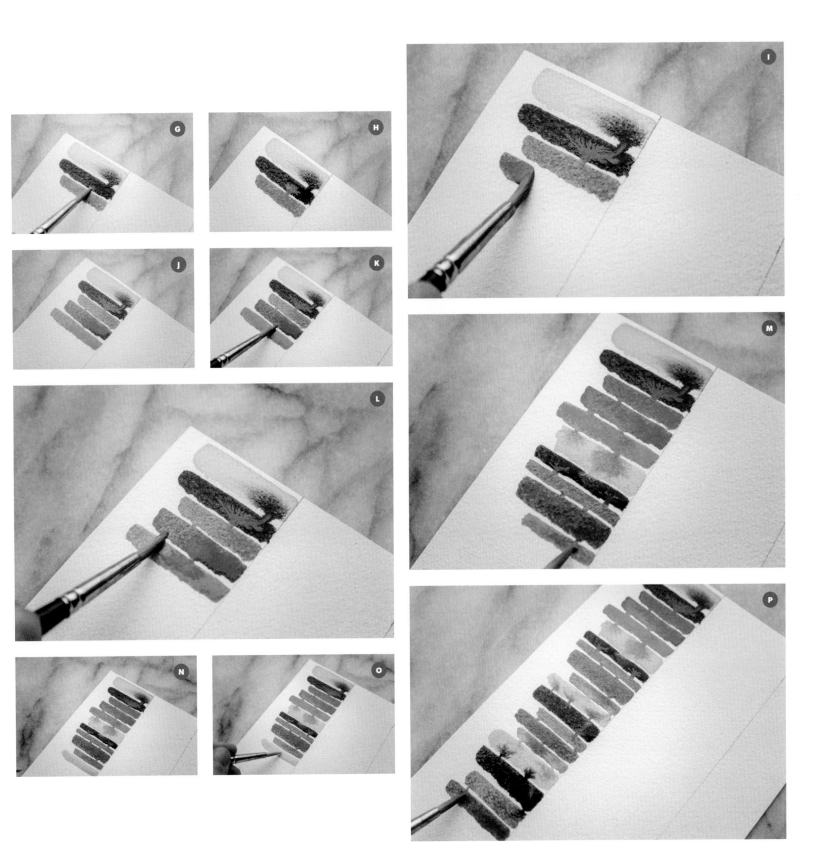

SIMPLE STROKES
SHAPES, MARKS & LINES

NOW YOU'RE READY TO START EXPLORING MORE SHAPES AND marks. In this lesson, you'll create three charts—one for lines and marks you can make with watercolor, one for lines and marks you can make with gouache, and one for lines and marks you can make with pens, pencils, and colored pencils. Then you'll combine all the skills from the charts we've created together into a beautiful abstract piece of watercolor, gouache, and colored pencil.

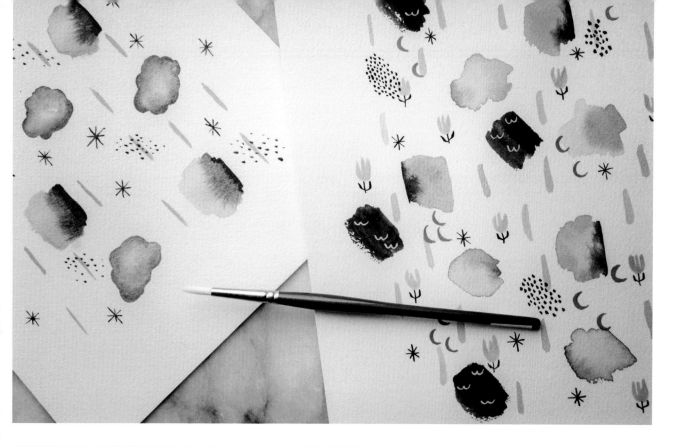

TOOLS

- 140-lb. watercolor paper (It's best to do this exercise on the type of paper you plan to use the most for your work.)

- Round watercolor brush, size 4

- HB pencil

- Pencil sharpener

- Light source for tracing (a well-lit window or a light box)

- Tape (washi or drafting)

- Watercolor Chart (page 80), Gouache Chart (page 83), Pen, Pencil & Colored Pencil Chart (page 86)

- Traceable "Abstract Painting" worksheet (see page 197)

- Micron pens, sizes 01 and 02

- Colored pencils, in light blush and light gray

- Artgum Eraser

- Ruler

- 2 Mason jars of water

PAINT PALETTE

PAYNE'S GRAY

(or one dark pigment and one light of your choosing)

Your palette for this lesson will have one dab of dark paint and one dab of light paint. Leave space between them so you can add and play with water near each paint dab.

COLOR RECIPE

APRICOT
Chinese White + Peach

TECHNIQUES

Watercolor washes

Gouache washes

Wet-in-wet

Combining gouache, watercolor, colored pencil, and ink

AS YOU BEGIN

- Ready your Mason jars of water and prime your brush.

- Create or reanimate your painting palette with the paints listed.

- Prime your palette with water; use your brush to transfer water from the Mason jar to the palette. Remember, you are mixing a sauce!

WATERCOLOR CHART

WATER-TO-PAINT RATIO	MAGIC SAUCE COMPARISON	WASH	MARKS
10W/90P	MUSTARD		
50W/50P	HEAVY CREAM		
80W/20P	SOY SAUCE WITH WASABI		
90W/10P	SOY SAUCE		

BRUSH: Round 4

PAINT CONSISTENCY: you will work through various consistencies of Payne's Gray as you fill out the chart, including 10w/90p "mustard" dab of tube paint, 50w/50p "heavy cream, 80w/20p "soy sauce with wasabi," and 90w/10p "soy sauce"

The marks you make in this chart are what I like to call "Simple Strokes." They all involve one repeated motion, with the same hand position, applying the same pressure throughout the entire stroke. For the "Wash" column, you will use a side-to-side, left-to-right stroking motion with your brush. For the "Marks" column, I will walk you through the pressure and the stroke for each consistency.

WATERCOLOR CHART

1 Using your HB pencil create a chart, like the example on page 80, on your own watercolor paper. Label the first two columns on the left "Water-to-Paint Ratio" and "Magic Sauce Comparison" and the next two columns "Wash" and "Marks." Fill in the correct water-to-paint ratio and sauce as you work through the lesson.

2 Use your brush to bring water from your Mason jar to your palette and create your 10w/90p "mustard" consistency of Payne's Gray. Load your brush with this mixture and bring it to the

upper left-hand corner of your watercolor paper.

3 Hold your brush in the classic hold (see page 26) and, stroking your brush from left to right on your paper, create an uneven, tacky wash that is primarily paint. You will likely return to the palette many times in order to transfer enough paint to your paper for this bold and highly concentrated wash. Have fun painting such a thick wash—it's rare that you'll do so! [A]

4 I've found that this thick consistency works best for fine lines or small dots, called "stamps." To make stamps like these, use your brush to pick up the mustard consistency of Payne's Gray from your palette and bring it to your watercolor paper to the "Marks" column. Using light pressure, just accessing the point of your brush to make contact with your paper, touch the brush to the paper

and then lift up. Notice that as you increase your pressure, your brush produces larger marks, while less pressure produces smaller ones. [B]

5 Next, dip your brush in your Mason jar of water and use your brush to bring water over to your palette. (I like to add water to my fresh tube paint dab AND to the dried paint that's already there, but it depends on what you're working with and what is already on your palette.) Keep adding brushfuls of water until you arrive at a 50w/50p consistency of Payne's Gray. [C]

6 Pick up the 50w/50p "heavy cream" sauce with your brush and bring it to your watercolor paper. Stroking your brush from left to right, create a new wash under your 10w/90p wash. Because this 50w/50p consistency has more water, you'll notice that it gives a slightly lighter color pigmentation and more movement as you stroke the brush on your paper. You'll still feel a good amount of control, but you'll be able to make more strokes before needing to refill your brush with paint. [D]

7 Now move your brush to the "Marks" column and use this

50w/50p consistency of Payne's Gray to create some stars. [D]

8 As you make the stars using simple strokes with your brush, be sure to pull the paint down toward you or move it from side to side, as opposed to "pushing" it upward. This gives you more control. Feel free to move your paper around as much as you need to find the best angle to make your strokes. [D]

9 Notice how the amount of pressure you use as you touch your paintbrush to paper affects the shape and style of your stars and marks. Applying light pressure engages just the point of your round watercolor brush and gives you access to marks of small details and delicate lines. Applying more pressure engages the full width of the brush, allowing for broader strokes and larger deposits of water and paint on your paper.

10 To get ready for the next row, dip your brush in your Mason jar of water and use your brush to bring water to your palette to create an 80w/20p "soy sauce with wasabi" mixture of Payne's Gray. [E]

11 Pick up the "soy sauce with wasabi" mixture with your brush and bring it to your watercolor

paper. Stroking your brush from left to right, create a new wash under your 50w/50p wash. Notice how much more easily this wash smooths into the paper. Notice that by increasing the water ratio, you don't have to use as many brushstrokes to fill the box. It's a lot less work to watercolor when you are using the right ratio for the right size boundary!

12 Now, move your brush to the "Marks" column with the 80w/20p "soy sauce with wasabi" mixture still on your brush. Here you will recreate your side-to-side wash motion but round off your strokes to make a cloud-like form. This 80w/20p mixture is prime for the wet-in-wet technique, so feel free to drop in more Payne's Gray around

the edges to add a little depth to your new raincloud. [F]

13 Now it's time to test the final consistency in our chart, the 90w/10p consistency. Dip your brush in your Mason jar and use your brush to bring water to your palette. Add a few brushfuls of water until you arrive at a consistency that is closer to a very runny soy sauce. [G]

14 Pick up the new consistency with your brush and bring it to your watercolor paper. Stroking your brush from left to right, create a new wash under your 80w/20p ratio wash. Notice how much less saturated the pigment is, and how much more the water sits above the surface of the paper. Washes that are heavy

in water are not as easily controlled in small boundaries and tend to work best for covering large expanses of paper. For example, this would be the consistency to use if you were painting an expanse of sky or a sea. Plus, lots of water on the paper gives you more time to make changes—for example, using a paper towel to blot out pigment for white clouds.

15 For your "Marks" column with the 90w/10p "soy sauce" mixture, repeat your side-to-side wash motion, keeping the strokes narrow, connected, and hard on the ends. Using light pressure is always preferred, only pressing into your brush more firmly when trying to broaden your stroke. [H]

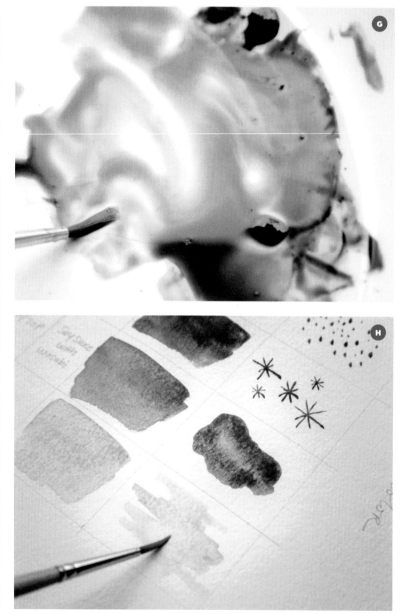

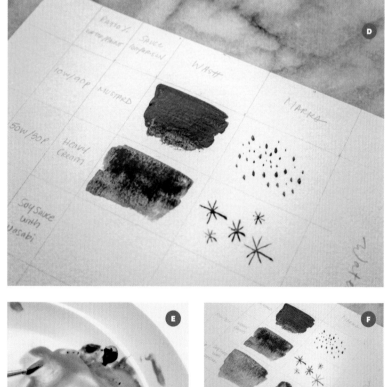

GOUACHE CHART

WATER-TO-PAINT RATIO	MAGIC SAUCE COMPARISON	WASH	MARKS
10W/90P	MUSTARD		
50W/50P	HEAVY CREAM		
80W/20P	SOY SAUCE WITH WASABI		
90W/10P	SOY SAUCE		

BRUSH: Round 4

PAINT CONSISTENCY: you will work through various consistencies of the Apricot color recipe (Chinese White + Peach), including 10w/90p "mustard" dab of tube paint, 50w/50p "heavy cream," 80w/20p "soy sauce with wasabi," and 90w/10p "soy sauce."

GOUACHE CHART

1 Using your HB pencil create a chart, like the example on page 83, on your own watercolor paper. Label the first two columns on the left "Water-to-Paint Ratio" and "Magic Sauce" and the next two columns "Wash" and "Marks." Fill in the correct water-to-paint ratio and sauce as you work through the lesson.

2 Use your brush to bring water from your Mason jar to your palette. Create your 10w/90p "mustard" consistency of Apricot by pulling pigment from your fresh tube paint dabs and mixing with water on your palette. Load your brush with this mixture and bring it to the upper left-hand corner of your watercolor paper. [A]

3 Hold your brush in the classic hold (see page 26) and, stroking your brush from left to right, create an uneven, tacky wash that is primarily paint. You will likely return to the palette many times in order to transfer enough paint to your paper for this bold and highly concentrated wash. Have fun painting such a thick wash—it's rare that you'll do so! [B]

4 As we saw with watercolor, this thick consistency of gouache works best for fine lines or small dots, called "stamps." To make stamps like these, use your brush to pick up the "mustard" consistency of Apricot from your palette and bring it to your watercolor paper to the "Marks" column. Using light pressure, just accessing the point of your brush to make contact with your paper, touch the brush to the paper and then lift up. Notice that as you increase your pressure, your brush produces larger marks, while less pressure produces smaller ones. [C]

5 You are working with the 10w/90p "mustard" consistency, so the color is bold and highly opaque. Just like we learned in the Watercolor Chart, if you were to attempt to make these small stamp-like marks using a different water-to-paint ratio, for example 50w/50p, you would observe that the higher ratio of water in a mark this small would create the biodome effect. A "mustard" consistency for smaller marks, or when you're filling small boundaries and doing fine-line detail with gouache, is the magic sauce.

6 Next, you'll mix your "heavy cream" consistency for the second row in your chart. Use your brush to bring water from your Mason jar over to your palette. Keep adding brushfuls of water until you arrive at a 50w/50p consistency of Apricot. [D]

7 Pick up the "heavy cream" consistency with your brush and bring it to your watercolor paper. Stroking your brush from left to right, create a new gouache wash under your 10w/90p wash. Because the 50w/50p consistency has more water, you'll notice that it gives a slightly lighter color pigmentation and more movement as you stroke the brush on your paper. [E]

8 Now move your brush to the "Marks" column, and use this 50w/50p consistency to create

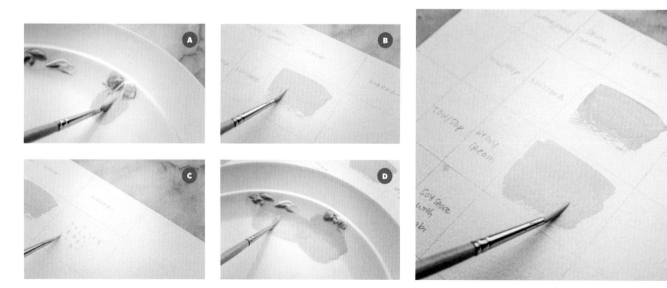

some abstract, rounded shapes that look a bit like a lowercase "m." [F]

9 To get ready for the next row, dip your brush in your Mason jar of water and use your brush to bring water to your palette to create an 80w/20p "soy sauce with wasabi" mixture of Apricot.

10 Pick up the "soy sauce with wasabi" mixture with your brush and bring it to your watercolor paper. Stroking your brush from left to right, create a new wash under your 50p/50w wash. [G]

11 Pick up more of the paint consistency from your palette with your brush and move to the "Marks" column. Using light pressure and moving from top to bottom, draw a line with your paintbrush. Play around with your pressure as

you draw these lines. You'll notice that an increase in pressure increases the width of your stroke, while a decrease in pressure decreases the width. [H]

12 Now it's time to test the final consistency in our Gouache Chart, the 90w/10p "soy sauce" mixture. Dip your brush in your Mason jar and use the brush to bring water to your palette. Add a few brushfuls of water to the 80w/20p mixture already on your palette until you arrive at a consistency that is closer to a very runny soy sauce. [I]

13 Pick up the new consistency with your brush and bring it to your watercolor paper. Stroking your brush from left to right, create a new gouache wash under your 80w/20p wash. Notice how much

easier it is to work with gouache as you water it down!

14 For your final "Marks" column, repeat your side-to-side wash motion to create a simple

and unified wash with your 90w/10p consistency. Notice how light it is! [J]

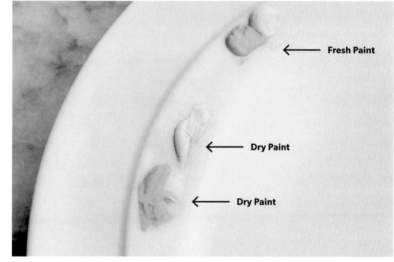
← Fresh Paint
← Dry Paint
← Dry Paint

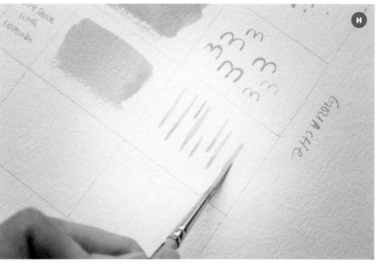

PEN, PENCIL & COLORED PENCIL CHART

MARK	PENCIL	MICRON 01	MICRON 02	COLORED PENCIL

BRUSH: Round 4—plus your pens and pencils!

PAINT CONSISTENCY: 80w/20p "soy sauce with wasabi"

PEN, PENCIL & COLORED PENCIL CHART

1 Using your HB pencil create a chart, like the example on page 86, on your own watercolor paper. Be sure to label your top rows all the way across with your different tools. [A]

2 In the example shown, I included sizes 01 and 02 of the Micron pen, but feel free to test as many as you want—you just might want to use a bigger sheet of watercolor paper.

3 Using your HB pencil, make all the marks in the left column by tracing or drawing them freehand.

4 Use your different tools to complete your chart, taking note of the different movements and pressures required for each mark. Your hand position will alter slightly, and different amounts of pressure will make darker or lighter marks. The toothy texture of the watercolor paper can take a little while to get used to drawing on.

5 Now for the fun part: painting on your chart and bringing all of the techniques of this lesson together!

6 You'll use your Apricot to paint in the circle you drew in each column on your chart.

7 Dip your brush in your Mason jar and use your brush to bring water to your palette and reanimate the Apricot. Keep adding brushfuls of water until you have an 80w/20p consistency that is close to soy sauce with a touch of wasabi. [B]

8 Pick up the new consistency with your brush, bring it to your watercolor paper, and fill in your first circle. Use a side-to-side motion with your brush, curving it around to fill in the circular shape. [C, D, E, F]

9 Since these circle boundaries are so small, experiment with how you fill them in. Do you prefer to outline the shape first with the point of your brush, and then stroke side to side inside the boundary? Or do you prefer to fill the circle in, and then use your brush's point to outline the shape and smooth any hard lines? Observe how the paint interacts with the pencil, colored pencil, and inks you used to draw your circle outlines.

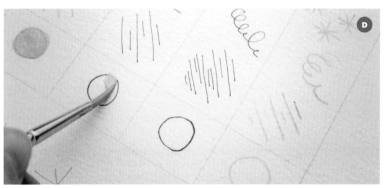

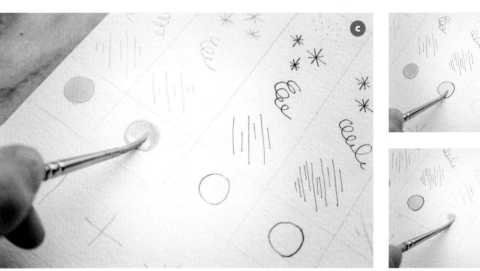

BRUSH: Round 4

PAINT CONSISTENCY: you will work through various consistencies of both Payne's Gray and Apricot, including 10w/90p "mustard," 50w/50p "heavy cream," 80w/20p "soy sauce with wasabi," and 90w/10p "soy sauce"

In this final exercise, you'll use all the simple strokes and magic sauce blends you've been practicing and combine them into an abstract watercolor piece. You will also incorporate the wet-in-wet technique you learned in Lesson 1 (page 47), dropping in color to add interest and contrast.

ABSTRACT PAINTING

1 Using your colored pencils and light source, lightly trace the shapes from the "Abstract Painting" traceable onto your watercolor paper. Trace the stamp marks, stars, and clouds with your light gray pencil and everything else with your blush pencil.

2 Trace lightly! Even though the colored pencil pigments tend to dissolve more readily in water than regular HB graphite, they will still show through if you trace too heavily. [A]

3 Dip your brush in your Mason jar and use the brush to bring water to your palette. Add a few brushfuls of water to the dried (or drying) consistency of Payne's Gray already on your palette until you arrive at a 90w/10p consistency that is close to a very runny soy sauce. Pick up this mixture with your brush and bring it to your watercolor paper to paint your Payne's Gray clouds.

4 For the cloud shapes, use your side-to-side wash motion, but round off some of your strokes to make a cloud-like form, like you did in your Watercolor Chart. This mixture is prime for the wet-in-wet method, which will add a little depth to your new raincloud. [B]

5 To add the wet-in-wet drops of more concentrated paint, pick up a slightly thicker consistency of Payne's Gray, moving toward 80w/20p "soy sauce with wasabi," and drop in this mixture around the edges of your cloud-like forms. [C]

6 Next, we'll add the Apricot squares. Dip your brush in your Mason jar, clearing it of all excess Payne's Gray paint. Use your brush to bring water to your palette and animate the Apricot that is dried or drying. Add a few brushfuls of water until you arrive at a consistency of 90w/10p. Pick up this water-paint mixture with your brush and bring it to your watercolor paper.

7 Use the side-to-side wash motion to paint your peach boxes, rounding off some of your strokes for a more abstract look. [D]

8 Again, because this boundary is small and the mixture is very wet, it is prime for adding more pigment wet-in-wet. Paint all of your Apricot wash boxes first.

9 Then, bring your brush to your palette and pick up your 80w/20p consistency of Payne's Gray and bring it to one of your wet Apricot boundaries. Gently draw a thin line across the right side of the wet Apricot boundary to drop in the darker concentration of Payne's Gray along this edge. [E]

10 Continue adding Payne's Gray to your Apricot boxes using this technique, observing how each time you drop in the darker pigment, the paint and water move and swirl for a different effect. [F–H]

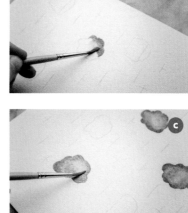

11 Now you'll add some simple strokes to the painting: Apricot lines and Payne's Gray stars.

12 For the lines, bring your brush to your palette and pick up a 50w/50p consistency of Apricot, pulling in more pigment as needed to thicken up your sauce to resemble heavy cream. [I]

13 Bring your loaded brush to your watercolor paper and, using light pressure and moving

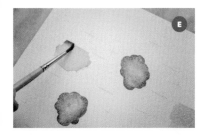

from top to bottom, draw a line with your paintbrush following your trace marks. An increase in pressure will increase the width of your stroke, and a decrease in pressure will decrease the width. [J, K]

14 Move and rotate your paper to access different angles. This will help keep your marks sure and strong and help you avoid running your hand through wet paint!

15 Once you've filled in all the lines, dip your brush in your Mason jar and use your brush to bring water to your palette to create a 50w/50p "heavy cream" consistency of Payne's Gray. Pick up the cream-like consistency with your brush and bring it to your scrap paper to practice making some stars.

16 As you begin to make these simple strokes with your brush, keep in mind that you have

the most control if you use your brush to pull the paint down, or move it from side to side, as opposed to

WATERCOLOR RATIOS: TAKEAWAYS

- Smaller, more detailed and controlled strokes are easier to create with a higher paint-to-water ratio.

- To get more movement and shine in your boundary, increase the water in your paint consistency. Greater amounts of water also smooth the boundary you've painted, giving your wash a more even look throughout.

- A higher ratio of water to paint works best for expansive boundaries, like a sea or sky. More water also gives you more time to make changes within your wet boundary.

- Always create your consistency of paint to water on your palette, and then transfer it to the watercolor paper.

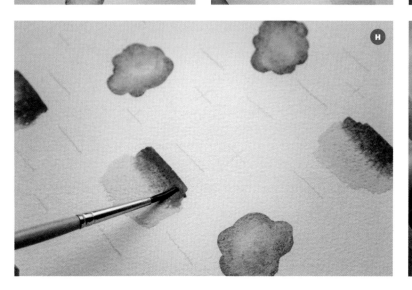

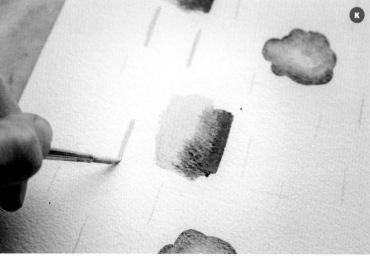

"pushing" the paint upward. Once you're ready, add the stars to your watercolor paper following your traced marks. **[L–P]**

17 Lastly, bring your brush to your palette to pick up more of the cream-like consistency of Payne's Gray. Bring your brush to your watercolor paper and start making your stamps, alternating your pressure, sometimes applying more, then applying less. See how the greater pressure produces larger marks, and less pressure produces smaller marks. Rotate the paper to access your marks until you've added them all. **[Q–R]**

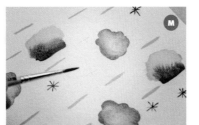

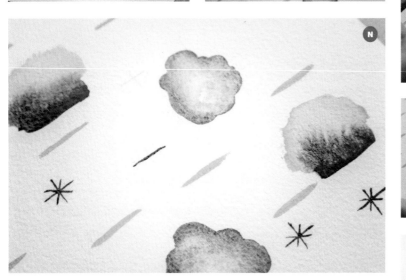

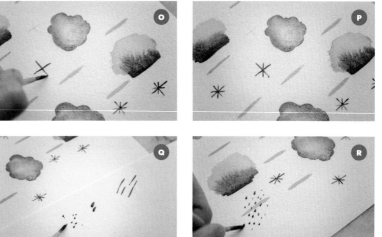

GOUACHE RATIOS: TAKEAWAYS

- Higher ratios of paint lead to smaller, more detailed and controlled gouache strokes.

- To get more movement and shine in your boundary, increase the water in your gouache consistency.

- You cannot see your watercolor paper as well through the dried washes and marks on your Gouache Chart. By now, you can tell that it's a tackier texture that requires a bit more determination and finesse as you wield it with your brush. I like to think of watercolor and gouache as sisters: they are so similar and play nicely together, but they have wonderful stand-alone qualities that make them unique mediums.

THE RIGHT CONSISTENCY FOR THE BOUNDARY

Here we began working with the "mustard" 10w/90p consistency, so the color was bold and highly opaque. If you were to attempt to make these small stamp-like marks using a different water-to-paint ratio, for example 50w/50p, you would observe that the higher ratio of water in a mark this small (which is a very small boundary!) would create the biodome effect.

Making stamps with 10w/90p is a great example of using the right paint consistency with the correct boundary size. For filling small boundaries and doing fine-line detail with watercolor, "mustard" is the magic sauce. However, if you try to make a boundary much larger with this thick consistency, you will begin to see the paper coming through. As you create throughout the rest of this book, you will see how when you increase the water in your painting ratio, the reward is increased movement that can cover larger boundaries. The increase of water leads to smoother and larger boundaries, and the decrease in the paint concentration leads to a desaturation of the color pigment.

THE REWARD OF BEING VULNERABLE

THE TIME FINALLY ARRIVED TO SHARE MY ARTWORK WITH THE WIDER world. Up until now, I had been only sharing pictures of my plants. I knew I needed to share my art too. The day began early, around five in the morning. I had just fed my two-month old daughter and she was snoozing contentedly. Instead of rolling back into bed, I sat in the living room at my great-grandmother's writing desk. I watched the sun rise, captivated by the soft morning light as the breeze shook the leaves of the trees. Inspired, I painted a few monochromatic green leaves. Suddenly, I felt that someone needed to hold the plant I had just painted. In those quiet hours, my character "Florence" was born. She came to life, embracing leafy eucalyptus boughs in a large vase, her face hidden by the greenery. I loved the contrast of the watercolor plant with the simple, ink lines of her body. Next, I drew Florence holding one of our chickens. I knew I had to share her, but I still remember the vulnerability I felt as I hit "post," sharing a piece I cared about with an audience for the first time.

Sharing your art with other people is vulnerable. On social media, or just with a close friend over coffee. A work of art comes from your own two hands. As you share it—or even think about sharing it—your heart beats faster and a negative voice may whisper in your ear, telling you all the reasons you are silly and unworthy to share your creation.

But believe this: sharing your work is good for you. Even when you are scared, even when you are giddy with excitement. These emotions show you that you are alive.

I invite you on this journey. Be bold. Be brave. Step through your feelings of vulnerability to the other side. Embrace the process, play with paint, trust the artist inside that has original suggestions. And when you do choose to share, the community that surrounds you and the joy you feel is so much stronger than the vulnerability or fear of sharing ever was. ●

COMPOUND STROKES

POINT-PRESSURE-POINT
BOTANICALS

NOW THAT YOU'VE PLAYED WITH SIMPLE STROKES, IT'S TIME TO practice compound strokes. These strokes are made with a continuous, fluid motion using the same hand position but varying degrees of pressure. We'll focus specifically on what I like to call the Point-Pressure-Point—or PPP—stroke. This stroke involves pulling your brush downward while simultaneously alternating your pressure from light to heavy and back to light again. You'll use this pretty compound stroke to move from the abstract shaping you've practiced in the last five lessons to begin creating recognizable botanical shapes.

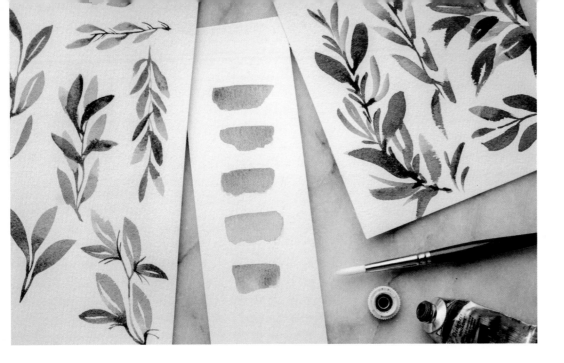

TOOLS

- Round watercolor brushes, sizes 4 and 1
- 140-lb. watercolor paper
- Traceable "Flower" worksheet (see page 199)
- Colored pencils, in light gray and blush
- Light source for tracing (a well-lit window or a light box)
- Tape (washi or drafting)
- 2 Mason jars of water
- Paper towel

TECHNIQUES

Point-Pressure-Point (PPP)

Wash

Clear water wash

Wet-in-wet

PAINT PALETTE

PAYNE'S GRAY **BURNT SIENNA**

PEACH **YELLOW OCHRE** **CRIMSON**

COLOR RECIPES

BLUSH
Crimson + Yellow Ochre + Peach

PINE
Viridian + Cerulean Blue + Yellow Ochre + Lemon Yellow

MONSTERA
Viridian + Payne's Gray

SAGE
Viridian + Cerulean Blue + Yellow Ochre

TIPS FOR THIS PROJECT

- For PPP work, you will use the classic hold on your brush (see page 26). While you are brushing your strokes on paper, all that will change is the pressure you apply—you will press lightly, then heavier, then lightly again to get the fluid botanical shape.

- Creating PPP strokes in this lesson will require an animated palette with lots of movement and shine.

AS YOU BEGIN

- Set out two Mason jars of water (one jar for dark pigment and one for light) and prime your brush.

- We are going to be creating the darker PPP leaves at first, so create or reanimate your painting palette using the paints and recipes listed, focusing on the dark colors first.

POINT-PRESSURE-POINT CHAINS

1 Use your Round 4 brush to bring clean water from your Mason jar to your palette and create your 90w/10p-to-80w/20p mixture of Payne's Gray on your palette.

2 Pick up the new consistency with your brush and bring it to your watercolor paper.

3 Use the lightest pressure to engage just the point of your brush to begin a small, thin mark of Payne's Gray on your paper. [A]

4 In a fluid motion, pull your brush down and begin to increase the pressure to engage the full width of your brush bristles, which will cause the mark you're painting to widen. [B]

5 Continue to pull down and decrease the pressure, ending your stroke by using the lightest pressure to engage just the point of the bristles of your brush. [C]

6 Without lifting your brush, begin another point-pressure-point stroke, using the lightest pressure to engage just the point of the brush, then increasing, and then decreasing the pressure.

7 Is your brush running out of your paint-and-water magic sauce? That's normal! Mid-stroke, or at the completion of one PPP motion, return your brush to your Mason jar of water and bring water to your palette to ensure you have that 90w/10p-to-80w/20p consistency of Payne's Gray still flowing on

your palette. Use your brush to pick up your mixture and bring it back to your watercolor paper, right where you left off.

8 To ensure your pattern remains seamless, make sure the spot where you lift your brush stays wet. Start your brush again using the wet boundary and continue the pattern. Dropping into the already-wet boundary will allow you to create a seamless pattern, as opposed to

starting a new boundary.

9 Continue this PPP pattern until you reach the bottom of your paper. [D]

10 Begin a new PPP pattern at the top of the page next to your first, taking care not to run your hand through your wet work. [E, F]

11 Continue to alternate your pressure from light to heavy to light as you pull the paint downward

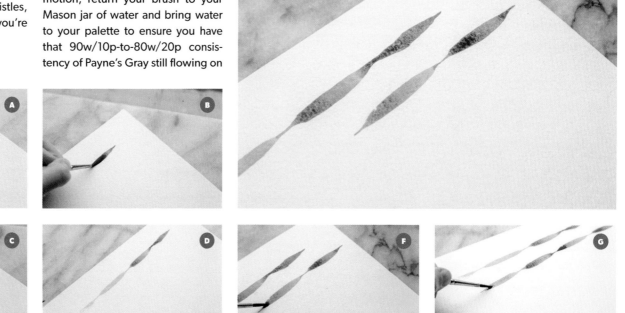

in a fluid motion. Reload your brush as many times as you need to complete the pattern down the page. [G]

12 Next, you'll practice lifting the brush between your fluid PPP motions, detaching the pattern to create individual leaf shapes.

13 Return your brush to your Mason jar and bring water to your palette to ensure you have that 90w/10p-to-80w/20p consistency of Payne's Gray moving and shining on your palette. Use your brush to pick up your magic sauce and bring it to your watercolor paper.

14 Begin a new PPP pattern at the top of your page, taking care not to run your hand through your wet work. Use the lightest pressure to engage just the point of the brush to make the smallest mark. [H]

15 Continue to pull down and increase the pressure in order to engage the full width of the brush bristles, widening your mark. [I]

16 Continue to pull down, and decrease the pressure, using the lightest pressure again to engage just the point of the bristles of your brush. [J]

17 Once you have created your first full PPP stroke, lift your brush! Now you can see a leaf begin to take shape, made with just one fluid compound stroke!

18 Continue down your page, separating the PPP strokes between each leaf. Play around a bit! See if you can make long leaves and short leaves. Notice how the color of your leaves fade as the paint-and-water mixture in your brush begins to run low. [K]

CHECK YOUR BRUSH HOLD

Pause here and take a look at how you're holding your brush. Where is the handle of your brush falling as you paint? Is it resting along your thumb, running almost parallel to your paper? Or is it jutting up, near the knuckle of your forefinger? You have more control when the handle of the brush rests near your thumb. Try adjusting your hold and see if you can make a fuller, more complete PPP stroke with this adjustment.

If the handle of your brush is sitting at too high of an angle in your hand, it's difficult to engage the full width of the bristles.

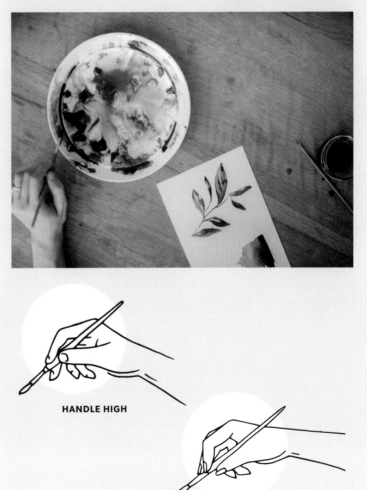

HANDLE HIGH

HANDLE LOW

19 Now try adding a small curve to your compound stroke. Use the same PPP motion, but curve your hand slightly as you pull down during the stroke to get a rough edge on your leaf shape. You can smooth the line by retracing it with refilled brush bristles. **[L–R]**

20 Now for the fun part—creating two curved PPP strokes together to make a full leaf shape.

21 Return your brush to your Mason jar and bring water to your palette to ensure you have that 90w/10p-to-80w/20p consistency. Use your brush to pick up your mixture of Payne's Gray and bring it to your watercolor paper.

22 Begin a new PPP pattern at the top of your page, taking care not to run your hand through your wet work. Use the lightest pressure to engage just the point of the brush to make one curved PPP stroke.

23 Now, starting at the top point of your just-completed stroke, echo the shape you just created, but curve your stroke the other way, mirroring the first. Be careful to leave a very small amount of white paper showing between the strokes. When you connect your PPP strokes together, you're left with two thick strokes side by side, creating a full leaf shape with a white vein in the middle. Complete a line of these compound leaves. **[T, U, V]**

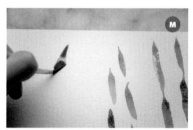

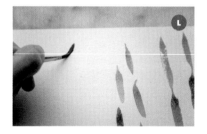

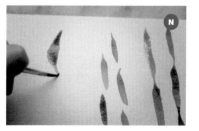

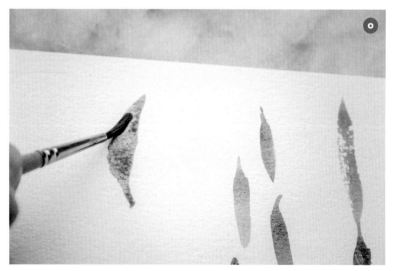

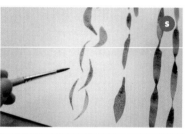

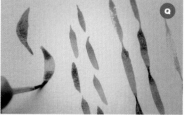

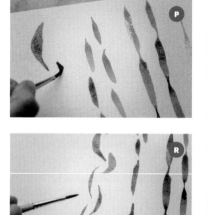

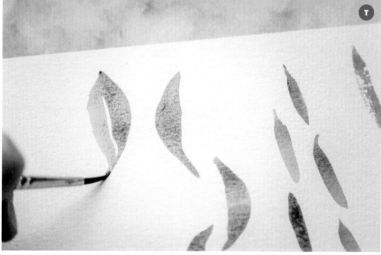

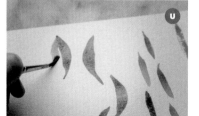

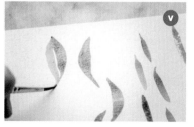

24 Once you have a nice leaf shape of two PPP compound strokes, try incorporating a wet-in-wet effect. Using your brush, pick up more of your Payne's Gray mixture and drop it into the wet boundary of your leaf point to give it a dark, contrasting effect. Notice how the Payne's gray darkens the point and bleeds into the rest of the leaf but the vein remains white due to the boundary created. **[W, X, Y]**

25 Now rinse and set aside your Round 4 brush and pick up your Round 1. Prime your brush with water and bring it to your palette to pick up your 90w/10p mixture of Payne's Gray. Bring your brush to your watercolor paper and begin a new line of your continuous PPP pattern using the Round 1.

26 Notice how much more often you have to reload your brush, since the Round 1 doesn't hold as much paint as the Round 4. And how much more petite your PPP leaf shapes are with a Round 1! Also, because the Round 1 brush doesn't carry as much water as the Round 4, you aren't able to make as many changes to the coloring of the small wet boundaries once they are down.

27 Begin another line at the top of your page, this time creating individual PPP leaves with your Round 1. Use the double PPP motion to create petite leaves with small white veins in the centers. **[Z]**

28 Make your leaves small, narrow, long, short—play around with different combinations in size, switching between your brushes.

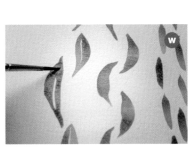

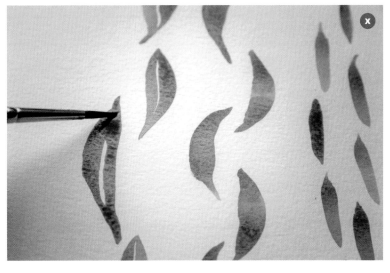

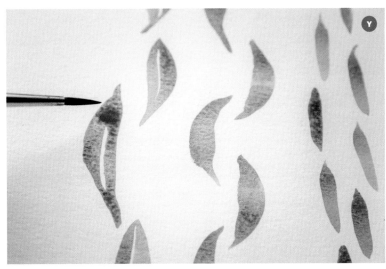

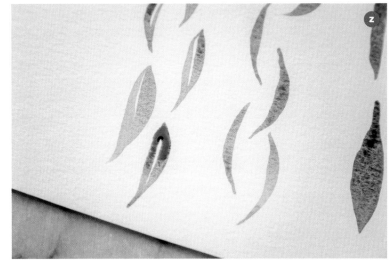

POINT-PRESSURE-POINT FLOWERS

1 Dip your brush in your light-color Mason jar and use your brush to bring water to your palette to create an 80w/20p "soy sauce" consistency of your Blush color recipe. [A]

2 Once you've added a few brushfuls of water and achieved the consistency of that magic sauce of runny soy sauce, pick up the mixture with your brush and bring it to your watercolor paper.

3 Using just the point of your brush, make a series of simple stroke marks. These are small stamps that will make up the flower center. These dots should be very full of water and actually appear to be small biodomes of color. Don't worry about this at all—you will be blending them out into each flower petal. [B]

4 To begin your first petal using your PPP motion, place your brush in the center of one of the wet stamps you just created. Beginning the point of the petal in the wet boundary of your center will not only serve to blend your petal color but will also allow the petal to seamlessly connect to the flower center. [C]

5 Begin your PPP stroke by using the lightest pressure to engage just the point of the brush to make the smallest mark.

6 Continue to pull down and increase the pressure to engage the full width of the brush bristles and widen your mark. [D]

7 Continue to pull down and decrease your pressure, using the lightest pressure again to engage just the point of your brush. Lift your brush from the paper once you've completed the full PPP stroke—you've just completed your first petal! [E]

8 Flip your paper 180 degrees and begin another PPP petal directly opposite your first, once again starting in the wet center stamps of the flower and pulling your PPP stroke downward. [F]

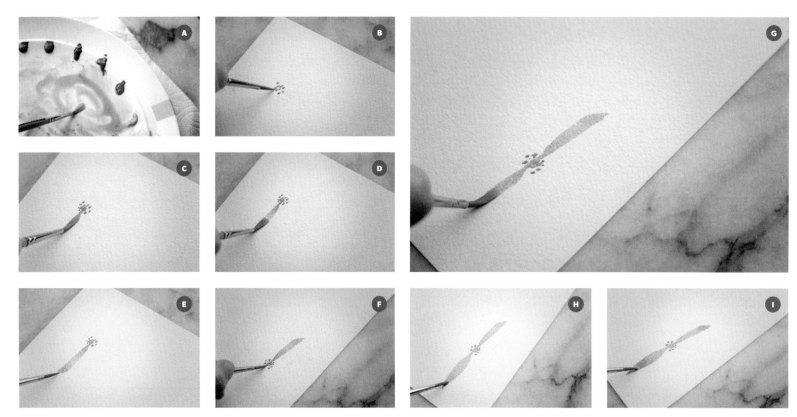

9 You have the most control when you can pull the paint down toward yourself, so continuing to reorient your paper will help you create each petal seamlessly. **[G]**

10 While your petal boundary is still wet, drop in a touch more of your Blush consistency, picking up the mixture from your palette and dropping it in the using wet-in-wet method. Taking your time to make each petal its own little masterpiece while each is wet is both relaxing and rewarding. **[H, I]**

11 Continue moving your paper and creating petals around your flower center until you've painted about eight to ten petals (depending on the width of each or how full you'd like your flower to be).

Leaving interesting white space between each petal allows the flower to form its most natural shape (and prevents it from turning into one large wet blob).

A FEW FUN THINGS TO TRY WHILE YOU PLAY:

- Try making some petals lighter by using less paint. **[J-N]**

- Try dropping in just water to a drying petal and see what happens—you can create watercolor blooms (see page 29) within the petals of your new flower! **[O]**

- Keep painting flowers. Make shorter-petaled flowers, overlap petals of different flowers . . . play and learn, and see what happens. **[P]**

I RAN MY HAND THROUGH MY WET WORK . . . HELP!

If you do happen to run your hand through your work at any point, it's nothing a wet paper towel can't fix! Dip your paper towel in your clean water and immediately blot your whoopsie. This should remove most of the mistake. And be sure to use a dry paper towel to blot dry any new wet spots on your paper, so your paint doesn't find its way there!

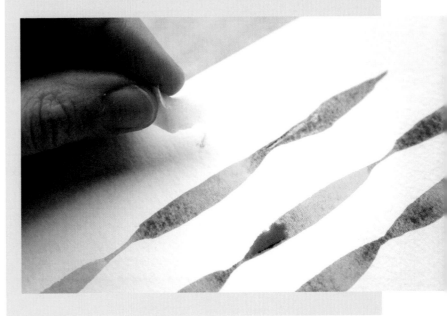

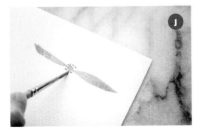

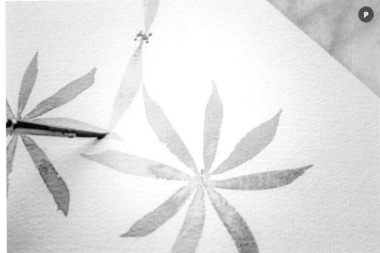

BRUSHES: Round 4, Round 1

PAINT CONSISTENCY: 80w/20p "soy sauce with wasabi," moving toward 50w/50p "heavy cream"

Slowly but surely, exercise by exercise, we are moving out of abstract shape making and into botanical shaping. This is all great practice as we move into painting a loose leafy wreath for Lesson 7. We are going to animate a mix of recipe colors to create a swirling mix of foliage.

POINT-PRESSURE-POINT LEAVES

1 Dip your Round 4 brush in your Mason jar and use your brush to bring water to your palette. Add water to your Payne's Gray and Burnt Sienna paints and your color recipes for Monstera, Pine, and Sage. I like to make a small color swatch palette to test my colors on a scrap paper before I bring my paints to my final paper, so I know exactly what my brush is reanimating. Keep adding brushfuls of water until you have an 80w/20p-moving-toward-50w/50p consistency of all the colors you'll use for the exercise. **[A–E]**

2 Dip your brush back in your Mason jar, pick up your Sage from your palette, and paint your first PPP leaf. Return your brush to the Mason jar for another dip of water, pick up more Sage paint from your palette, and paint another PPP leaf near your first. Brush to water, brush directly to the sauce on your palette, and then brush to paper—keep making those PPP strokes until you have two full leaves painted. **[F]**

3 Return your brush to your Mason jar for water, and then to your palette to pick up a Monstera green in the 50w/50p-to-80w/20p consistency. Bring your brush to your watercolor paper and, using only the point of your brush for a light-pressured mark, draw your paintbrush from the bottom of one leaf downward, making a slender stem. Notice how the darker paint bleeds into the lighter green of the still-wet leaf. Do the same from your other leaf, connecting the stems. **[G]**

4 By using the point of your brush to drop darker color into your leaf corners before forming your stem, you've successfully used the wet-in-wet technique to add color to a wet boundary.

5 Slowly build more leafy branches, using the PPP motion. As you paint, dip into the lighter greens of your palette, changing the coloring slightly as you paint more leaves. **[H, I, J]**

6 Notice how alternating the pressure on the brush as you make contact with your paper changes the shape of your leaf. A longer stroke will create a longer leaf. Increasing the pressure as you brush will create a fuller leaf.

7 Move quickly and don't spend too much time on one leaf shape. If you made a mark that's not your favorite, don't worry about fixing it. Just move on to a new leaf. You're learning, leaf by leaf, what your hand and paintbrush can do.

8 Returning to a leaf as it dries and dropping in a deeper green will help you understand the timing for dropping in color. If you wait too long, the new wet paint won't move. But if you time it just right, the wet-in-wet drop of a bolder color bleeds and veins and adds interest that a paintbrush could never achieve. [K, L]

9 Leave interesting white space between the different leaves and branches as you work, giving each boundary a bit of room to breathe. White space allows the leaves to "pop" off the page and helps your eye identify them as leafy shapes. If you end up with a leaf blob, move away and paint in another area. Don't let the blobs get you down! Just remember to leave more white space next time. [K, L]

10 Continue to play and fill your paper with leaves and their small branches. Alternate sizes by switching between your Round 1 and your Round 4 brushes as you get more comfortable with the PPP movement, and keep dropping in color in your wet boundaries. [M, N, O]

11 Cross smaller, darker leaf shapes with lighter, broader shapes and see what happens. Identify where your boundaries are still wet; add a leaf and see what happens. [P, Q]

12 Twist your hand mid-stroke to give your leaves a curve. Use PPP to leave bigger white veins down the middle. Have some leaves faceup, some facedown. [R, S, T]

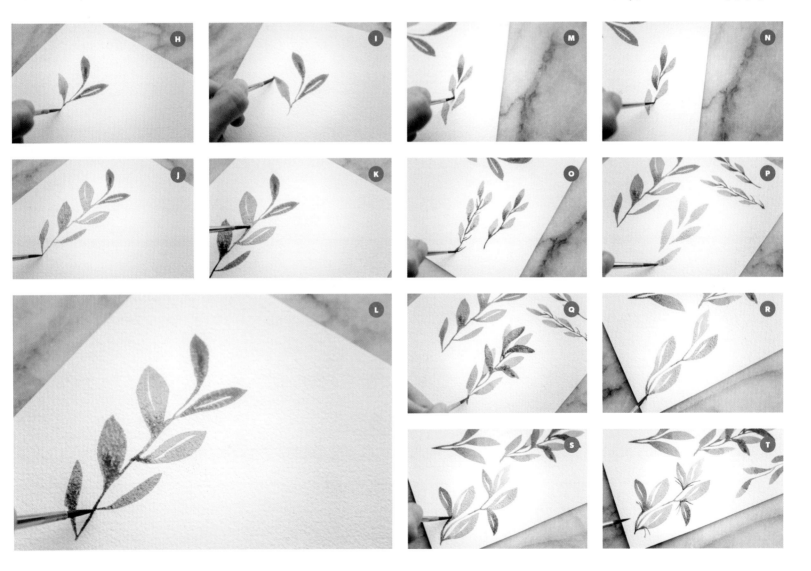

BRUSH: Round 4 **PAINT CONSISTENCY:** 80w/20p "soy sauce with wasabi"

How's the color of your water? This is a good time to pause, stretch, and refill both your Mason jars with fresh water. You'll want to keep the water of one jar clear for this exercise.

You may be noticing and enjoying the lovely rhythm of creating a pattern of leaves and petals. In this exercise, you will play with painting a large loose flower using a photo of an Itoh peony as your subject. You will get to see more of what wet-in-wet can do within a larger boundary of a flower petal, and how just a small amount of watercolor paint goes a long way.

POINT-PRESSURE-POINT GARDEN FLORAL

1 Using your blush colored pencil and light source, lightly trace the flower shape from your "Flower" onto your watercolor paper. The lighter you trace, the easier it will be to blend in the lines with your water and paint.

2 Dip your Round 4 brush into your Mason jar of clear water and use your brush to bring water to your palette to reanimate your Blush color recipe until you have an 80w/20p consistency of Blush. By priming your palette using only one Mason jar, you will leave the second one clear. Add dabs of Crimson, Yellow Ochre, and Peach tube paint to your palette as well, and feel free to add some water to the dabs of paint to prime them.

3 First you will create a clear-water wash within your flower petals. To create almost transparent blush flowers, beginning with a clear water wash primes your paper and creates the wet boundaries of your petals without adding any color. Then, while your clear washes are still wet, you can slowly build in color.

4 Dip your brush in your Mason jar of clear water, bring the water to your paper, and begin to create a clear wash boundary for your petals. Use your brush to "scrub" the light-colored pencil markings, moving your brush from side to side to work the water into the paper and rub the colored pencil lines into the clear wash. [A]

5 Once you have a clear wash on the first few petals, you will use the wet-in-wet method to create points of color while your boundaries are still wet. [B]

6 Be sure to dip your brush in the Mason jar that already has pigment, as you want to keep your

continues on next page

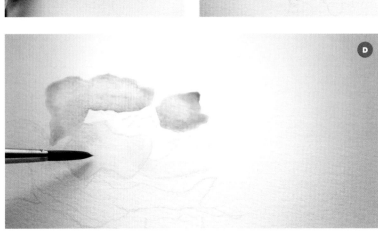

other jar clear to create the rest of the petals. Then dip your brush in your 80w/20p mixture of Blush and lightly tap your now paint-filled brush into the wet boundary to watch the pigment bleed. Let the paint move slowly through the wet, clear petals, naturally spreading color as it dries. [C]

7 Next, take your brush to the raw pigment dabs of the Crimson, Yellow Ochre, and Peach, and drop these colors into your wet petal boundaries as well. Use the lightest pressure as you tap your brush into the wet boundary, letting the colors blend and move. [D]

8 The more you saturate your wet petal boundaries in color, the more pigmented they will become. If you prefer an airy and light look, don't add as much color when your flower is wet. [E]

9 Once you've created your top petals, bring your brush to your palette and pick up your 80w/20p Blush mixture. Bring your loaded brush to your watercolor paper and, using light pressure to just access the point of your brush, suggest your flower center by making small, thin lines. As these are small boundaries, don't apply too much pressure for these marks. Focus on small, quick strokes, occasionally crossing the boundaries of your freshly painted petals. [F]

10 Rinse your brush and then dip it into your clear water jar and continue creating clear washes for your petals. By painting in small clusters of petals, you can work quickly and use the wet-in-wet technique to add your color, blending the look of the overall flower. [G]

11 Once your petals are all painted, and still drying, it's time to create your leaves.

12 Rinse your brush and bring water to your palette to animate the green palette you used for your leaves. Bring brushfuls of water to your palette until you have an 80w/20p "soy sauce with wasabi" consistency of your greens.

13 Load Sage onto your brush and bring your brush to your watercolor paper, to the edge of a flower petal. You will use PPP to create the leaf, starting with light pressure on the point of your brush, transitioning into fuller pressure and a broader stroke, and back to light pressure until you complete the leaf's point. Immediately use the same motion to create the second leaf segment, joining it to the first at the flower petal and the bottom tip of the leaf, leaving a line of white space in the center. [H, I]

14 Step back and admire your lovely, loose floral shape!

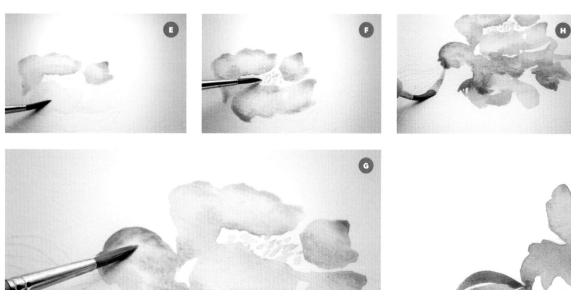

TIPS FOR PAINTING FLOWER FORMS

Flowers in nature have depth and shape, dancing light, moving shadows, and interesting and varied textures, as well as color gradation in each petal, stamen, and bud. An artist working in oil paints may attempt to capture all of these details by adding layer upon layer, scraping, dotting, and revisiting the form over many sessions. But in watercolor, we are minimalists. Our challenge is to simplify a complex subject with a few quick and decided strokes, while uniquely representing its true beauty and essence.

So, how to take a complex three-dimensional flower in real life and translate it to a two-dimensional watercolor painting? Here are three tips to remember.

SMALLER STROKES TOWARD THE CENTER

It's best to indicate the center of your flower by painting smaller strokes, as those center petals (and central details, like the stamen and pollinators) are usually smaller than the surrounding petals. Your paintbrush strokes begin smaller near the perceived center of your painted flower and grow larger as you move out. The eye accepts this as true to flower form. Watercolor does this very well through the PPP method, as we saw with creating your PPP daisies (page 98). Smaller, thinner brushstrokes draw your eye in and suggest a focal point of the flower. Longer, thicker brushstrokes suggest the expanding width of a petal.

INTERESTING WHITE SPACE BETWEEN BRUSHSTROKES

A rose may have forty-plus petals per flower, and these layers of petals give the form of natural fullness that we all love. The same is true for a peony. So how do you communicate that decadent, almost unruly, feel with watercolor paint? You need to use the white of your paper beneath the paint to communicate this depth. As you create petals near one another, leave interesting white space between each of your brushstrokes. The white space differentiating the petals takes on a life and purpose of its own and is key to every watercolor flower. Remember, you can create boundaries with water and the paint will stop where you place your petal boundary.

COLOR GRADATION

Flower petals are rarely one color. Even within a white flower, there are shades of cream or green, or even hints of blue-gray. Take our peony, for example: there's orange, magenta, pink, cream, and even some small hints of deep red-black at the center. These varying shades in color create depth within each petal. Using the wet-in-wet technique allows you to represent this beautiful variety by dropping in hints of other colors and letting the paint blend and mix and move.

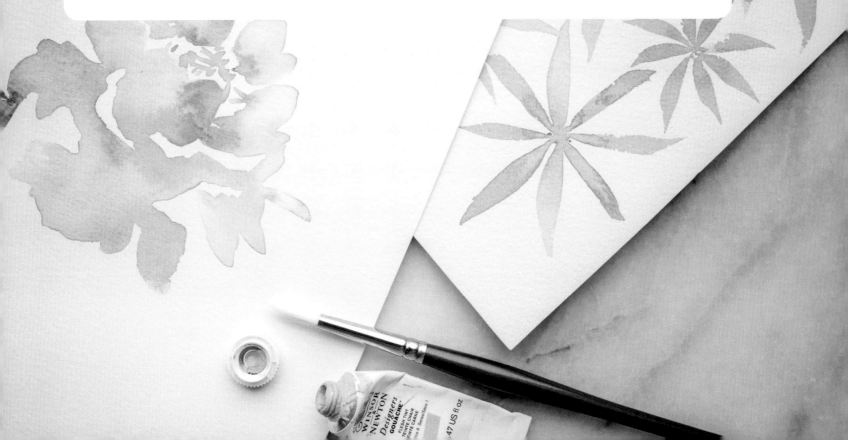

LOOSE LEAFY WREATH
ANALOGOUS COLORS

CONGRATULATIONS! YOU'VE COMPLETED THE FUNDAMENTAL lessons and are ready to start creating your botanical pieces. For the rest of the lessons, I've included suggestions on how to make each lesson simpler OR a bit more challenging. Everyone comes to the table with different skill sets, so I encourage you to sit down, read through the lesson you are going to paint, and decide which level feels best for you. Whatever level you work at, I know that once you've completed the lessons one by one, in order, your skills and confidence will improve. I am so excited to see your progress, and the beautiful art you create!

We'll start with one of my favorite botanicals—a wreath. Wreaths have become a way for me to relax and meditatively create without thinking too much. But, I remember that my first wreath took me over five hours to paint and was a source of much struggle and frustration. Now, I paint wreaths to warm up or calm down, and I often find myself returning to them as pieces of comfort. Be patient with yourself and try to enjoy the process. Practicing the techniques in this wreath will only help you watercolor more skillfully as you work through this book and beyond.

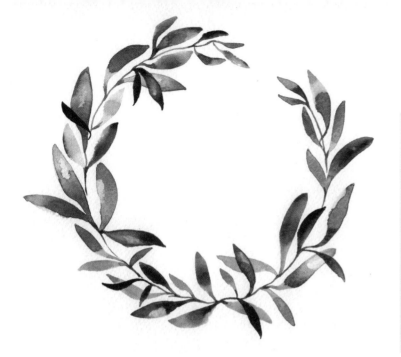

BEGINNER

- Trace the circle and the leaf shapes on the "Leafy Wreath" worksheet (page 201). Tracing the entire leaf shape can be considered optional, and thought of as "training wheels" for your eyes to teach you about compositional placement. They help train your eye to find where to add leaves, in what direction they should face, how much white space to have between each leaf, and where to overlap leaves.

ADVANCED

- Trace only the circle from the "Leafy Wreath" worksheet (page 201), which will become the vine you to which you add your painted leaves.

- Challenge yourself with a new color scheme!

TOOLS

- Round watercolor brushes, sizes 4 and 1
- 140-lb. watercolor paper
- HB pencil
- Traceable "Leafy Wreath" worksheet (page 201)
- Light source for tracing (a well-lit window or a light box)
- Tape (washi or drafting)
- Mason jar of water

PAINT PALETTE

PAYNE'S GRAY

COLOR RECIPES

SAGE
Viridian + Cerulean Blue + Yellow Ochre

PINE
Viridian + Cerulean Blue + Yellow Ochre + Lemon Yellow

TECHNIQUES

Point-pressure-point Wet-in-wet

Washes

TIPS FOR THIS PROJECT

- As you place your leaves on the center circle/vine, don't worry about painting the vine of the wreath and its connecting stems and branches until the end. Trace or paint your leaves around the penciled circle, and then we will add the stems connecting the leaves to the circle of the wreath at the end.

- As you place your leaves, do a few leaves on one side of the wreath and then switch to the other side. By alternating sides as you add your leaves, you will create compositional balance.

- Add a few leaves at a time, then pull back one or two feet from your work and observe. This will allow your eye to settle and find the right spot to add the next batch of leaves. Often, when we work close to the paper, it feels natural to just add a leaf in the next blank spot. It's better to step back and see where the next leaf is actually needed. You will find aesthetic balance in your work if you continue to pull back and assess your next steps as you go.

AS YOU BEGIN

- With your HB pencil and light source, lightly trace the forms you plan to use for this lesson onto your watercolor paper.

- When you trace the circle of the wreath, feel free to close it into a circle, or leave an opening at the top, a bit off to one side, as I've done in the photos. This lightly traced circle will act as a guide for you. Pretend it's a real vine of a plant that you're adding leaves to as you create your wreath.

- Once your center circle is lightly drawn, trace your leaf shapes, if you so choose.

- Ready your Mason jar of water and prime your brush.

- Create your painting palette with the paints and color recipes listed.

- Prime your palette with water; use your brush to transfer water from the Mason jar to the palette. Remember, you are mixing a sauce!

WATERCOLOR LEAVES

1 Use your brush to bring clean water from your Mason jar to your palette and create your 80w/20p consistency for all of the green colors you will use for your piece. Keep in mind that you will need to continue to reanimate the colors on your palette as you go in order to maintain the movement and shine you want to transfer to your paper.

2 Dip your brush in your Mason jar of water, then soak up your 80w/20p consistency of Sage and bring it to your watercolor paper. Start with a leaf near the middle of the circle—if the circle were a clock, I like to start at 8 o'clock.

3 Add your first leaf using the PPP method (see page 100). Begin at the outside point of the leaf and pull the shape down, increasing the pressure for the middle fullness of the leaf, and decreasing the pressure to create the slender stem. End your PPP leaf stem near the penciled circle line. You will eventually add a stem to attach the leaf to the circular vine. [A, B]

4 Find another spot on the opposite side of your circle to add another leaf. By popping around the wreath using a similar wash color, all of the leaves in one area will not be the same green wash. This way, when the piece is complete, the eye will register the pattern of analogous colors as they move around the wreath, giving the piece balance and a rhythm that guides the eye around the wreath with color. [C]

5 Remember, each leaf is its own boundary, its own tiny little painting. This is the dynamic stage when you are painting, as you need to make quick decisions for creating more interest and depth within your leaves. You can decide if you'd like to pick up a darker shade of paint and drop it into your leaf, to add a deeper pigment with the wet-in-wet method. Or, you can decide if you'd like to remove a bit of the paint by blotting with a paper towel to create a point of light on that leaf. You can also drop in a bead of clear wash water to create a little light point within your leaf boundary, and then use your paper towel to soak up that space using the waterdrop method (page 52).

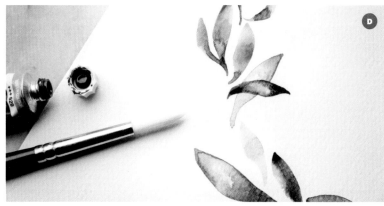

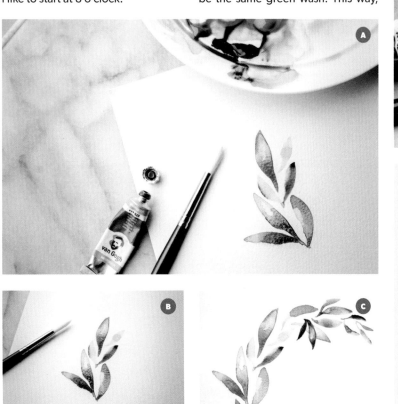

WATCH YOUR WATER

Are your leaves flooding into biodomes? It can be tricky to find the right balance of water to paint for this piece. You want enough water to allow the paint to move on your paper within its wet boundary, but not SO much water that every leaf is threatening to overflow. And you don't want to overuse your paper towel, which can give a bleached-out look in your final piece because you prevent the paint from fully settling into the wet boundary, losing a lot of your painting work. If you were to tip your paper, would all of your leaves flood out of their boundaries and head down the page as raindrops? Then you're using just a touch too much water. Bravo for getting water onto your paper, but be aware that with smaller leaf boundaries, like the leaves on this wreath, using a little less water will give you the movement and shine without a biodome.

Both the adding and removing of pigment creates depth on each leaf boundary, and by mindfully giving each leaf its own character, you add to the richness of your final piece. [D]

6 As you move around your wreath, you will use different colored washes from your green palette for the different leaves. You'll see that I placed a darker leaf near my lighter-washed leaves. I am still using the same paint duo of green colors, but I have mixed in the deeper shade of Payne's Gray on my palette. [E]

7 You also want your leaves to have generally the same shape but be different lengths and widths. This indicates a pattern to the eye and is aesthetically pleasing. Consistently shaped leaves indicate that it's a wreath of olive tree branches or sage bush branches. Wreaths made up of different leaf shapes and colors can be very beautiful, too, and work best when you choose three or four shapes and repeat them throughout the circle.

8 Avoid having all your leaves pointing up or all pointing down. If you happen to be observing a live branch, you'll notice that there is a natural symmetry, but leaves move in the wind, grow in odd angles as they follow the sun, or are connected at different angles than their sister-leaves next to them. By angling your leaves differently around your wreath, you're mimicking nature. Also, while observing a branch in nature, note that new growth is generally near the end of the vine. Use a Round 1 brush to create smaller leaves that echo the shapes of your larger leaves, using the same PPP method.

9 As you paint around your wreath, continue to reorient your paper. You are not on a solid plane—you can move your paper upside down if you need to in order to best utilize the point-pressure-point method of pulling your brush down toward you.

10 It's nice to leave interesting white space between leaves. Leaving smaller or larger white spaces allows you to give the eye a pause, or rest, between areas of color. Notice the two wreath examples shown here. One has large white spaces and fewer overall leaves, and the other is the opposite. Both are lovely, but different. [F, G]

11 Overlapping a few leaves here and there also imitates nature. To achieve this effect, make sure the base leaf boundary is completely dry and use the wet-on-dry method (page 53). Once you're sure your first leaf is dry, painting a darker leaf over it will give you the natural overlapped look without any blending of boundaries. [H]

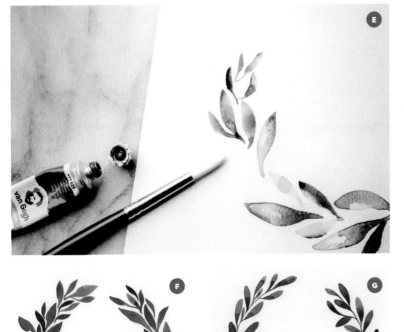

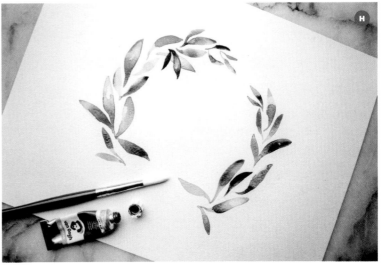

VINE & STEMS

1 Once you've added all of your leaves, it's time to paint your vine and attach your vine to your leaves with small stems. Use your Round 1 for this delicate task. Be aware of wet areas on your piece, as you don't want to smudge your leaves with your hand as you work.

2 Load up your Round 1 brush with just the 80w/20p mixture of Sage from your palette. If you find that the 80w/20p consistency is a bit too wild and uncontrolled for your taste on these small boundaries, bring more paint to your palette to take the consistency closer to a 50w/50p "heavy cream" mixture. Load your brush with your paint mixture and bring it to your watercolor paper. **[A]**

3 Choose the bottom tip of one leaf and paint a thin line to gently connect it to a sister leaf or to the vine. Work slowly, rotating your paper as you connect leaves to stems to vine. In some places, the most natural way to paint the vine is by following your penciled circle. In other spots, leaves overlap the vine and you'll need to use your eye to discern the next natural connection point. **[B]**

4 Step back and enjoy your piece! Wait a few hours (I wait overnight) to let everything dry; then you can go in and erase any pencil lines.

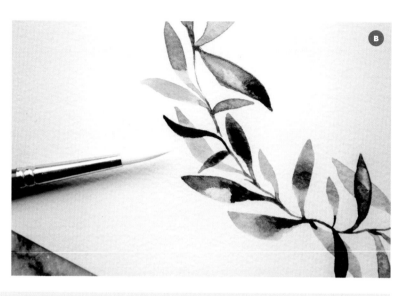

SMOOTH & ROUGH EDGES

As you use your PPP method, sometimes the paper texture will come through in parts of the leaf, or along the edges. This is a sign that your brush is running out of your water-and-paint sauce. On some leaves, I enjoy this texture and I leave it. On others, I go back to my palette, pick up more of the 80w/20p mixture from my palette, and add a second wash to this original leaf boundary to smooth and blend hard edges.

To achieve smoother lines, add water. To make rougher, textured strokes, use less water.

Alternating between leaving some leaves with the paper texture showing and others with a smooth-edged wash is another way to add dimension to your painting.

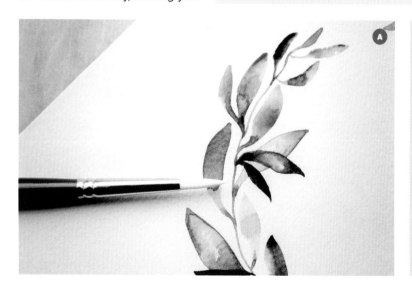

FIXING BLOBS

Don't panic if you overlap leaves and your perfect leaf lines begin to bleed, and your two lovely leaves start to turn into one giant blob. Grab your paper towel and try to soak up as much paint and water as you can from both leaves. Move on to other parts of your wreath until the leaf blob has dried.

Once the leaf blob is really dry (be sure this time!), use PPP to add another wash of watercolor to the base leaf. You will get your hard lines again. And once this leaf is really dry, go ahead and overlap with a darker wash. People often try to fix their mistakes while the problem area is still wet. This just leads to problem areas getting bigger and bigger, since water will continue to move the paint. The best thing to do is sop up as much paint and water from a mistake as possible and wait until things are completely dry to repaint.

CREATE, FOR THE JOY OF IT

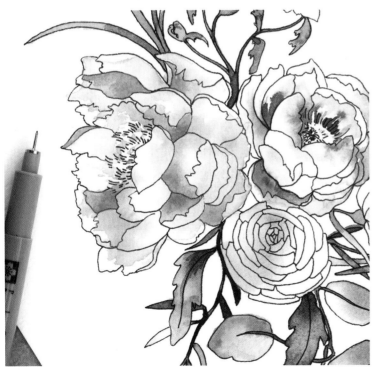

AS GOOD AS IT MAY FEEL TO SELL A PIECE OF YOUR WORK OR TO GET SOME solid "likes" on social media, I am here to tell you that the accolades and praise you receive for your work will not be enough to keep you creating. The worth of your art, and your journey as an artist, are not defined by other people's opinion or measurement of it. If you love to create, there is a fountain deep inside of you that must flow wildly free. A wellspring, as I like to say, that needs to be expressed.

Think about the great artists throughout history. Many of them did not sell many pieces of work during their lifetime. Some were even ridiculed, yet they persisted because they simply had to create. They showed up for the day with brush in hand because the work demanded to be created. They were essentially a channel and had to bring something new into the world, acknowledged by others or not. Van Gogh, El Greco, Vermeer, and so many others—they each have a unique story to tell.

So often, we allow busyness to consume us. We allow it to be our excuse to not create. Work harder, work more. Achieve. But in our efforts to do, what if we forget that we are meant to grow and evolve, to become? If you lose track of who you want to be . . . pause, breathe, and look at the path you are on.

Create something for the joy of it—for the thrill of seeing something come from your hands, a shape or color that would not exist but for you. Paint for the joy of moving your paint with a brush. To pursue a passion, to feel a deeper purpose, to create rather than consume. This is why we paint. Pause in the busyness, and you will find time to make something the world needs from you, and simultaneously, you refuel your soul. This is a path worth traveling, even if it's "just" something you do on the side. Work with your hands, open the channel of creativity, and let it flow.

This is your journey. Embrace the learning process: the awkward shapes, wobbly lines, and the frustrating gaps between what your mind sees and what you paint. You are growing. You are creating. ●

PALM FRONDS
SINGLE LAYER

WELCOME TO THE LESSON OF THE PALM FRONDS! I DESIGNED this watercolor plant to practice the immediacy of watercolor, and to celebrate its transparent capabilities. We will use the point-pressure-point (PPP) stroke, incorporate some stunning green colors, and see the beauty of the glazing technique as we overlay one frond, and then another. I would invite you to return to these loose and rhythmic leaves again and again, even after you've completed this lesson through the Beginner, Intermediate, and Advanced challenges. The shaping of these leaves and the structure of the plant lend itself to such an enjoyable process. Repeating the longer leaf brushing with the point-pressure-point stroke that we've been practicing only encourages you to get better with watercolor and to find your repeated pattern of movement with your own brush.

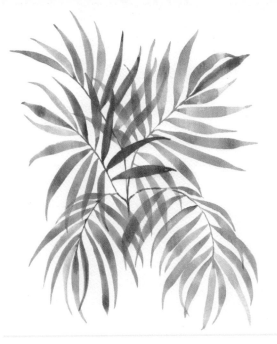

TOOLS

- 140-lb. watercolor paper
- Round watercolor brush, size 4
- HB pencil
- Traceable "Palm Fronds" worksheet (see page 203)
- Light source for tracing (a well-lit window or a light box)
- Tape (washi or drafting)
- Mason jar of water
- Scrap paper for testing strokes

PAINT PALETTE

PAYNE'S GRAY **YELLOW OCHRE**

COLOR RECIPES

SAGE
Viridian + Cerulean Blue + Yellow Ochre

PINE
Viridian + Cerulean Blue + Yellow Ochre + Lemon Yellow

TECHNIQUES

Point-pressure-point Washes

TIPS FOR THIS PROJECT

- Pause to observe as you paint, allowing your eye to balance and find the right spot to paint additional leaves. Even if you use leaf markers to help with spacing, this exercise trains your eye to see natural shapes and where positive and negative spaces complement; over time, you will learn to find that aesthetic balance in your work.

- The boundaries of each leaf of the fronds will remain wet for only a short period of time, so there is no need to worry about dropping in wet-in-wet. These fronds are ONE WASH ONLY!

- You will paint quickly by laying down a light wash that slightly varies in color, based on the pigment you have picked up before each leaf creation. Be sure to complete this piece with the fluid motion of point-pressure-point as one wash.

- This lesson teaches the fluidity of the point-pressure-point technique, and that once a leaf is down, it is down. Move quickly, and without looking back.

- Remember, you are learning, so give yourself grace and the time to build your skills.

BEGINNER

- Trace the palm frond stems and the small line to indicate where the next frond should be painted. Make a small dot to indicate where the end of each leaf should fall; this will help you know how long to use the point-pressure-point method for each leaf. You may also wish to lightly label each palm frond (like on the tracing sheet) to more easily follow the order.

- If you are new to watercolor, you may wish to select just one color from the palette. Explore the variety of pigment within that color as you paint your leaves.

ADVANCED

- For more experienced artists who are comfortable with a greater level of difficulty, consider letting your eye guide you to place the leaves and fronds, rather than relying on tracing. You may even wish to "plant" your palm fronds in a decorative pot! You may also want to mix your own palette of colors. For a tropical twist, add some blush, deep viridian, or a beautiful sky blue.

AS YOU BEGIN

- With an HB pencil or a light green colored pencil and light source, lightly trace the center lines of each palm frond onto your watercolor paper. The lighter you trace, the easier it will be to erase any pencil lines you don't paint over.

- Once your center stems are drawn, use an HB pencil to lightly label each palm frond 1 through 5 as they are on the tracing sheet, so you can follow the painting instructions easier. Then you can erase the numbers when you're all done!

- Ready your Mason jar of water and prime your brush.

- Create your painting palette with the paints and color recipes listed.

- Prime your palette with water; use your brush to transfer water from the Mason jar to the palette. Remember, you are mixing a sauce!

PALM FROND 1

1 Before you begin your PPP fronds, feel free to use scrap paper to test a few strokes and check the colors that are animated on your palette. Once you feel confident in your colors and form, it's time to begin! We begin painting each frond at the end of the stem and work our way into the center of the plant. **[A]**

2 Dip your brush into your water, then into the green wash mixture of your choice, and bring your brush to the paper. Using the PPP method, lightly press the point of your brush to the spot on the paper where the frond connects to the stem. Increase the pressure on your brush as you pull down, creating a long, slim center for the frond. Complete your continuous and fluid stroke by decreasing the pressure on your brush, just accessing the point of the brush, and then lift the brush from the paper. Voila—you have the first leaf on your first frond! As you paint each frond, don't worry about painting the stems in just yet. We are going to paint each of the leaves on one frond, paint its stem, and then move onto the next frond.

3 Do you like the color, texture, and consistency of your leaf? If not, use practice paper and fill it with point-pressure-point frond leaves until you feel ready to make a mark on your project. If yes—let's keep going!

4 Add the next two leaves. In the picture, notice that these are a bit lighter in color than the first leaf. When I went back to my palette, I rubbed my brush in the mixture closer to the Yellow Ochre for a more yellow tone. I curved the third leaf slightly and ended the PPP motion of this one in the still-wet boundary of the first leaf. This provides a little interest without creating a blob, but still mimics real-life palm fronds. **[B]**

5 Use your PPP motion to complete all of the leaves on Frond 1. Move back and forth on the Frond, alternating sides as you paint. I tend to move my paper and angle it toward me, so I can access PPP, always pulling down.

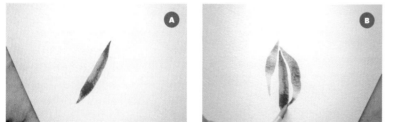

BRUSH: Round 4 **PAINT CONSISTENCY:** You'll pull paint out of the leaves to create the stem

STEM

1 To create a very thin stem, use very light pressure (accessing just the point of the brush) to lightly drag a bit of the wet/drying paint from the most recent leaves to connect them to the stem, and then to the surrounding leaves. I like to create a thin stem at this point, rather than wait until the very end. Since these palm fronds do not have as much variance in color, a stem painted at the end tends to show up more boldly. By slowly dragging a touch of pigment out of drying leaves, you continue the frond naturally down to the base. **[C]**

WATER CHECK

Check to see if any excess water or biodomes are forming within your leaves. If so, lightly press the corner of a paper towel into your biodome to lightly "vacuum" up excess water. By ridding your leaf of this excess water, you ensure that the outside boundary lines will be smooth once dry.

Another common problem at this point is "rough patches" where the paper breaks through and affects the shape and hard lines of your leaf. This is a sign of not enough water on the brush. Now, some people really enjoy this variance, but if you want a fuller, richer leaf shape, try soaking your brush in a Mason jar. Ensure the brush is primed and thoroughly soaked by pressing it from side to side (see page 22). If you use a toothier paper, like Arches, your blending will be better within the leaf boundaries, but you may need a bit more water to ensure smooth edges.

PALM FROND 2

1 Reorient your paper as you begin to paint the tip of Frond 2. [A]

2 Pause and assess. How do the colors of the first palm frond appear as they dry? If you want lighter colors, add more water. If you want bolder leaves, mix more paint into your "soy sauce with wasabi" mixture. (This is a good time to check that you have enough water remaining on the palette to fluidly paint another frond.) [B]

3 Start from the tip of Frond 2 and begin to paint your leaves. [C]

4 Just like on Frond 1, add a very light stem as you bring the leaves close to the center of the palm plant. [D]

5 As you add leaves, take care to keep white space between your leaves to avoid a leaf blob. By decreasing the length of your leaf with a shorter PPP motion, you can trick the eye into thinking that the leaf is shorter and thus farther away, or perhaps at a different angle. Because this is smaller and closer to the center of the plant, it makes the longer, larger leaves in the forefront of the painting "pop" and appear closer. This gives depth and perspective, adding visual interest. [E]

6 Overlap a new wet wash of Frond 2 over the dry washed leaves of Frond 1. To tell if the leaves of Frond 1 are dry, lightly move the paper around and look for the shimmer and shine of a wet wash. If the leaves of Frond 1 are still shiny, make yourself some tea or stand up and stretch—be sure to let that first frond dry until there is no longer any shine before you paint another layer. Once dry, add the leaves of Frond 2 over the top of the leaves of Frond 1. One of the key characteristics of watercolor is translucence, so you will see the ghost of Frond 1 beneath Frond 2. Much like a real palm frond when the sun shines behind it, and you see the shadows of the background sister-leaves darkening the color of foreground leaves. [F]

7 Note that the very end of Frond 2 is primarily stem. This is the connection to the base of the palm plant, where all of the fronds "grow" from. Keep this bit of stem open on Frond 2 as well. Remember, it will get crowded as you begin to add leaves on the other fronds.

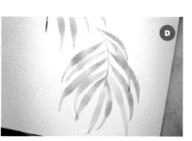

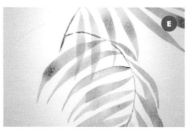

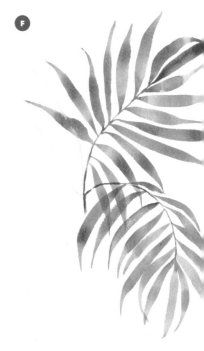

PALM FROND 3

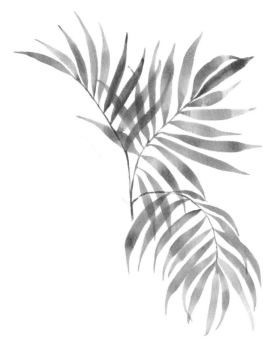

1 As you can see, this frond is unlike the others; it is at an angle, with the leaves reaching up. I painted this frond to show a side view; you will only paint one side of the frond.

2 Begin Frond 3 like the others, starting at the tip of the frond and working your way in. Since the leaves of Frond 3 overlap those of Frond 1 and you know they are dry, you can continue your PPP leaf creation almost all the way down the stem.

3 Note that the very end of Frond 3 is primarily stem too. It's always easier to *add* extra leaves to a frond at the very end of the piece if it looks a little sparse, but you can't take them away! Err on the safe side and give yourself plenty of stem to work with.

4 By nature, palm fronds are somewhat sparse, so leave room for the "light" to come through.

PALM FROND 4

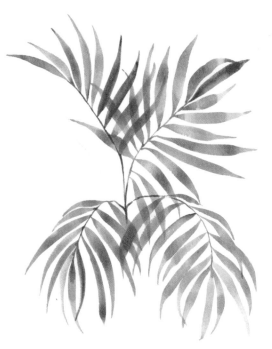

1 As Frond 3 dries, move to Frond 4. Since Frond 2 is already dry, you should have no problem overlapping leaves here. Begin Frond 4 just like the others, starting at the tip of the frond and working your way in. Notice that here, I used a bit more Payne's Gray to add some variety to the leaves. You can add interest in your "green" paintings by working in analogous colors that complement the green.

PALM FROND 5

1 Begin this frond like the others, starting at the tip of the frond and working your way in. [A]

2 As you work downward and place your final leaves, be mindful of your placement and color choices. These are your final PPP motions! Notice that the stem of Frond 5 connects into the stem of Frond 4; to emphasize this, I left a bit of white space at the connection point. [B]

3 Once you've connected the final stem of Frond 5, you're all done!

- This project is an excellent exercise in patience, as it requires steady, fluid point-pressure-point strokes. One could spend days (years, really!) perfecting this stroke and mastering how to achieve a balance of interesting white space. Remember, each plant has its own definitive leaves and flowers, as well as distinctive spacing where the leaves connect to the stems and interact with surrounding parts.

- Observe the positive and negative space in your favorite plant. Identify easily recognizable characteristics (red juicy fruits or long, lean leaves; clover-shaped flowers or spotted stems) and the plant's white space. The more you observe botanical forms in nature, the more true to form your watercolors will become.

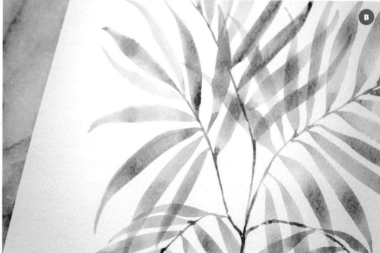

SEEKING MOMENTS OF JOY

HOW DO YOU MOVE PAST FEAR AND INTO A PLACE YOU CAN CRE-**ATE FREELY?** For me, the answer is to look for joy in each day.

I've learned to savor and look forward to small moments of happiness throughout my day—a new iris bloom ruffling her petals, the way our white bedroom curtains sway in the afternoon breeze, dreamy and slow, the cool dirt around my toes as I water the garden at dusk. Milky tea brewed to perfection. Hearing the waters of the lake lap rhythmically at the shore. Small, gentle moments that fill me with peace, joy, and inspire me to be.

Painting feels like an almost decadent act, especially on busy days. Chores pile up and there are important tasks that must be done. But it is equally essential to seek joy amidst life's endless requirements, to find ways to feed your soul. I like to look for those small moments of joy within the fabric of everyday life and fit them in where I can. I may step over baskets of laundry waiting to be folded or fail to sweep my kitchen floor as often as I should, but it's worth it to me to make time for the small joy of watching wet colors swirl on my paper.

When we have eyes for the beauty surrounding us, we add something of value to our life that tends to break the spiral of fear, frustration and resistance. Finding joy in our everyday life begins a new cycle that inspires and beckons us to create—to express ourselves and share the beauty we are seeing and feeling.

These moments when I create space for beauty—for me, gardening and painting—are what make my days feel full and good. I experience quiet. Calm. Peace of mind. Reflection.

How do you experience joy? Joyful moments in our day are not superfluous; joy is what makes the moments of our life count. The drive toward joy is the drive toward life. ●

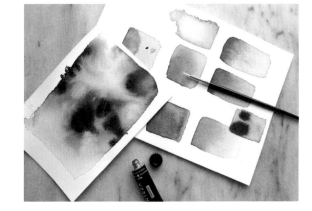

> **"If you hear a voice within you say 'you cannot paint,' then by all means paint, and that voice will be silenced."**
>
> **—VINCENT VAN GOGH**

LOOSE PEONY

ANALOGOUS &
COMPLEMENTARY COLORS

LOOSE, FLOWING FLOWER PATTERNS—PEONIES AND PETALS AND dark, contrasting leaves . . . oh my! As we have learned, watercolor painting is like a dance between the artist and her work, taken one fluid step at a time. Creating a continuous piece like the one in this lesson allows you to play with timing as you mix your magic sauce and incorporate your wet-in-wet method, adding pops of color to make each flower unique. This lesson is also a wonderful way to experiment with wet and drying boundaries, playing with consistency and learning when you can still add a bit more paint, and . . . when you should walk away and let the paint dance itself out on your page!

TOOLS

- Round watercolor brushes, sizes 1 and 4
- 140-lb. watercolor paper (preferably Arches or Hahnemühle cold press)
- Colored pencils, in blush and gray
- Traceable "Loose Peony" worksheet (page 205)
- 2 Mason jars of water
- Paper towel
- Tape (washi or drafting)
- Light source for tracing (a well-lit window or a light box)

PAINT PALETTE

PAYNE'S GRAY **YELLOW OCHRE** **PEACH**

CRIMSON

COLOR RECIPE

BLUSH
*Crimson + Yellow
Ochre + Peach*

TECHNIQUES

Wet-in-wet Blotting

Wash PPP
 Point-pressure-point

AS YOU BEGIN

- Determine whether you will be tracing the flowers as I've laid them out or, if you'd like, arranging and placing them in your own artful composition.

- If you are tracing, tape the traceable to the watercolor paper. This allows you to move the papers as one piece as you trace your lines.

- Use a light source, such as a window or a light box, to view the traceable design through your watercolor paper as you trace.

- With your blush colored pencil, lightly trace the floral lines onto your watercolor paper. The lighter you trace, the easier it will be to blend the lines into your paint as you wash over them.

- Now, using your gray colored pencil, and referencing the design, identify and trace the leaves, stems, and stamen (the small central elements of a flower) of your piece.

- Prime your brush and ready your Mason jars of water.

- Prepare your painting palette by reanimating the Blush recipe on your light palette, adding extra dabs of paint as needed.

TIP FOR THIS PROJECT

- As you trace and paint, remember that you are not on a solid plane. Continually turning your piece's orientation will allow you to access different angles of your art and keep your brush marks strong. It will also help you avoid running your hand through wet paint!

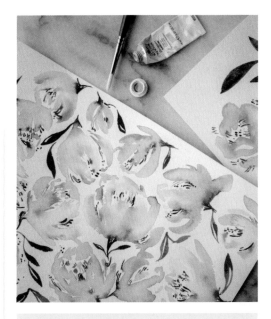

BEGINNER

- Trace the design lightly with colored pencils—a light blush for the petals and a light gray for the supporting foliage—so you're not worried about drawing the shapes as you are painting. Approaching this lesson as a Beginner and using the tracing sheets allows you to focus on creating the right consistencies for blending your watercolors. Concentrate on the consistencies and blending, and use my guides as your lines.

ADVANCED

- Study the design with your artistic eye, and begin to create the shapes in paint only—without tracing the designs beforehand. Let your hand translate what your eye sees onto your paper, creating your own designs. Also, if you'd like a further challenge, create a complementary color scheme of your own. Test out your colors on some scrap paper, using the recipes we have created in Lesson 3. Review what we learned about finding triadic colors, or use analogous color harmony for your flowers and a neutral (like Burnt Sienna or Payne's Gray) for the foliage. Perhaps a Blue-Violet-Red color scheme would be stunning as a darker version of this design.

LARGE BLUSH PETALS

1 Use your brush to bring clean water from your Mason jar to your palette and create your 80w/20p consistency of Blush.

2 Once your Blush paint recipe is primed and ready, rinse your brush in the Mason jar of clear water and load up the bristles for your clear water wash.

3 Bring your brush to your watercolor paper and fill in your first large flower boundary with a clear wash, working from left to right, and using your paintbrush to lightly "scrub" the paper texture in a back-and-forth motion. [A]

4 Once your first flower has a nice sheen, it's time to add your Blush paint recipe. Bring your brush to your palette and load it with your 80w/20p Blush mixture. [B]

5 Take your fully loaded brush to your wet flower boundary, using the wet-in-wet method to drop in the Blush at different points of the flower—both the edges and where the lines intersect. Let the color bleed out, creating its own masterpiece within your flower shape. [C]

6 As you watch the paint move and bleed within your watery boundary, pick up your Round 1 brush, prime it with water, and bring some water over to animate the pure pigment colors of Yellow Ochre, Peach, and Crimson on your palette, in order to drop in some additional color. Aim for a 50w/50p consistency, which works best for dropping in pigment with the wet-in-wet method.

7 A lighter point will naturally form within your petal, usually near the large center area, depending on how much paint color you add to the edges and points of your flower. You can accentuate this light point by using one or a few of the blotting methods you learned on page 50. By blotting your paper towel in the center of your petal or using the waterdrop method to increase the light spot on your petal, you'll accentuate the light point and add more interest to your petal.

8 You can also add a clear waterdrop (see page 52). Depending on your timing, the clear waterdrop will simply diffuse the paint color where you drop it in or, if your petal has begun to dry, the waterdrop will create a watercolor bloom within the petal as the water encounters the drying Blush paint.

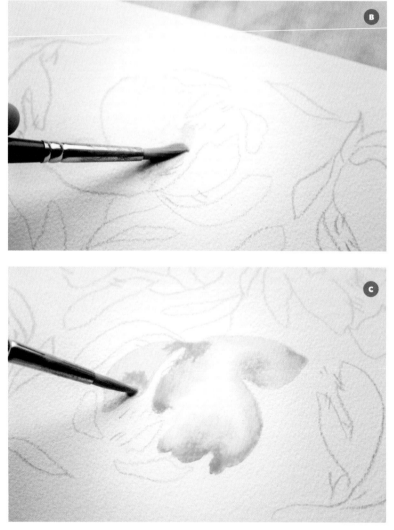

LEAVES, STEMS & STAMENS

1 We are going to begin with the smaller stamping marks in the centers of the flowers, the stamens. Prime your Round 1 brush with water. Mix your Payne's Gray paint on the palette, bringing in more paint from your pure paint dab to move toward the thicker 10w/90p "mustard" consistency.

2 Paint the fine lines of the stamen, dragging your Round 1 from the white watercolor paper into the wet Blush petal boundary. Blending these boundaries will cause some bleeding and veining. [A, B]

3 Use your brush to bring clean water from your Mason jar to your palette and create your 50w/50p "heavy cream" consistency of Payne's Gray. Because you'll be working within small boundaries for your leaves and stems, you want a thicker consistency for these steps, but with a bit more movement and shine, since the leaves are larger than the flower stamens.

4 You can use a Round 1 or 4 to fill in this boundary, depending on how comfortable you are with the shape. A smaller brush will give you more control, but it will take longer to fill the space.

5 Bring your loaded brush to your watercolor paper. Using the side-to-side motion of your brush, fill in the stem boundary, allowing the Payne's Gray to come into contact with your still-wet Blush petal boundary and bleed together. [C, D]

6 Using the PPP motion (see page 100), paint your leaves. [E, F]

7 You will continue painting the petals, stems, leaves, and stamens of each flower following the previous steps.

8 Remember to pause and take the time, while the petal is still wet, to make each one a little painting masterpiece. Drop in color with the wet-in-wet method, nudge the colors around with a damp brush, but ultimately let the water do the work of moving the paint for you. You are only suggesting where color should be as you drop in Blush in one spot and Yellow Ochre in another, but the water will move the paint within each boundary.

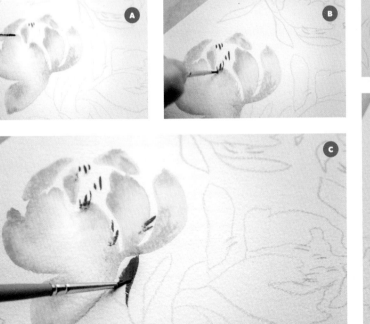

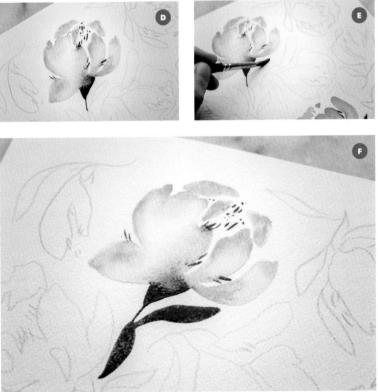

FLORAL BOUQUET
LAYERING &
COMPLEMENTARY COLORS

LESSON 10

IN THIS LESSON, WE'LL COMBINE OUR WET-IN-WET FLOWER-blending skills with our point-pressure-point leaf work to create a bouquet—and bring our skills and a complementary color palette together. We will also play with adding a new playful element—berries! Notice the triadic color scheme and the balance of using blush, yellow ochre, and pine green, and how lovely they look together. Within the petals of our main flowers, the colors are analogous and naturally flow together, much like you'd witness in a real-life flower from the garden. Watercolor is such a perfect medium to capture the variegated beauty in a petal, and by creating the magic sauce on your palette first, and using your brush to gently drop in color, you are merely suggesting where this or that color might be pretty. Remember to not overwork your piece. If you wonder if a petal is done or needs more color, I find it's usually better to leave it and let it blend and dry at that point. Learning to walk away and let the paint do its thing can be the biggest challenge—but it often rewards you with surprises as it dries!

TOOLS

- Round watercolor brushes, sizes 4 and 1
- 140-lb. watercolor paper
- Colored pencils, in blush and gray
- Traceable "Floral Bouquet" worksheet (page 207)
- Light source for tracing (a well-lit window or a light box)
- Tape (washi or draft)
- An inspiring cluster of real flowers from your garden or the market
- 2 Mason jars of water (one for light colors and one for dark colors)
- Paper towel

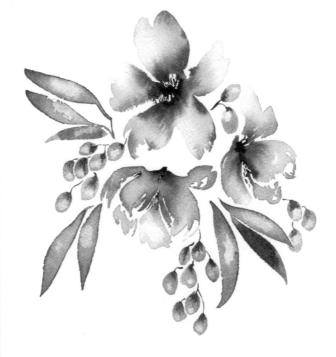

PAINT PALETTE

PEACH **RAW UMBER** **CRIMSON**

YELLOW OCHRE **PAYNE'S GRAY**

COLOR RECIPES

PINE
Viridian + Cerulean Blue + Yellow Ochre + Lemon Yellow

BLUSH
Crimson + Yellow Ochre + Peach

MAUVE
Yellow Ochre + Peach + Violet

TECHNIQUES

Point-pressure-point Wet-in-wet

Wash

TIPS FOR THIS PROJECT

- Flowers done in this airy, modern style are QUICK. You need to make decisions while everything is wet. Your strokes also need to be minimal. Too much fussing and touching of your flower petals can actually interrupt the fluidness of your watercolor.

- Take a moment now to turn to page 105 and review the three observations of Flower Shaping.

AS YOU BEGIN

- Tape your papers together to secure your watercolor paper to your tracing sheet. This way, you can move and reorient your paper while tracing without having to realign the marks every time.

- Use a light source, such as a window or a light box, to view your traceable design through your watercolor paper as you trace.

- Using your colored pencils, lightly trace your botanical shapes onto your watercolor paper. The flower shapes with dotted lines signify those that you will paint in a light palette, so be sure to use your light blush colored pencil to trace the dotted lines. Trace the rest with your gray colored pencil.

BEGINNER

- Trace the design lightly with colored pencils—light blush for the petals and berries and light gray for the supporting foliage—so you're not worried about drawing the shapes as you are painting.

ADVANCED

- Try not to trace beforehand; use your eyes to soak in the image and then freehand with the paint.

- Try a different flower shape, perhaps a daisy or a rose.

- Try a new color palette! Perhaps a different combination of analogous colors within the flower petals. For example: Mauve, Violet, and Blush. Or mix up the color scheme completely and perhaps try a Buff Titanium flower with petal tips of Blush/Magenta.

- Play with your boundaries: try painting more flowers, overlapping more petals, adding more berries and leaves.

- Play with the timing of your wash vs. your wet-in-wet additions, learning more control as your paint is slowly drying.

FLOWERS: WASH

1 Use your brush to bring clean water from your Mason jar to your palette and create your 80w/20p consistency of the Blush and Mauve color recipes. These flower petal boundaries will be light and airy, and you will add interest and dimension with Blush and Mauve, as well as the many colors and tones that make up these color recipes.

2 Rinse your brush in the Mason jar of clear water and load up the bristles for your clear water wash.

3 Bring your brush to your watercolor paper and fill in your first petal boundary with a clear wash, working from left to right and using your paintbrush to "scrub" the paper texture in a back and forth motion until your first petal shape has a nice clear and shiny sheen. [A]

4 Next, bring your brush to your palette and load it with your 80w/20p Blush recipe.

5 Take your fully filled brush to the wet boundary of your petal and use the wet-in-wet method to drop in the Blush color at different points of the boundary—around the edges and in parts in the center of the petal. [B]

6 It is important to work quickly as you fill your petal boundary with color, so you can create seamless gradations of color within your petal.

7 Next, bring your brush to your palette and load it with your 80w/20p Mauve recipe.

8 Take your fully filled brush to the wet boundary of your petal and use the wet-in-wet method to drop in the Mauve color at different points of the boundary. [C]

9 Don't worry too much about the colored pencil lines; view them more as guidelines to help you leave interesting white space between petals and layers. Some of your colored pencil lines may show through your paint, depending on how lightly you traced and how much paint you add to your petal. Don't worry about these—we are aiming for progress, not perfection! If you do see the lines you traced after you've painted over them, next time try tracing a bit lighter and they will blend in more easily with your paint.

10 Complete the rest of the flower petals by following the previous steps, being sure to drop in your complementary colors with the wet-in-wet method while your boundaries are still wet.

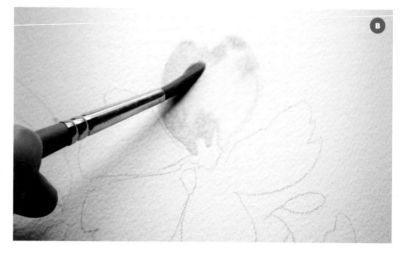

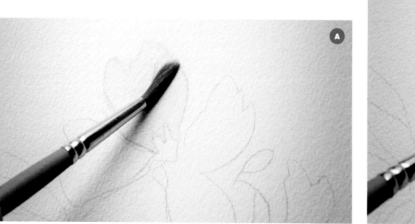

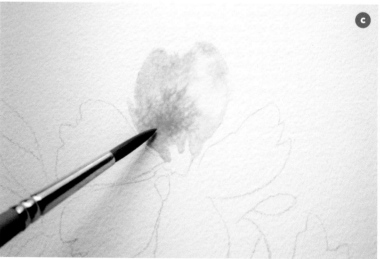

FLOWERS: WET-IN-WET

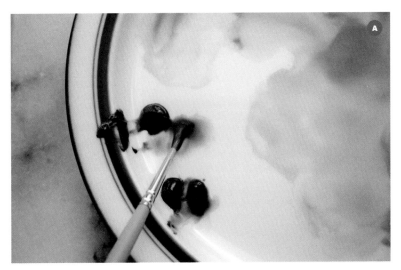

painted these darker colors last, there will be less movement in their wet-in-wet effect, as the wash on the petals is beginning to dry. This will ensure your petals keep their light Blush hues, while still blending with the center stamens.

4 Now it's time to add the color gradation that will be unique to every petal in your flower.

5 Dip your brush in your Mason jar and use it to add more water to the pure paint color dabs of Payne's Gray, Yellow Ochre, Crimson, and Peach on your palette until you have a 50w/50p consistency.

6 Be mindful of your two Mason jars, keeping them separate as you dab colors of light, then dark, into your petals.

7 In this petal, I dropped in Payne's gray, Raw Umber, Mauve, and a touch of Peach while

the boundary was still wet. [C]

8 These colors will become little fireworks within the petal boundaries, mixing amongst themselves, making each petal unique and one of a kind.

9 With a small paper towel, or a thirsty brush, you can use the blotting method to lightly blot out the color or excess water. I tend to add colors to the borders or corners, and or lift or blot away from the centers of the petals. But remember, the less you touch these minimalist flowers, the better. Let them do their watercolor thing. [D]

10 Here is where you can hide your colored pencil tracing lines, in case a few are still showing through, by saturating any visible lines with paint as you work wet-in-wet. [E]

continues on next page

1 Dip your brush in your Mason jar of water and bring it to your palette to create a 50w/50p consistency of Raw Umber. [A]

2 Pick up the mixture with your brush and bring it to the wet boundary of your first flower. Use just the point of your brush with the lightest pressure to create small downward, delicate marks. Because the petal boundary is wet, the Raw Umber will blend, running up through your petal. [B]

3 Make delicate, short lines starting from the dry white paper center and moving into the petal, flicking them gently toward the wet petal boundaries. The dark colors will begin to bleed and blend into the light petals. Because you have

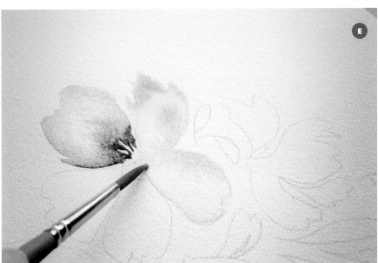

11 As you paint each flower, follow the previous steps to paint your petals. Experiment with washing multiple petals at once to see what the timing is like as they dry. [F, G]

12 For this flower, I washed the entire boundary (all three petals) with a clear wash of water, and then used the wet-in-wet method to drop in the extra colors. [H, I]

13 For this final flower, I washed the first half in clear wash, and then used the wet-in-wet method to drop in colors. I quickly washed the second half of the flower, and continued the wet-in-wet coloring, then used a paper towel to blot excess color and water out of the centers of the petals. [J–M]

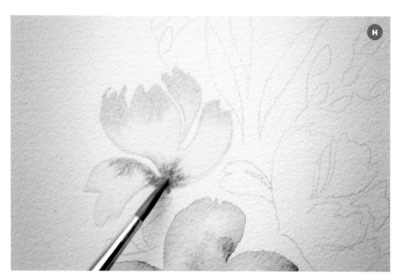

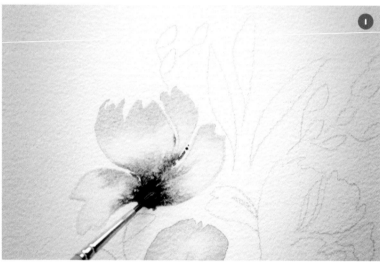

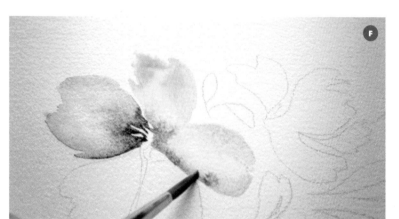

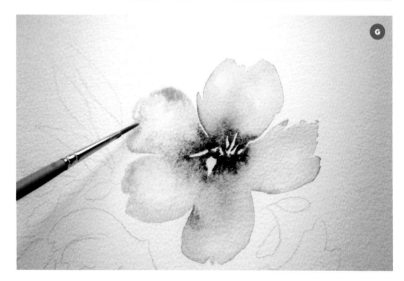

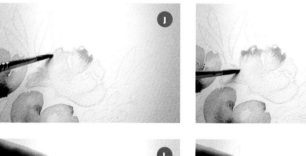

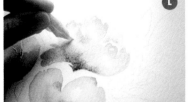

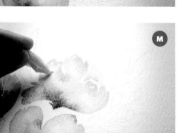

BRUSH: Round 4 **PAINT CONSISTENCY:** 50w/50p "heavy cream," moving toward 80w/20p "soy sauce with wasabi"

WATERCOLOR LEAVES

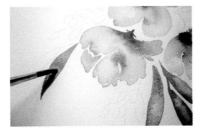

1 To paint your long, slender leaves, use your Round 4 paintbrush to add more water to your Pine recipe on your palette until you have a consistency of 50w/50p, moving toward 80w/20p.

2 Bring your loaded brush to your watercolor paper. Using the point-pressure-point technique, pull down your paint in a fluid motion to complete your leaves. Add your dark points of wet-in-wet color and your lighter blotted spots while each leaf is still wet.

BRUSH: Round 4, Round 1 **PAINT CONSISTENCY:** 50w/50p "heavy cream," moving toward 10w/90p "mustard"

WATERCOLOR BERRIES & STEMS

1 To paint your berries, use your Round 4 brush to bring water to the pure Yellow Ochre paint on your palette and mix until you have a consistency of 50w/50p. Do the same for your Raw Umber. I use my larger Round 4 to bring water to my palette, and then switch to a Round 1 to actually paint the berries for better control. Load your Round 1 with your 50w/50p mixture of Yellow Ochre.

2 Bring your loaded brush to your watercolor paper and paint in the oblong round berry shapes. I like to paint them in small clusters, completing the Yellow Ochre shapes, blotting out small points of light with a paper towel. [A]

3 Then, rinse your brush in your wash water, bring your brush to your palette, and pick up your 50w/50p Raw Umber, which you will use to draw the most delicate lines. Bring your brush to the short lines leading to the berries and pull your brush from the dry white paper toward the wet boundaries of the berries. The darker pigment of the line will begin to bleed and blend into the lighter Yellow Ochre of the berries.

4 Remember to keep rotating your paper so you have the most control of your brush and best access to the area you're painting without running your hand through the still-wet parts. [B]

5 Once your piece is completely dry (I like to wait twenty-four hours), erase your penciled-in flower numbers. Now put your piece on display for all to see—you've done a beautiful bouquet!

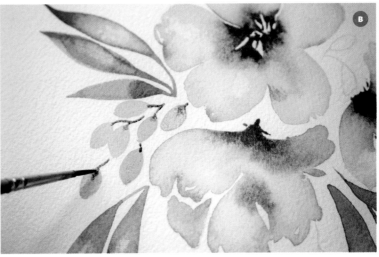

TROPICAL LEAVES
LAYERING WATERCOLOR

FUN FACT: BUILDING UP COLOR IN YOUR WATERCOLOR PIECE IS done by layering transparent washes, one on top of the other, after the first has dried. A washed boundary, once dry, can be darkened, adding contrast and interest, by painting another layer of transparent color on top. The technical term for this is glazing. This technique works as you build color, going from light to dark in tone. Similar to the wet-on-dry method, we use glazing to add wet watercolor onto a dried watercolor wash. However, I primarily use wet-on-dry to provide intense accents of color, or color pops, that cover very small surface areas, whereas I use glazing to cover larger boundaries. This lesson uses glazing to build up the transparent saturation of green colors, as we paint these green leaves in segments. Watercolor tends to dry lighter in appearance than when applied in its wet and water-saturated form. Glazing, or layering your paint on, will allow you to deepen your piece with contrast.

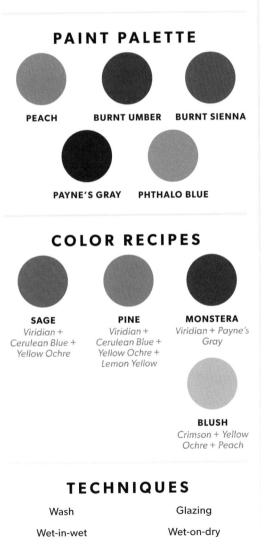

TOOLS

- Round watercolor brushes, sizes 1 and 4
- 140-lb. watercolor paper
- Tape (washi or drafting)
- HB pencil
- Traceable "Tropical Leaves" worksheet (page 199)
- Light source for tracing (a well-lit window or a light box)
- 2 Mason jars of water
- Paper towel
- Scrap paper

PAINT PALETTE

PEACH **BURNT UMBER** **BURNT SIENNA**

PAYNE'S GRAY **PHTHALO BLUE**

COLOR RECIPES

SAGE
Viridian + Cerulean Blue + Yellow Ochre

PINE
Viridian + Cerulean Blue + Yellow Ochre + Lemon Yellow

MONSTERA
Viridian + Payne's Gray

BLUSH
Crimson + Yellow Ochre + Peach

TECHNIQUES

Wash Glazing

Wet-in-wet Wet-on-dry

TIPS FOR THIS PROJECT

- Take a look at the final project (see page 132) and focus on the differences in the leaves. Notice how some leaves have the white of the paper showing through, indicating that the leaf is being viewed straight on. Others have a light green wash showing through, indicating the leaf is folded, and offering a glimpse of the inner green of the leaf.

- I suggest painting Leaves 1, 4, and 5 first. These will require you to paint around the small holes in the leaves, allowing the white of the paper to show through. Then move on to paint Leaves 2, 3, and 6, which you can paint more quickly. For these, you will wash the entire boundary without being careful of any small leaf holes.

AS YOU BEGIN

- Tape your papers together to secure your watercolor paper to your tracing sheet. This way, you can move and reorient your paper while tracing without having to realign the marks every time.

- Use a light source, such as a window or a light box, to view your traceable design through your watercolor paper as you trace.

- Using your HB pencil, lightly trace the lines. The lighter you trace, the easier it will be to erase the pencil lines later if they end up showing through the paint. If you trace lightly enough, you will not see the pencil lines after you paint over them. Since we use dark colored paint for our second layer in this project, it's fine to trace using an HB pencil, instead of a colored pencil here.

- Trace one leaf at a time, shifting the orientation of your page as you go, so you can continue to pull your lines down as you draw. Again, this gives you the most control over the thickness, direction, and look of your lines.

- After you trace all of your leaves, lightly number them following the diagram.

BEGINNER

- As a Beginner, one way to make this lesson feel approachable is to just focus on ONE leaf. Select a leaf from the plant tracing that you like the shape of, and follow the instructions until you're comfortable with the concepts of glazing. Then, once you're ready, use the tracing guide to trace the entire plant, and tackle the leaves one by one. Flowers and the plant pot are optional, and can also be added in once you feel ready for the challenge. Another way to approach this lesson is to not worry about so many leaf segments on each leaf. Paint the base layer of your leaves and only leave a single vein down the center of each leaf.

ADVANCED

- If you're ready to take this lesson to the next level, I suggest you create your own leaf shapes. This would be a fabulous fiddle leaf fig plant, with each leaf segmented and shaped in the fiddle's recognizable style. For another added challenge, perhaps you are ready to mix your own recipes! Try a different color as your base wash in a green recipe of your own—or perhaps you'd like a wet-in-wet bottom layer of color, incorporating some pinks or reds. If you need some inspiring plants with beautiful red veining, check out the leaves of the caladium plant online—incredible coloring! Or a purple-veined winter red kale would be another fun challenge. And with a little glazing, your watercolor leaves can become small masterpieces of contrasting veins and leaf segments.

- Prime your brush and ready your Mason jars of water.

- Reanimate your painting palette with the paints and color recipes listed.

- Keep a piece of scrap paper nearby to test your color recipes.

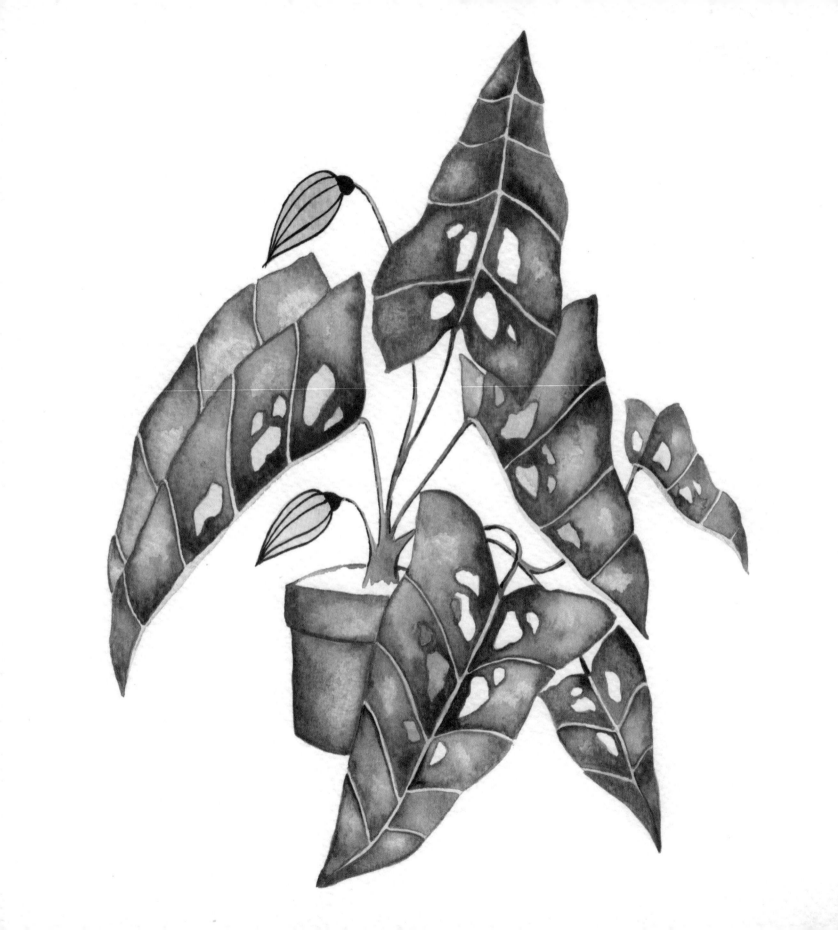

BRUSH: Round 4, Round 1 **PAINT CONSISTENCY:** 90w/10p "soy sauce"

WATERCOLOR LEAVES

WASH

1 Use your brush to bring clean water from your Mason jar to your palette and create your 90w/10p consistency of the Pine and Sage color recipes.

2 You will begin by painting a watercolor wash base layer on all of the leaves. While you're creating washes on each of the leaves, alternate between Sage and Pine to add interest from one leaf to another. The base layer of the wash should be LIGHT and dry quickly. If you find that you are making puddles or biodomes of water, use your paper towel to blot excess water. You want this base wash layer to be light and dry quickly

so you can add your wet-on-dry color—there is no need for movement in this base wash layer. Use just enough water to get the light green Sage and Pine washes onto the leaves. [A]

3 Load your Round 4 with your 90w/10p mixture of Sage.

4 Bring your loaded brush to your watercolor paper to paint Leaf 1. Fill in the entire leaf section with your wash, defining the boundaries of the outside of your leaf and the small leaf holes as you go. This is the first layer; we'll give the veins their coloring once we add a second layer of color later. [B, C, D]

5 Continue to paint Leaves 1, 4, and 5, as they are harder and will take a bit longer.

6 Remember to alternate between Sage and Pine, keeping

continues on next page

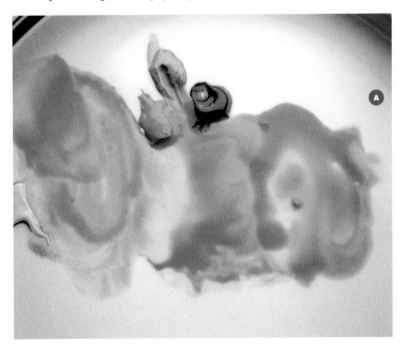

the base washes of these leaves slightly different as you go.

7 When you get to Leaf 4, feel free to switch to a Round 1, as

this leaf has a small boundary. [E, F, G]

8 Next, using a Round 4, and continuing to alternate colors, paint Leaves 2, 3, and 6. You will fill in the entire shapes of the leaves with your 90w/10p wash of either Sage or Pine.

9 As you begin to paint Leaf 2, you will notice that this leaf is "behind" Leaf 1. You can start defining them as separate boundaries by painting one wash in Sage and the

other in Pine. Be sure the first boundary of Leaf 1 is dry before you paint the second leaf boundary of Leaf 2. [H, I, J]

10 Remember to continue to rotate your paper to gain the best access to each leaf as you work. For the strongest and most precise strokes, you always want to pull your paintbrush toward you. [K]

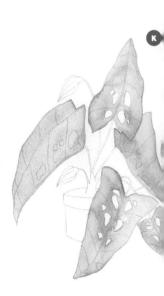

BRUSH: Round 1

PAINT CONSISTENCY: 50w/50p "heavy cream," moving toward 10w/90p "mustard"

WATERCOLOR STEMS

WASH

1 Once all the leaves have their first wash, or underpainting, switch to a Round 1 brush to begin the stems.

2 Use your brush to bring clean water from your Mason jar to your palette and create your 50w/50p-to-10w/90p consistency of Pine. The paint consistency you'll use to paint the stems contains much less water than your base wash on the leaves. With the thicker paint and smaller brush, you will have more control with the paint.

3 Start the beginning of the stem within the dried, or drying, boundary of Leaf 1, and, with the lightest pressure, use your paintbrush to trace over the pencil lines of your stems.

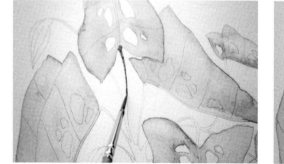

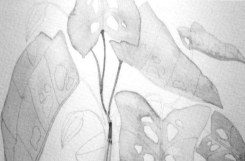

4 Remember, you don't need a wash-like movement for the stems—you just want to make pigmented thin lines. By using a heavier percentage of paint to water, you won't end up with a biodome.

WATERCOLOR LEAVES

SECOND LAYER, WASH WITH WET-IN-WET

1 Once you're done painting your stems, your first wash layer on your leaves should be dry enough to add your second layer with the glazing technique. I suggest painting the second layer on your leaves following the same order as the first.

2 As you layer new wet washes over dried washes, take care to paint the water around—not over or across—the area of the leaf that you would like to remain the lightest shade of green. This way you define the wet boundary where the darker second layer will settle. Keeping certain areas of the first layer wash dry will allow the light vein of the leaf to shine through and contrast even more once all layers are dry.

3 Dip your Round 1 brush in your Mason jar and use your brush to bring clean water to your palette to create your 80w/20p consistency of Sage and Pine.

4 It's also time to add some more color to your palette! If you don't have them already there, add small dabs of paint in Viridian and Payne's Gray (to mix together and make the Color Recipe "Monstera") and a small dab of Phthalo Blue on your palette. We will be using all of these paints to drop in color saturation with the wet-in-wet method once the second wash layer of paint has been added to the leaves. Use your Round 1 brush to bring clean water from your Mason jar to your palette to create a 50w/50p consistency for each of these colors.

5 This is what your palette could look like [A]

6 You also see dabs of Sky Blue, Lemon Yellow, and Yellow Ochre in this picture, since I had them on my palette from Lesson 3. As you add water to your palette, new colors will naturally start to animate. That is OK! Sometimes you get a new blend that you weren't altogether expecting, which can lead to interesting colors. This is also why I suggest testing your color recipes on scrap paper to make sure each shows up on paper the way you're expecting.

continues on next page

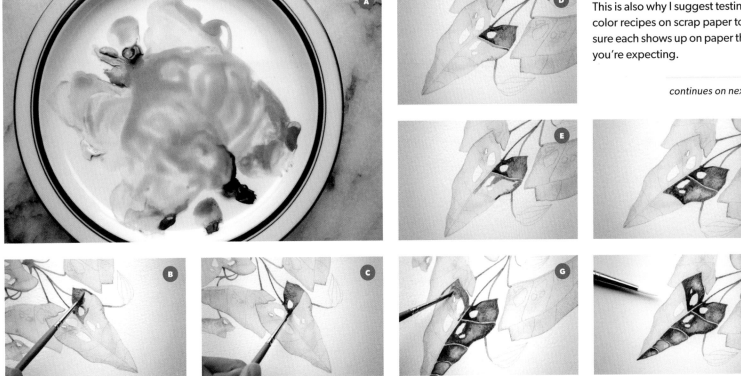

7 Dip your Round 1 in your 80w/20p mixture of Sage and bring your loaded brush to your watercolor paper. Beginning with Leaf 1, closest to the stem, add your second layer wash of color into the leaf. Define your boundaries by only tracing the outside four sides of this section with your paintbrush and the outside of the holes. Start at the top of your leaf and paint to the middle vein line, leaving the center vein dry, with only the first layer base wash, and paint until the pencil-lined boundary. [B]

8 Once you've filled in the small leaf boundary with the second layer wash, drop in a bit of the 50w/50p Monstera. By dropping a bit of this darker mixture, you add depth with your wet-in-wet technique.

9 While this boundary is still wet, feel free to drop in a bit of your 50w/50p consistency of Viridian or Phthalo Blue to the leaf corners to add more dimension, if you'd like.

10 You can also drop in clean water using the waterdrop technique to add more interest to this boundary. Remember, you want each leaf to feel unique! [C]

11 Using this same technique of first defining your small wash boundary and then dropping in color using the wet-in-wet method, move on to the next section of the leaf. Be sure to leave a small area where only the base layer wash comes through, which creates the small leaf veins. [D]

12 When you create the next boundary for the following section, paint all the way down to the next pencil line. [E]

13 Continue straight on down the leaf, painting the entire first side of Leaf 1. Leave room for the leaf veins and use your wet-in-wet and paper-towel blotting techniques to add a bit of color gradation to each leaf section. [F]

14 As you paint these small boundaries within each leaf, refresh the water-paint mixture on your palette between every few boundaries, making sure you continue to paint with an 80w/20p consistency so you can capture movement within the second wash layer. Although we are painting with a Round 1, I often refresh my palette mixture with a Round 4, as the larger brush brings more water from my jar to my palette, so I can reanimate it faster and get back to painting!

15 Once you have completed the first half of Leaf 1, move back to the beginning of Leaf 1, where the leaf attaches to the stem, and repeat these steps. [G–I]

16 Using the same process, paint in Leaves 4 and 5. Remember to rotate your paper so you can best access each leaf!

17 Move to Leaf 6 after you complete Leaves 1, 4, and 5. You will paint the bigger half of the leaf first. [J]

18 Follow the same steps to complete Leaves 6, 2, and 3. Note for the leaves that are essentially "folded," be sure the boundaries of the first half are completely dry before moving to the second half. This way you'll get a clear, hard line to delineate the break. [K, L]

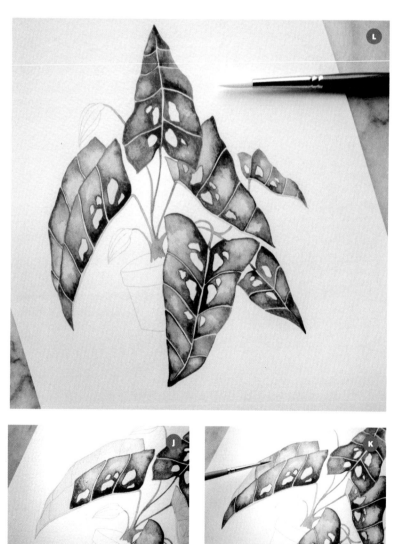

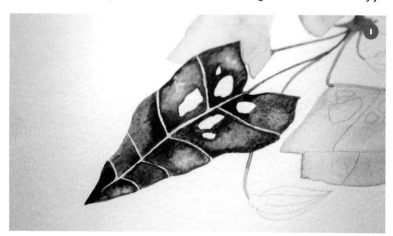

WATERCOLOR FLOWERS

WASH

1 Use your Round 1 brush to bring clean water from your Mason jar to your palette and create your 50w/50p consistency of Blush. Once you have the right consistency, load your brush and bring it to your watercolor paper.

2 Using a Round 1, paint along and within your traced pencil lines for the flowers, creating a thin wash to cover each entire flower, all the way to where the flower connects to the stem. [A]

3 If you're finding that the paint is "catching" and not flowing as easily as you would like, try adding a tiny bit more water to your consistency on the palette. Likewise, if you find your water is pooling, add a bit more pigment to your palette consistency. This is a great time to have scrap paper nearby so you can practice getting the exact consistency you want before bringing the paintbrush to your piece.

4 If you'd like a more vibrant addition of color, you can drop in a bit more pigment by dropping in a dab of 10w/90p Peach paint, letting it spread within the small flower boundary to create that natural wet-in-wet effect. [B]

5 Let the flower boundaries dry completely.

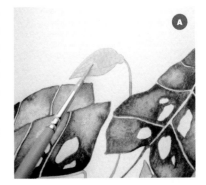

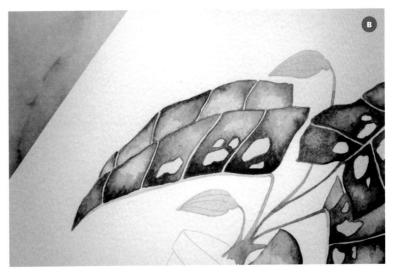

WATERCOLOR TERRA-COTTA POT
GRADED WASH & WET-IN-WET

1 You'll paint this small pot as two separate boundaries: the first is the pot itself and the second is the upper lip of the pot. By treating these as two separate boundaries, you can create a hard line to delineate the depth between the two sections. Once the first is dry, you can paint the second, and they will not bleed into one another.

2 Here you will use a graded wash (see page 48) on the pot to create high-to-low contrast in color, simulating a light source touching the terra-cotta surface.

3 Use your Round 1 to bring clean water from your Mason jar to your palette and create your 80w/20p consistency of Burnt Sienna. Once you have the right consistency, load your brush and bring it to your watercolor paper. Start at the left of the pot and work to the right to cover the entire bottom pot area with a light wash. [A, B]

4 While this first layer is still wet, bring your brush to your palette and mix a bit of Burnt Umber into your Burnt Sienna, maintaining your 80w/20p consistency, to slowly darken your wash. Now, add the darker wash to the top two-thirds of the pot, again starting at the left and working to the right. [C]

5 To add a bit of light reflection to the terra-cotta, use the waterdrop technique to drop in water on the right side of the pot. Move the paint over with your brush, creating a highlighted spot. Use your paper towel to blot out paint and water from that spot. [D]

6 Now, you will add your third layer to the graded wash on the pot. Using your brush, mix a bit more Burnt Umber into your Burnt Umber + Burnt Sienna mixture, maintaining the 80w/20p consistency. Bring your brush to your watercolor paper and wash the left third of your pot in this color.

7 You can use the waterdrop method again to add a bit more water on the right side of the pot to redefine the highlighted area. Use your paper towel to blot out extra paint and water so you have a clear point of light on the right and a darker shadow on the left.

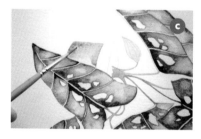

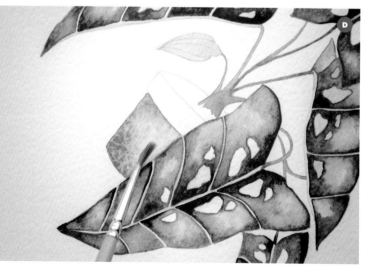

FINISHING THE WATERCOLOR FLOWERS

WET-ON-DRY

1 Make sure that your flower boundary is dry before adding your fine lines in Payne's Gray. If the base wash is wet in any place, the added lines will bleed and dry blurry.

2 Use your brush to bring clean water from your Mason jar to your palette and create your 10w/90p consistency of Payne's Gray. Load your brush with the mixture and bring your brush to your watercolor paper.

3 Using the slightest pressure on your brush, paint along your pencil-drawn lines where you want the flower veins to be and at the bulb where they connect to the stem. If you're finding that the paint is "catching" and not flowing as easily as you would like, try adding a tiny bit more water to your Payne's Gray consistency on the palette. Likewise, if you find your lines are too thick, or if water is pooling and not allowing them to be as thin as you'd like, add

a bit more pigment to your palette consistency. This is a great time to have scrap paper nearby so you can practice getting the exact line thickness you want before bringing the paintbrush to your piece. [A]

4 Remember to use the lightest amount of pressure on your brush, engaging just the point and moving slowly. Continue to pull back from your work, ensuring that you like the thickness and placement of your Payne's Gray lines.

5 If you add your lines and decide they are too thick, or perhaps too close together, you can add

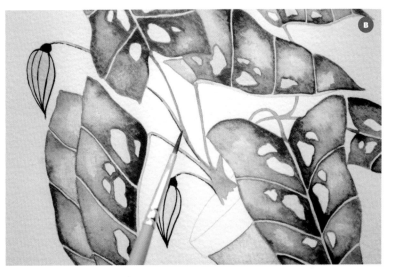

water and repaint the entire flower boundary. Just rewet the boundary, blot your paper towel on the addition of the Payne's Gray lines (a bit of the Peach will come up too), and repaint the entire flower once the area is completely dry.

6 Continuing to use the point of your brush, add some very thin Payne's Gray highlights to your stems to add extra interest and dimension. [B]

BRUSH: Round 1, Round 4

PAINT CONSISTENCY: 80w/20p "soy sauce with wasabi," leaning to 50w/50p consistency for the smaller boundary

FINISHING THE TERRA-COTTA POT

GRADED WASH & WET-IN-WET

1 Use your Round 4 brush to bring clean water from your Mason jar to your palette and reanimate the Burnt Sienna + Burnt Umber mixture you used for the pot base, aiming for an 80w/20p consistency. Using slightly less water in this mixture, leaning toward the 50w/50p consistency, for the pot lip will enable you to have more control over this smaller boundary.

2 Load your brush with your mixture and, starting at your left and working to the right, cover the entire pot lip with a light wash.

3 While this first layer is still wet, bring your brush to your palette and mix a bit more Burnt Umber into your mixture, aiming for the same paint consistency. Bring your brush loaded with this slightly darker mixture to your watercolor paper and wash two-thirds of the pot lip, again starting at your left and working to the right.

4 To add a bit of light reflection to the right side of the lip, use the waterdrop technique to drop in water on the right side of the pot. Move the paint over with your brush, creating a highlighted spot. Use your paper towel to blot out paint and water from that spot.

5 Now you will add the third layer of your graded wash on the pot lip. Using your brush, mix a bit more Burnt Umber into your Burnt Umber + Burnt Sienna mixture on your palette, maintaining the same paint consistency. Bring your brush to your watercolor paper and wash the left third of your pot lip in this color.

6 Feel free to use the waterdrop method to drop in water on the right of the pot again and move any of the paint that may have spread over with your brush, redefining the highlighted spot. Use your paper towel to blot out extra paint and water from that spot, so you have a clear point of light on the right and a darker shadow on the left. [A]

7 Now it's time to fill in the pot that's appearing through the holes in our leaf! Since the holes are on the highlighted part of the leaf, you want to add terra-cotta color that's on the lighter side, but not as light as the highlighted part of your pot. Bring your brush to your palette to play around with your Burnt Sienna + Burnt Umber mixture and test it on your scrap paper until you are happy with the color. Since these boundaries are very small, aim for a 10w/90p consistency on your palette.

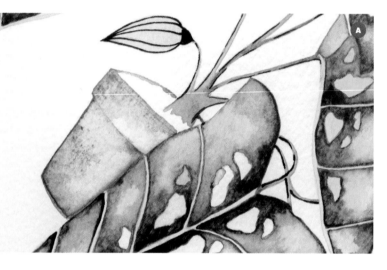

8 Once you have your desired paint-and-water mixture, load your Round 1 (or smaller!) brush with paint and bring it to your watercolor paper. Using the slightest pressure, paint in the pencil-outlined boundaries of these "glimpses" of the pot.

9 Once all of your lines are painted, stand up and take a moment to be proud of your accomplishment! Once your piece is completely dry (I recommend waiting twenty-four hours), you can erase any unwanted pencil lines that remain. Then put that baby in a frame on your wall.

RECONNECTING TO OURSELVES & RECHARGING WITH ONE ANOTHER

THE MAJORITY OF PEOPLE WHO TAKE MY CLASSES ARE women: mothers, young professionals, grandmothers. These women have different life stages and circumstances. Yet as we sit together, face-to-face and hand-to-brush and I teach them how to shape a peony petal or how to mix the perfect sauce for their brush, I hear the same story again and again: these women have given themselves over to others: family, coworkers, friends. They have strived to meet the needs of everyone around them and have forgotten how to care for themselves, and they are left unfulfilled.

Responsibility and nurturing others is a good thing. But the rub comes when we allow the time we give to others to become an excuse for not taking time for ourselves. We give attention to our careers, our children, our families and friends, our obligations and to-do lists . . . but what do we leave off the list? Ourselves! We incorrectly believe that to grant time to something "nonessential" like a creative endeavor requires us to neglect the necessary things in life. Or, we worry that our efforts will end in failure, and that we will have wasted time that could have been spent in areas where we already know success.

Those who take the leap (like you, my friend!) begin creating as a way to connect with themselves, and even a way to recharge to meet life's challenges. Painting requires total focus and is yet so calming; I love to see women discover the soul-quieting effect of dipping their brush in paint and water. I love to watch these new artists discover their own abilities and to know that they will make this practice a part of their lives. It can be difficult to live in a world where it feels like everyone wants something from you. But I believe that art gives back tenfold; it reminds you to keep seeking beauty in simplicity and in that way empowers everyone it touches, including you. Art is a practice to foster goodness and connection between creative souls. This book, and the skills and techniques you learn from it, will help you to see yourself as part of this creative community, spreading hope and joy with each stroke of the pen and brush of paint. ●

FIND JOY IN WORKING TOGETHER

Time and again, I witness the phenomenon of "group joy" in my classes as my students learn, discover, and celebrate together. They bond as they share a new experience: they feel empowered, excited, refreshed, energized, and centered. They glow! I love to watch friendships develop or deepen, as words and feelings are shared while painting. There are moments of laughter at common errors, and exclamations of wonder as one person sees another's talent bloom. When a new concept is grasped and applied, it is something to behold. Sharing these moments makes them even sweeter.

This is part of the reason why I built each lesson with a Beginner, Intermediate, and Advanced option. I want to encourage you to bring your friends together so you can create with one another and build your own community. The lessons in this book are designed to meet each person where they are, so all can come to the table and find joy in working together.

PLANT LADY
WATERCOLOR & INK

THIS PLAYFUL, COLORFUL PIECE FEATURES A CHARACTER WHO HAS shown up in my work for years: Florence. If you scroll through my Instagram, you'll find Florence in many of my paintings—holding plants, chickens, leaves, eggs in a skillet, and more. In fact, Florence was how I first started sharing my work online. The anonymity of her simple body, hidden face, and neutral clothing allowed her to serve as an interesting framework for the central focus of my pieces, and she quickly became a recognizable character my followers grew attached to. In this project, Florence will be the "plant lady" framing this striking abstract tropical plant. This lesson is all about playing with color—some of the leaves are in analogous green colors, while others feature a rainbow of complementary colors. You'll be lightening and darkening pigments throughout the lesson to get the desired color effect. This is also an excellent lesson for practicing washes in different sizes and shapes of boundaries.

TOOLS

- Round watercolor brushes, sizes 4 and 1
- 140-lb. watercolor paper
- HB pencil
- Micron pens, sizes 005, 01, and 02
- Traceable "Plant Lady" worksheet (page 209)
- Tape (washi or drafting)
- Light source for tracing (a well-lit window or a light box)
- Eraser
- 2 Mason jars of water (one for dark colors and one for light)
- Paper towel
- Scrap paper

PAINT PALETTE

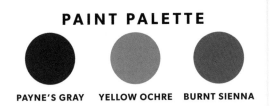

PAYNE'S GRAY **YELLOW OCHRE** **BURNT SIENNA**

COLOR RECIPES

PINE
*Viridian +
Cerulean Blue +
Yellow Ochre +
Lemon Yellow*

PAPAYA
*Peach + Yellow
Ochre + Crimson*

TECHNIQUES

Washes Working in ink

Wet-in-wet

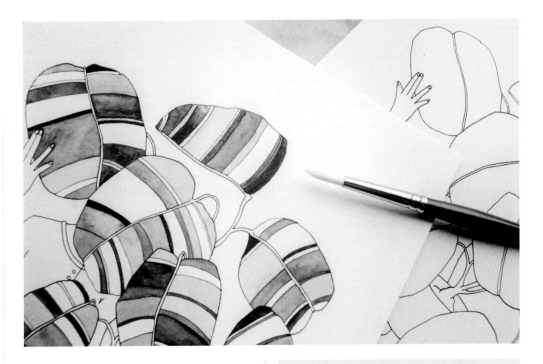

TIPS FOR THIS PROJECT

- As you trace and paint, remember that you are not on a solid plane. Continually changing the orientation of your piece will allow you to access your art from different angles and keep your marks sure and strong.

- You can add visual interest by alternating the thicknesses of your leaf lines while drawing with your Microns. Try a few lines near one another in a 005 size, and then make a bold line with a size 02. Just make sure that the spaces you make aren't too small to paint within, as you will be adding a light wash to these small segments. You can always add more lines to create more segments later.

- Test your pen tips on your scrap paper as you work to ensure you make your marks with the best size.

- You will have the most control over your lines when you pull your pen down toward you. Move your paper as you work so you can continue to pull lines, marks, and strokes down toward yourself.

- If you prefer larger boundaries, leave off the petite leaf lines when you trace, and practice

BEGINNER

- Trace a simpler version by leaving off Florence the Plant Lady, and/or do not draw in the individual leaf lines. Or draw a few lines on every leaf, but perhaps not so many!

ADVANCED

- Can you imagine a different outfit for Florence the Plant Lady? Dress her up in your own style. Or perhaps you'd like to paint these rainbow leaves in a different color scheme, or a completely different leaf shape. Remember, to find the complementary color of a pigment, jump across the color wheel (see page 31). When it comes to complementary color, opposites DO attract!

watercolor washing with wet-in-wet color fireworks (see page 47) instead.

- As you paint your piece, continue to pull back by two or three feet and check the progress while things are still wet. Let your eye assess where the next color needs to go. Doing this as you work ensures that you will love the overall look once it's all complete.

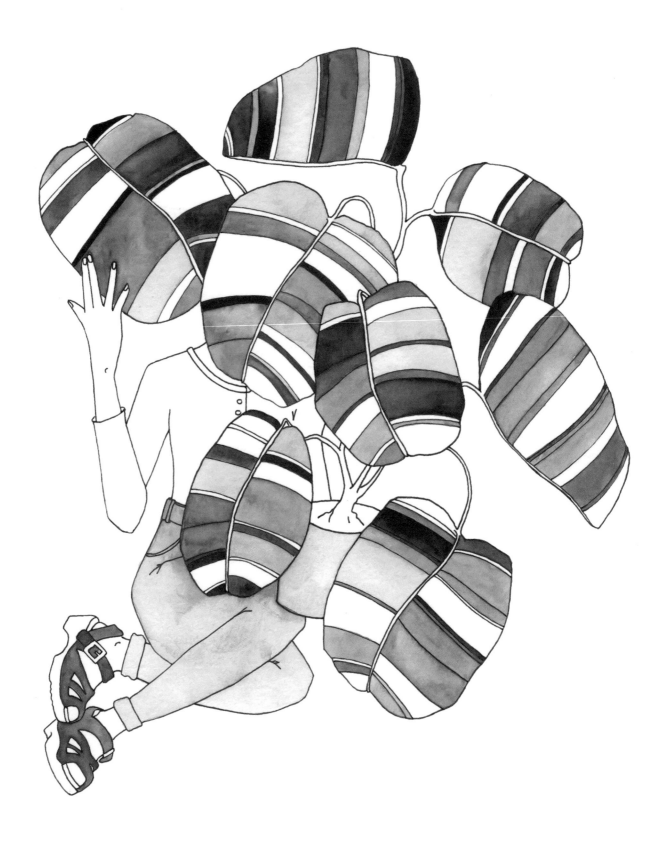

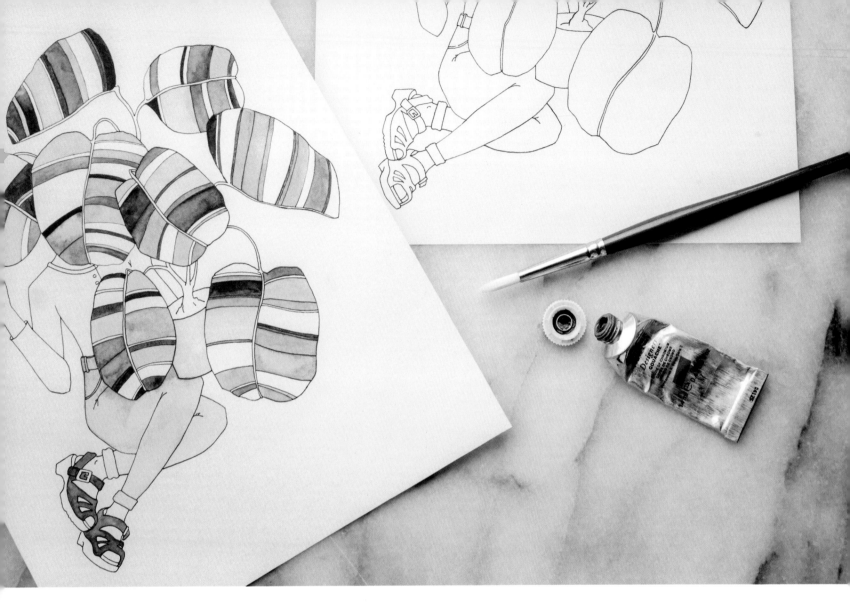

PENCIL & INK

1 Tape your papers together to secure your watercolor paper to your tracing sheet. This way, you can move and reorient your paper while tracing without having to realign the marks every time.

2 Use a light source, such as a window or a light box, to view your traceable design through your watercolor paper as you trace.

3 Using your HB pencil, lightly trace Florence the Plant Lady onto your watercolor paper. The lighter you trace, the easier it will be to erase the pencil lines once you ink over them.

4 Trace over your pencil lines with your Micron pens. I suggest using the 005 or the 01 sizes for Florence's finer lines (her hands, fingers and nails, sandals, and outfit details) and the 01 for the finer lines of the branches. I use the 02 size for Florence's outline and the leaf outline.

5 Alternate between the 005, 01, and 02 sizes for the lines on the leaves to give each one unique depth and interest. Each leaf is its own little creation!

6 Once all of your art is inked, begin erasing your pencil marks where the ink is driest, which is where you first began tracing. Go slow.

7 You're ready to begin painting! Prime your brush and ready your Mason jars of water.

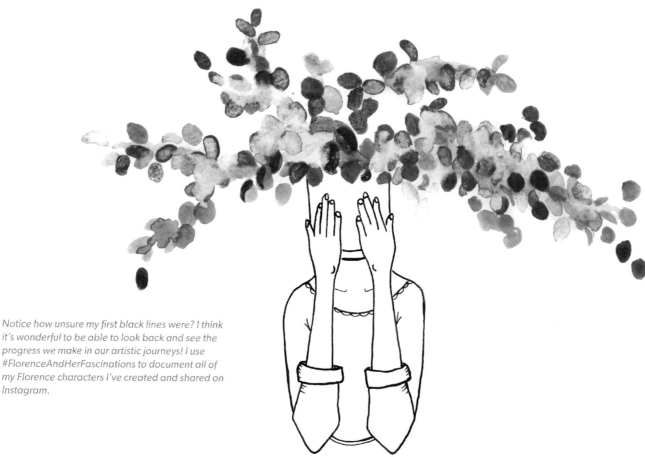

Notice how unsure my first black lines were? I think it's wonderful to be able to look back and see the progress we make in our artistic journeys! I use #FlorenceAndHerFascinations to document all of my Florence characters I've created and shared on Instagram.

MY FIRST FLORENCE

Florence was the girl who began it all.

It was five in the morning and I was sitting at my great-grandmother's writing desk. I had a new set of watercolor paints and I had just finished feeding my two-month-old baby girl. While she was snoozing contentedly, I stayed and watched the sunrise instead of rolling back into bed. We have a few beautiful eucalyptus trees in our backyard, and I was struck by how the light danced off the small round sage-green leaves whenever they shook in the breeze. I decided to paint a few of the monochromatic green colors I saw and then thought to myself, what a lovely plant this is—should I draw a vase to hold

these branches? Or maybe a person? And Florence was born.

Her arms embraced my leafy eucalyptus boughs and because there was so much greenery, her face was hidden behind the leafy branches. After I penciled in her body, I loved the contrast of the soft watercolor botanicals with the simple, stark lines of her body, and I decided to draw her in ink. The next day, I drew another Florence, this time holding one of our chickens. Naturally, the chicken was a bit larger than life, and commanded a lot of attention, but Florence was there in her subtle neutrality, cradling yet another fascinating hobby. I was hooked.

I posted my Florence drawings on Instagram and my followers took a liking to her and encouraged me to share more. From then on out, I would draw Florence's shape in ink, and then watercolor in a new fascination: eucalyptus leaves, chickens, an egg in a skillet. I tried new paint and tested new techniques, with her as my constant.

Florence is Every Girl. She is anyone who has ever wanted to try something new. She is someone who loves the adventure of a new fascination. She pursues people and excitement in earnest. She dives into new pursuits and loves to share. And I love sharing her with you now.

BRUSH: Round 1

PAINT CONSISTENCY: 50w/50p "heavy cream," moving toward 80w/20p "soy sauce with wasabi" as you add water to dilute the colors, tinting them to their analogous versions.

Use your brush to bring clean water from your Mason jar to your palette and create your 50w/50p consistency of the Pine color recipe. Because each boundary is so small, we're not going to worry about creating a wet-in-wet effect within them. Like we did in Lesson 11, you want to use enough water and paint within each to create an even wash with no hard lines, but not so much water that you flood the small boundary. When you have your desired consistency, dip your brush in water and then load it with your Pine color mixture.

ANALOGOUS & RAINBOW LEAVES

1 Starting with a leaf of your choice, bring your brush to your watercolor paper and begin painting the leaves on the right. Paint a fine sheen of your Pine wash into your chosen segment. **[A]**

2 Fill in a few of the small boundaries with your Pine color, rotating your paper as you work so you can access different angles. **[B]**

3 Now to add some pops of rainbow! Dip your brush into your designated dark Mason jar to clear the Pine out of your brush, and then dip it into the clear water of the light Mason jar. Use your brush to pick up your 50w/50p consistency of your Papaya color recipe and add a band of light and brighter color to one of your small leaf segments. If a boundary is wet, let it dry completely before

you try to add another wet color right next to it, to prevent bleeding between leaf segments. **[C]**

4 To lighten the color within any of your boundaries, blot with a dry paper towel. To darken, add another layer of transparent color.

5 It may take a couple strokes to watercolor the larger segments and cover the entire boundary. But for many of the small boundaries, it will take just one stroke to color the

entire boundary. Don't overthink it; get a fun color down on a boundary and move on to another. **[D]**

6 Next, it's time to paint your analogous leaves. For these, you will work on a sliding scale of color. This means Pine will be your featured pigment, and you will lighten it in varying degrees on your palette by adding water and darken it in varying degrees on your palette by mixing in Payne's Gray.

7 Maintaining a 50w/50p "heavy cream" consistency for most of your sauce mixing on the palette will help you stay within these small leaf boundaries. However, as you begin to lighten your Pine recipe with water, you will move closer to an 80w/20p consistency, and that's ok. Notice, the lighter parts of my leaves are usually the larger of the leaf segments, so I had room to add

continues on next page

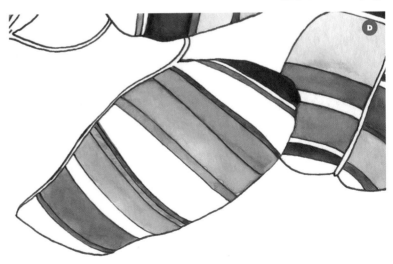

the wetter consistency. Mix up your analogous colors on your palette by watering down your Pine recipe to create the lighter green color (which is tinting), and darkening your Pine recipe by mixing in Payne's Gray (which is toning). Feel free to test the range of green colors you can create on a scrap paper. Once you have a few, you're ready to begin painting an analogous leaf. [E]

8 Continue painting the segments of your analogous leaves using your own color placement or pattern. Some leaf segments can be very dark, toned deeply with Payne's Gray, and some can even be left blank, letting the white of the paper shine through as a nice break in color. [F]

9 Alternate your leaves as you paint, making some with a rainbow theme, and others with the analogous color theme. As you paint, be careful not to overlap wet boundaries because, as you know, the colors will bleed into one another. [G]

10 Your leaves can be as understated or as wild as you like! By following different color harmonies, you can create calm leaves or leaves that are truly the life of the party! [H]

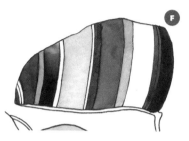

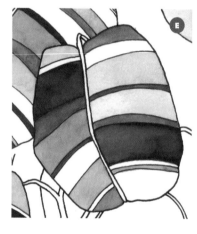

INK LINES AREN'T BOUNDARIES

Does the Micron pen act as a water-repellent border, keeping the paint within the boundary?

The answer is no.

The ink lines do not provide a border for your paint to stop. Use the ink lines as guidelines to direct your paintbrush. They will not bleed with your watercolor, but they are not going to stop your paint from flooding a boundary either. Try, instead, to paint within the lines you've drawn, which will require some practice and training of your hand on the brush.

But also remember that this is art! You're human, and imperfection is what makes your style and piece your own. This lesson suggests you stay within the lines as much as possible, but you could always go your own way and treat the lines as simply that—black lines—and watercolor right on over and through them! Do what feels best. Just remember, the ink lines are NOT the same as a wet boundary.

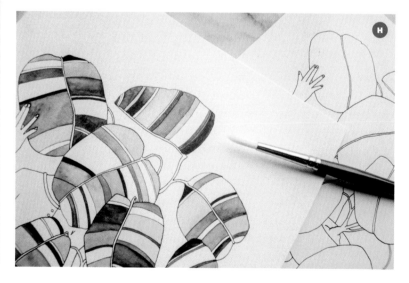

BRUSH: Round 1 **PAINT CONSISTENCY:** 50w/50p "heavy cream"

PLANT POT

1 To paint the pot, you will create a simple wash using your Round 1. You can paint the pot in any color you like. For the example, I used a watered-down shade of Payne's Gray from my analogous color scale, adding just a touch of Yellow Ochre on my palette to get a cement-like color. Be sure to use a piece of scrap paper to test your colors before you bring them over to your watercolor paper.

2 Before you paint, make sure all the boundaries around the pot are dry, to prevent leaf colors from blending or bleeding into your pot boundary.

3 Dip your brush in your Mason jar, pick up the 50w/50p consistency of your chosen pot color, and begin to fill the pot boundary with a wash. Come back with a paintbrush or two of the lighter wash water to fill in the entire boundary. Again, you are not looking for too much movement in this wash, just a nice wet sheen.

BRUSH: Round 1, Round 4 **PAINT CONSISTENCY:** 50w/50p "heavy cream"

First, you'll paint Florence's sandals in Burnt Sienna. Dip your Round 1 brush in your clear water and bring it to your palette to create a 50w/50p consistency of Burnt Sienna.

FLORENCE

1 Bring your loaded brush to your watercolor paper and fill in the sandals using light pressure with your brush to create a consistent wash—a little sheen to ensure there are no hard lines, but not so much water that your paint bleeds over the lines of the sandals.

2 Switch to your Round 4 brush. To create the color for Florence's jeans, bring water from your Mason jar to the Payne's Gray on your palette until it turns to your preferred shade and blends into a 50w/50p consistency.

3 Bring your loaded Round 4 to your watercolor paper and cover the majority of the jeans boundary with your wash. [A]

4 Since you're using such a light wash on a small boundary, your jeans wash will dry quickly. See that hard line forming? To get rid of any hard lines, you can use your wet brush in a side-to-side scrubbing motion to essentially rub the beginnings of hard-drying lines out.

5 Continue to use water and more of your 50w/50p sauce consistency to fill in all of the boundary for Florence's jeans, and bring the water-and-paint mixture up to all of the lines, filling in the smaller spaces near her waistline and the pot and leaves. [B]

6 True to my original idea of Florence, I like to leave a decent amount of her in purely ink, so she remains simple and uncomplicated. I also left color out of the stems of my potted rainbow plant. But feel free to color her in according to what *your* imagination prefers!

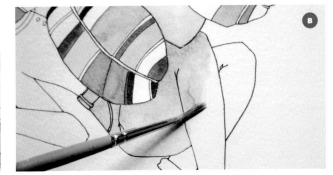

THE CREATIVE CYCLE

WE CREATE IN CYCLES. THERE ARE DAYS OF FEVERISH INSPIRATION, WHEN ideas are prolific, and they bump around in your mind and heart, distracting you from everything else until you finally express them on paper. And there are days (sometimes weeks) of drought, seemingly devoid of any original creative thought. In those slumps, you wonder if it is gone forever, or worse—you were never an artist at all.

Don't believe that for a minute! The dreaded Imposter Syndrome lurks around every creative lull. We all experience these highs and lows in our journey, and you never know how long either will last. Remember, it's a cycle—both the highs and lows are part of the creative process.

That being said, I do believe there are two types of slumps we face and it's important to recognize the difference.

TAKE A BREAK (AND AVOID BURNOUT)

This slump typically comes when I've created at a frenetic pace, pouring myself out on the page for an extended amount of time. Then suddenly I've completed the piece and it feels like I've hit a wall. The gushing well of yesterday's creativity is all dried up. In this type of slump, I must allow myself to take a break.

My theory is that these are meant to be rest periods. A time to let old ideas fade, and prepare oneself for the birth of new ones. In this phase of the cycle, taking a few days to rest and gratefully recall the magic that was created is good for me. It makes the creation of those earlier pieces that much more special. It's a high like no other to create something that makes you smile every time you see it; it's also important to acknowledge that every day and every piece you attempt cannot be a masterpiece.

Here's a personal suggestion: when you're in the Creative Slump part of your cycle, do not go to the Internet for inspiration. Everyone shares their wins on the internet—which I'm not against; it is exciting and we should share our wins! But, when you're feeling unimaginative and doubting your talent, and then you start scrolling online in this state? Of course, the most natural feeling to follow is comparison and a sense of failure, more personal doubt, and even hopelessness. It's not pretty.

If you're exhausted and need to recharge, step away from trying to produce and instead do something to nurture your creative self! Remember those tiny moments of joy? Now it's time

to seek them even more earnestly. Spend your free moments in nature, digging in a community garden, soaking in the sunshine, walking barefoot on the earth and feeling growing-things beneath your feet. Speak and commune with other humans who have different passions, and viewpoints and come from different walks of life. Laugh with friends, a good and hearty laugh that makes your cheeks ache. Play your favorite song at the highest volume you can, and dance it out. Read the old poets who long ago tracked the familiar ground you are now traversing, learning about their journey and how their lives were day to day. Walk, run, garden, read*, embroider, speak with an encouraging friend that believes in you and your talent. Get offline for a few hours, or days. Whatever it takes to remember: it's your unique voice that is worth sharing, and it WILL BE BACK!

Do something else that slows you down, engages your hands, and helps you feel accomplished. Once you've rested and you begin to feel those urges and ideas trickle in again, you'll be better and stronger than you were before.

SHOW UP (AND RESIST THE CREATIVE BLOCK)

The second slump is different than the first because I want to paint; I have the energy and desire, I'm just fresh out of ideas. Saying we want to paint and actually sitting down with a wet brush are two very different things, aren't they? Sitting down to paint when we don't feel inspired takes discipline but we must show up for the proverbial Muse to alight. It's not a guarantee; inspiration doesn't come every day or every time I show up to paint. We cannot control the Muse, but we can prepare for it and try to be worthy of it when it arrives.

On days like these, when I'm fresh and excited but am not sure the direction to take, I start with exercises. Often, with a leafy wreath. The lessons in this book are so helpful this way: they provide you with prompts, tracings, ideas, and technique. As you show up and practice, you build your technique and knowledge, so on the day when your own unique idea strikes, you have the transferrable skills needed to communicate your own idea beautifully. You can think about technique and shaping leaves, and how to create that flowing wet-in-wet sauce, but the magic really happens when you show up and learn the skills.

I enjoy painting and drawing so much more when I show up without any expectations of grandeur or magic. I come to my desk with open hands, enjoying the act of creating itself. I've learned that, in the end, it is not the quality of the paint that makes or breaks a piece but the heart and discipline of the painter.

*I've included a Reference section in the back of this book, listing some of my all-time favorite books to read that have helped me during the slumps. One that I obviously enjoy that I've been quoting from is *The War of Art* by Steven Pressfield. He takes apart the creative cycle in small, one-page chapters, and helps you identify what's holding you back. And once you can see the cycle, and give a name to the obstacles, it doesn't feel as intimidating. ●

TROPICAL TERRARIUM
WATERCOLOR, INK & GOUACHE

THIS LESSON COMBINES ALL OF THE WATERCOLOR SKILLS WE HAVE learned so far, and incorporates more fine ink lines with the walls of the terrarium and your delicate cosmos flowers. And we are mixing it up by adding another layer of skills to our piece—with gouache! Those bright lines on the dark leaves are gouache, and we are going to break this piece down step by step. Every lesson has been building your skill set, setting you up to combine these mediums in a wonderful culmination of this piece, the Tropical Terrarium.

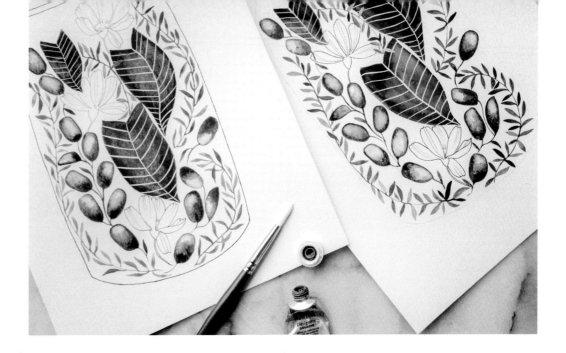

TOOLS

- Round watercolor brushes, sizes 1 and 4 (and smaller fine-liners if you have them: 0, 00, 5/0, 10/0)
- 140-lb. watercolor paper
- HB pencil
- Micron pens, sizes 005 and 05 or 03
- Traceable "Tropical Terrarium" worksheet (page 211)
- Tape (washi or drafting)
- Light source for tracing (a well-lit window or a light box)
- Artgum Eraser
- Paper towel
- Scrap paper
- 2 Mason jars of water

PAINT PALETTE

CHINESE WHITE OR DR. PH. MARTIN'S BLEEDPROOF WHITE　　**PAYNE'S GRAY**　　**VIRIDIAN**

YELLOW OCHRE

COLOR RECIPES

MONSTERA
Viridian + Payne's Gray

PINE
Viridian + Cerulean Blue + Yellow Ochre + Lemon Yellow

TECHNIQUES

Fine-line ink work　　　Wet-in-wet

Washes　　　Blotting, waterdrop and paper towel

TIPS FOR THIS PROJECT

- As you trace and paint, remember that you are not on a solid plane. Continually shifting the orientation of your piece will allow you to access different angles and help keep your marks sure and strong.

- You will notice that the completed example has multiple lines on each of the large leaves, added on top of the watercolor, in gouache. I left these lines off of your traceable so you can create your own. Do more or do less—totally up to you!

PRO TIP

I will often work out of a dried palette in the right tones to create the very petite leafy vines like the ones in this lesson. I find that dried watercolor paint that has already blended with other colors, and then lightly reanimated, makes for some really interesting palettes. If you want to do this, you can squeeze out some of your colors the night before you start the project, and then allow them to completely dry overnight. By reanimating this mixture with just 10 percent water when you're ready to paint, you will get some lovely, unique, varied color tones within your main pigmented colors.

- Keep a scrap paper nearby to test pen tips and watercolor brush marks, to ensure you make your marks in your desired size.

- You will have the most control over your lines when you pull your pen or brush down toward you. Reorient your paper so you can continue to pull lines, marks, and strokes toward yourself.

BEGINNER

- Feel free to trace a simpler version by leaving out the smaller leafy vines. Or, perhaps you might include them, but paint them in one color, rather than the analogous yellow, green, and blue colors suggested on the following pages.

ADVANCED

- This is your opportunity to fill a terrarium with all of the natural flora (and fauna!) that you can imagine. Trace the terrarium lines and, using a pencil, draw out your own designed pattern of terrarium life, filled to the brim with your own choice of botanicals.

TERRARIUM JAR: PENCIL & INK

1 Tape your papers together to secure your watercolor paper to your tracing sheet. This way, you can move and reorient your paper while tracing without having to realign the marks every time.

2 Use a light source, such as a window or a light box, to view your traceable design through your watercolor paper as you trace.

3 Using your HB pencil, lightly trace the terrarium onto your watercolor paper. The lighter you trace, the easier it will be to erase the pencil lines once you ink and paint over them.

4 After you trace the outline of the terrarium design in pencil, ink the outline of the terrarium using your Micron pen in size 03 or 05 for the thicker line of the outer terrarium and its upper lip. These terrarium lines are the easiest to mess up, so don't wait until the end! If you can get those done first, even if you have a few false starts, without putting work into inking the other elements, you won't be frustrated if you end up with a smudge or a wiggly line on the terrarium and have to start over.

5 For these long black lines, I find it helpful to draw a line a few inches along the pencil line and stop. I pull down, reorienting the paper so I have the most control. Then, to continue the seamless line, I place the tip of the pen back within the already drawn line and continue the ink mark without the interruption of a new starting point. If you're familiar with embroidery, it's almost like creating a "running stitch" with your pen.

6 Once you have inked solid lines for your terrarium, switch back to your HB pencil and continue to lightly trace all the inside details of your terrarium. Remember, you build up muscle memory by drawing shapes in repetition. If you trace all of the similar objects in a row, your drawing knowledge will naturally grow. [A,B]

7 Although the cosmos flowers need to be inked as well, you won't do this until the final step. It's nice to keep the cosmos flower lines in pencil as you work so you can erase and reposition them if needed, depending on what happens with the paint on the leaves, which can shift or bleed a bit during the painting process. [C]

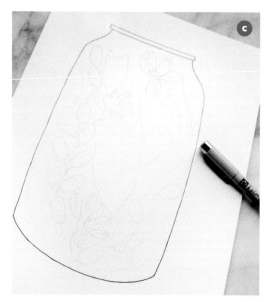

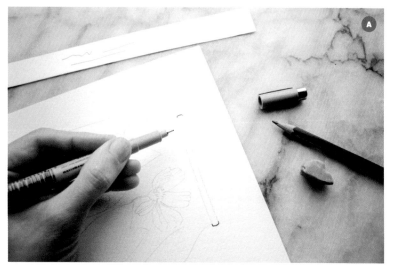

Prime your brush with water and use your brush to bring water from your Mason jar to your palette to create a 50w/50p consistency of Monstera. Because the boundaries of the leaves are not very large and you are after a deep green color, the 50w/50p consistency is the "magic sauce" for this step.

LARGE TROPICAL LEAVES

1 Load your brush with the 50w/50p Monstera color mixture and bring it to your watercolor paper to begin painting the base wash of your tropical leaves. Start with the upper left leaf and work your way down the page, rotating your paper as needed so you can best access each leaf. You're aiming to use enough water and paint to create an even, dark-toned wash with no hard lines. You want shine, but not a lot of movement. **[A, B]**

2 You will be layering gouache on top of this base wash in the form of the fine white lines later, so you want the base leaf wash to be dark and smooth. If you want a darker color than you see on the first wash, remember that you can keep adding in more pigment while the base layer is still wet with the wet-in-wet method. Use your Round 1 brush to drop in a 10w/90p consistency of Viridian to get some really dark shadowing for the leaves. **[C]**

3 Or, once your first wash layer is dry and not dark enough, since watercolor dries lighter, you can add another layer of color by glazing on another wash of Monstera. **[D]**

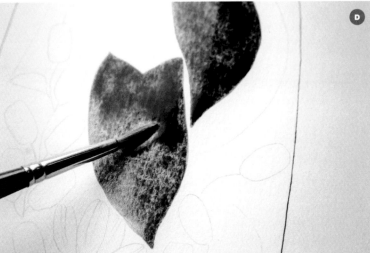

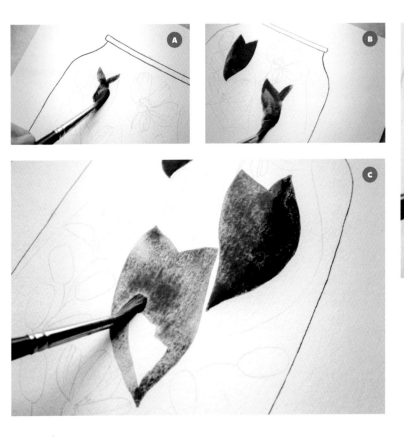

BRUSH: Round 1 **PAINT CONSISTENCY:** 50w/50p "heavy cream"

You'll use the smaller Round 1 brush for these leaves, as the boundaries are much smaller and the smaller brush gives you more control. You'll focus on painting all of the oblong leaves, and not worry about their stems until later.

 Prime your brush with water. Use your brush to bring water from your Mason jar over to your palette to create your 50w/50p consistency of Payne's Gray.

OBLONG LEAVES

1 Fill your brush with your Payne's Gray mixture and bring it to your watercolor paper. With your first stroke, outline the shape and define the leaf boundary of your first oblong leaf. **[A]**

2 For the second stroke, dip your brush in your Mason jar for water, pick up the 50w/50p consistency of Payne's Gray from your palette,
and fill in the leaf with a simple wash. This second stroke needs to be completed VERY quickly following the first—otherwise, the outline of your first stroke will dry and leave an "o" mark around your leaf. You want your leaves to have some sheen—enough water so there are no hard lines, but not so much water that you overfill the small leaf boundary edges. **[B]**

3 If your leaf appears to have the "o" outline effect, it's either because you didn't have enough water in your first and second strokes, or you needed to move a bit quicker between the strokes. If that happens, use your brush to bring more of your Payne's Gray paint-and-water mixture over to the leaf and use a light scrubbing motion to rub out the hard boundary line, much like we did in Lesson 12 with the Plant Lady's jeans (see page 149). **[C]**

4 After you have a nice wash in your little oblong leaf, use the waterdrop technique to drop in water and move the paint over with
your brush, creating a highlighted spot. **[D]**

5 To enhance the highlighted effect, use your paper towel to blot extra paint and water from that spot. This must be done while the base wash is still wet, in order to avoid any water blooms or hard lines within your small leaf boundary. **[E]**

6 To increase the contrast in this small leaf, you can use the wet-in-wet technique to add in a dark spot to contrast the light. Dip your brush in your Mason jar of water and bring more water to your palette to create an 80w/20p of Payne's Gray. Load your brush with the mixture and

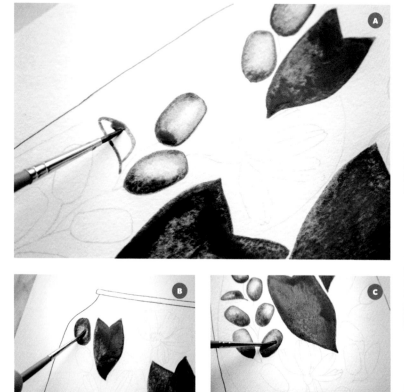

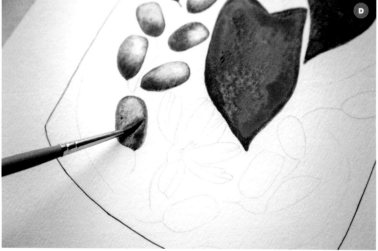

bring it to your wet leaf wash, gently dropping in the darker paint on the left side of the leaf. Let the added paint blend in slowly and naturally. Use a small amount of clear water on your brush to smooth any hard edges between the light and dark contrasting spots on your leaf. [F]

7 You've now painted one beautiful oblong leaf! Repeat this process to paint the rest of these leaves in the terrarium. I start in the upper left-hand corner and move down, rotating and reorienting my page to better suit what angle I need to access. I treat each of these leaves as an individual painting, spending time on every single one to make them unique. [G]

8 These steps may seem time intensive, but after you finish one leaf they are really quite simple! Here's a short breakdown to reference as you go:

- Outline
- Wash fill
- Drop in water to move paint away from a highlight spot
- Paper-towel blot that highlighted area
- Wet-in-wet drop in a dark spot to contrast the light
- Smooth
- Let it dry, and work on the next leaf!

9 Remember to leave the stems for now. You will fill these in after you've painted the leafy vines. [H]

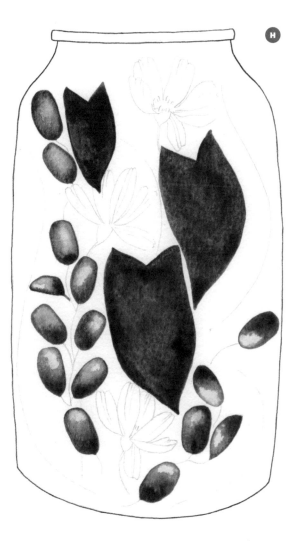

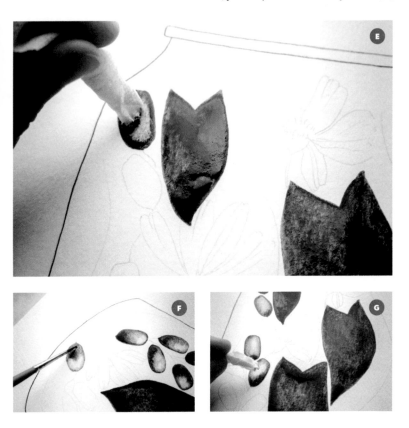

In this section you'll focus on painting a few of the leaves, then the stem of those leaves, and then move to the next set of leaves.

LEAFY VINES

1 Prime your brush with water and use your brush to bring water from your Mason jar to your palette to create a 10w/90p consistency of your Yellow Ochre and White watercolor, plus reanimated Pine. Reanimating your palette now, from the evening before when you poured the fresh wet tube paint, works wonderfully. But adding a few more paint dabs at this point so you can get a thicker consistency works well too. I put my paint dabs near one another, so the water I bring over ends up mixing the colors for some interesting combinations. **[A]**

2 You're practically painting with only pigment. You want just enough water to smoothly guide the paint out of your brush and onto your paper. Too much water will flood the boundaries and turn your small leaves into blobs. I like to keep scrap paper near me at this point to ensure the consistency I'm bringing to my paper is the right ratio of water to paint.

3 Dip your brush in the 10w/90p consistency of the color you want for your first leaf and use a point-pressure-point stroke to create your first leaf. Depending on your preference, you can start on the point of the leaf and work your way into the stem, with the last point being the connection to the stem, or vice versa.

4 If you've traced the leaf indication lines onto your vines, it might be easiest to begin your first point at the stem, on the indicator line, and pull down while applying pressure to create the center of the leaf, and then move to the final light pressure point to finish the tip of the leaf.

5 After you've painted one small leaf, change your paint color. Add variety to your small leafy vine by moving from light-toned colors to dark-toned colors and back again. If you stay within the analogous color palette, choosing three to four colors that are close to one another on the color wheel, the leafy vines will bring your piece together harmoniously at the end.

6 Once you've painted a few small leaves, pick up the 10w/90p consistency of one of your leaf colors and bring it to your watercolor paper to paint a very fine stem line. Connect the leaves to one another and draw the painted line down to connect it to the next leaf you plan to paint. You can see in this picture that the stem changes in color as I draw the line down. This is because I am using the paint from the palette, and as it combines with the wet boundaries of the small leaves, the colors move within the wet boundary forming in the stem, changing color as I draw it down. **[B]**

7 You can see here that I overlapped one of the leafy vine leaves with a large jungle leaf. Because the larger leaf below is dry, the small leaf will not blur or bleed into it. The white of the gouache shows up on top of the large leaf boundary. **[C]**

8 Continue to paint your small leafy leaves using the PPP stroke, alternating colors, and adding to the stem line. I like to start in the upper left area of my painting and move down and around the terrarium, painting leafy leaves and using the lightest pressure to connect to their vines. **[D]**

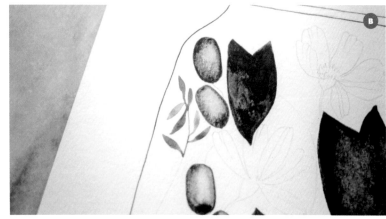

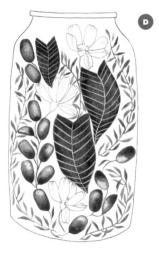

BRUSH: Round 1 (or thinner) **PAINT CONSISTENCY:** 10w/90p "mustard"

Now that you've painted all your leaves, it's time to connect the stems to your Payne's Gray oblong leaves. These stems will be very similar in consistency to the vines you just completed for your leafy vines. Prime your brush in water and use your brush to bring water from your Mason jar to your palette to create a 10w/90pconsistency of Payne's Gray.

FINE LINES & SMALL STEMS: WET-ON-DRY

1 Using a Round 1, 0, 00, 5/0, or an even thinner brush, like a Round 10/0, pick up the 10w/90p consistency of Payne's Gray and carefully paint along your pencil-drawn stem lines. If you find your paint is "catching" and not flowing as easily as you would like, try adding a tiny bit more water to your consistency on the palette. Likewise, if you find that water is pooling and your stems aren't as thin as you'd like, add a bit more pigment to your palette consistency. This is a great time to have a scrap paper nearby so you can practice getting the exact thickness you want before

bringing the paintbrush to your actual piece.

2 Once you've painted all of your Payne's Gray stems, you're ready to move to your thin white lines on your jungle leaves.

3 Prime your Round 1 or 10/0 brush in water and use your brush to bring water from your Mason jar to your palette to create a 10w/90p consistency of White. You can use Chinese White; however, if you want the opaquest, brightest, most vivid white, stick with Dr. Ph. Martin's Bleedproof White. Load

your brush with your 10w/90p consistency of White and bring it to your watercolor paper.

4 Using light pressure, paint a line right down the middle of the first tropical leaf. From here, draw your lines from this middle line out, refilling your brush as needed. You should be able to make two to three thin white lines before needing to reload your brush. **[A]**

5 Move slowly. Continue to pull back from your work, ensuring that you like the thickness and the placement of your white lines. If you decide they are too thick, or perhaps too close together, never fear. Just re-wet the entire leaf boundary and use a paper towel to blot out the white (a bit of the green will come up too). Once the leaf boundary is dry, you can repaint the whole leaf to get it to the desired green color again, and then you are ready to try your white

lines again once the area is completely dry. **[B]**

INKING THE COSMOS

1 Hooray—you're almost done with your newest masterpiece! All that's left are the very fine lines of the three cosmos flowers.

2 Use a Micron with a 005 or 01 tip to make your flower lines thin and delicate, contrasting nicely with the thicker outline of the terrarium jar. Before you mark your final piece with your pen, practice on your scrap paper. When you feel confident about making fine lines, proceed. **[C]**

3 Once all of your lines are inked and painted, the last step is erasing any unwanted remaining pencil lines. Wait until your piece is completely dry (ideally twenty-four hours) before running the eraser over your piece.

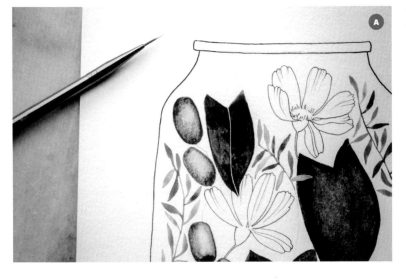

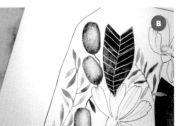

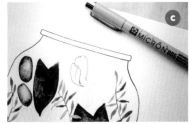

LAYERED WREATH

LAYERED WATERCOLOR & GOUACHE

WREATHS ARE SOME OF MY FAVORITE PIECES TO PAINT IN watercolor. They allow you to practice a few skills and techniques repetitively and can teach you a lot about color harmony. Learning how to position and place pointed or rounded elements, balancing proportions of big and small, and mastering color combinations are all useful skills to have in your watercolor practice. Wreaths can be adapted into leafy half-circle boughs, used to frame another focal point or celebrate a festive season, used as a border on a page, or simply featured as the main attraction. At the end of this lesson, I share some of my favorite wreaths I've created.

TOOLS

- Round watercolor brushes, sizes 4 and 1 (and 0, or smaller, if you have them)

- 140-lb. watercolor paper

- Colored pencils, in blush and gray

- Traceable "Layered Wreath" worksheet, beginner or advanced (see page 213)

- Light source for tracing (a well-lit window or a light box)

- Tape (washi or drafting)

- 2 Mason jars of water

- Paper towel

- Scrap paper

PAINT PALETTE

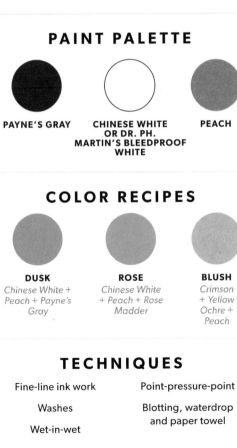

PAYNE'S GRAY **CHINESE WHITE OR DR. PH. MARTIN'S BLEEDPROOF WHITE** **PEACH**

COLOR RECIPES

DUSK
Chinese White + Peach + Payne's Gray

ROSE
Chinese White + Peach + Rose Madder

BLUSH
Crimson + Yellow Ochre + Peach

TECHNIQUES

Fine-line ink work

Washes

Wet-in-wet

Point-pressure-point

Blotting, waterdrop and paper towel

TIPS FOR THIS PROJECT

- Keep scrap paper nearby to test your colors as you work.

- The wreath you painted in Lesson 7 was more of a loose-leaf watercolor style, where you didn't worry about rough edges or perfectly smooth washes. This lesson encourages a more refined leaf, so you'll smooth out rough edges and hone the details and coloring of each leaf.

- When we use ink to create a boundary, we bring our paintbrush up to the edge of the ink to fill in the boundary. When we use colored pencils, as in this lesson, the lines are meant to be looser guidelines. I encourage you to paint over them—the coloring within the colored pencil line will dissolve into the paint, instead of forming a hard line.

- Remember, all the changes of color gradation and points of light (created when you remove color from your boundary using your paper towel or your brush) need to be made while your wash is still wet.

AS YOU BEGIN

- Tape your papers together to secure your watercolor paper to your tracing sheet. This way, you can move and reorient your paper while

BEGINNER

- Feel free to trace a simpler version by leaving out the large floral buds.

ADVANCED

- This is a wonderful time to design your own wreath. Botanical wreaths like this can be altered for every season, both in the foliage you choose to include and the color palette you select. Take a moment to observe the natural flora in your own corner of the world. Depending on where you live, and how diverse the seasons are, you could find some very stunning inspiration in the leaves and flowers all around you.

tracing without having to realign the marks every time.

- Use a light source, such as a window or a light box, to view your traceable design through your watercolor paper as you trace.

- Using your blush colored pencil, lightly trace the dashed lines on your Layered Wreath worksheet onto your watercolor paper. The lighter you trace them, the easier it will be to paint over them.

- Then use your gray colored pencil to trace over the solid lines, again tracing very lightly—dark enough to see, but light enough to paint over.

BRUSH: Round 4 **PAINT CONSISTENCY:** 50w/50p "heavy cream," moving toward an 80w/20p consistency of "soy sauce with wasabi"

Prime your brush with water and use your brush to bring water from your Mason jar to your palette to create a 50w/50p consistency of your Blush and Rose color recipes.

POINT-PRESSURE-POINT BLUSH LEAVES & BUDS

1 Dip your brush in water and fill it with your 50w/50p consistency of Blush and bring it to your watercolor paper. Working from the top left, begin your PPP motion on your Blush shapes. (You will come back to paint the little wisps and stems, so just ignore these for now, as they require a smaller brush.) **[A]**

2 Three or four fluid movements of PPP should cover each Blush leaf and bud. You should be able to make two PPP motions before needing to reload your brush. **[B]**

3 After you fill in a boundary, dip your brush in your wash water and use the point of your brush to smooth the fine edges of the boundary while it's still wet. **[C]**

4 Continue to paint each Blush leaf and bud, following the same steps. **[D]**

5 As you work, paint a few, pause, and then make subtle changes to the coloring of each while they are still wet. You can pull color out of the center by dropping in water and then blotting with a paper towel. **[E]**

6 You can also drop in a bit of the Rose color recipe to achieve a pinker tint, using the wet-in-wet technique. Use your brush to pick up the 50w/50p consistency of Rose and carefully drop it into an edge of a leaf or bud. **[F]**

7 Depending on how faintly you traced your colored pencil lines, they should be dissolving as you add character to each leaf and bud. If they are not dissolving, don't worry too much. You can deal with them later.

8 Work your way around the wreath, continuing to rotate your paper, painting in all of your blush buds and leaves and adding color interest as you see fit.

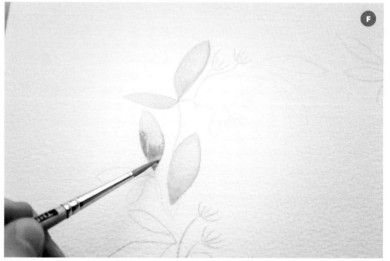

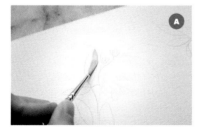

BRUSH: Round 4 **PAINT CONSISTENCY:** 50w/50p "heavy cream," moving toward an 80w/20p consistency "soy sauce with wasabi"

Prime your brush with water and use your brush to bring water from your Mason jar to your palette to create a 50w/50p consistency of your Dusk color recipe and your Payne's Gray paint.

POINT-PRESSURE-POINT DUSK LEAVES

1 Dip your brush in your 50w/50p consistency of Dusk and bring your loaded brush to your watercolor paper. Begin working in the top left, where your wreath is the driest, and start your PPP motion on your Dusk shapes. Ignore the little wisps, berries, and stems for now. **[A]**

2 Three or four fluid movements of PPP should cover each Dusk leaf. **[B, C, D]**

3 By dipping your brush into your water jar and using the point of your brush with just the tiniest bit of wetness, ensure the edges are smooth.

4 As you work, paint a few, pause, and then make subtle changes to the coloring of each while they are still wet. You can pull color out of the center by dropping in water and then blotting with a paper towel. **[E]**

5 You can also drop in a bit of Payne's Gray using the wet-in-wet technique. Use your brush to pick up the 50w/50p consistency of Payne's Gray and carefully drop it into the corners of a leaf to give it a deeper tint. You can also use the damp-brush technique to sweep the color away from the center. **[F]**

6 Work your way around the wreath, continuing to rotate your paper, painting in all of your Dusk leaves.

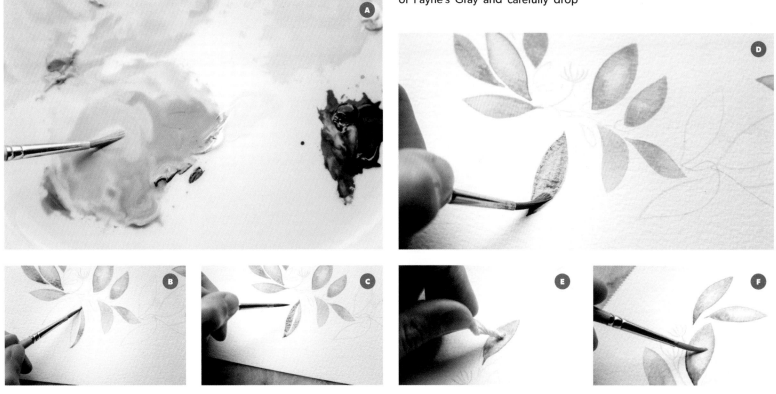

BRUSH: Round 1 (or smaller, if you have it)

PAINT CONSISTENCY: 50w/50p "heavy cream," moving toward 10w/90p "mustard"

Now it's time to paint the fine lines of the wisps and the stems and attach your encircling wreath vine to your leaves with small stems. You'll use your Round 1 (or smaller!) brush for this delicate task. Be aware of wet areas on your piece, as you don't want to smudge your leaves with your hand as you move around your page.

You'll use your 50w/50p consistency of Dusk and Blush from your palette, as you want very thin lines for the most control.

FINE LINES OF WISPS, STEMS & VINE

1 Fill up your brush with your Dusk consistency and bring it to your watercolor paper. Begin in the top left again and, with the lightest pressure, gently paint in the first wisp and connect it to the vine with the thinnest of lines. Artistically alternate between Dusk and Blush as you paint in the wisps and connect stems to the vine. [A]

2 Work slowly, rotating your paper as you connect leaves to stems to vine. In some places, the most natural way to paint the vine is by following your pencil-traced circle. [B]

3 In other spots, leaves overlap the center vine. Jump over these and allow your eye to dictate the next connection point.

4 Often, the center circle becomes a wisp, so follow the natural course, delicately and slowly painting the thin tentacles that make up your wisps.

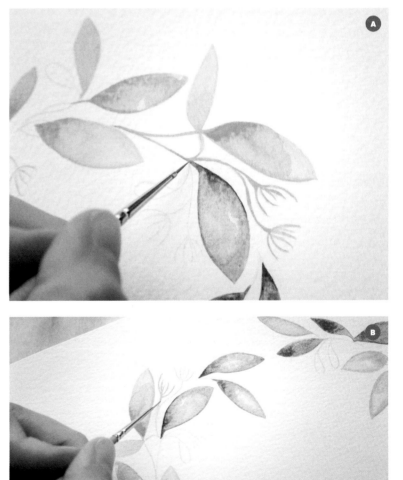

BRUSH: Round 1
(or smaller)

PAINT CONSISTENCY: 10w/90p "mustard"

Now it's time to add your Payne's Gray accents to the leaves, berries, and flower buds. A Round 1 brush will do the trick, but if you have a smaller size, like a 0 or a 5/0, use it! Smaller brushes have fewer bristles, and therefore soak up less water, allowing for more control.

WET-ON-DRY LAYERING

1 Prime your brush in water and use your brush to bring water to your palette to create your 10w/90p consistency of Payne's Gray. You do not need to add much water for this task, as you want very thin lines and more control with your paint.

2 Some leaves can just have a center line, and others can have a center line plus more down the halves. **[A]**

3 While you're detailing your leaves, you can go ahead and add the extra tips to your wisps and highlight some of your vine stems.

4 To complete your berries, dip your Round 1 in your Mason jar and pick up your 10w/90p "mustard" consistency of Payne's Gray. We want these to appear deep and solid in color, so this thicker consistency is your magic sauce.

5 Paint several lines of varying lengths of Payne's Gray on your buds as well. Notice that these lines flow at a slight curve, which seems to suggest that the bud is swollen in the center, about to open in bloom. The curved sweeping lines help suggest movement and the promise of a new flower! For the best result, turn your paper upside down, and pull your paint down from the stem, through the bud, and lift your brush as the line leaves the edges of the flower. The paintbrush strokes will have a more natural look this way. **[B]**

6 Dip your brush in your wash water and bring water to your palette to create a 10w/90p consistency of your Rose, Peach, and White.

7 Using the same upside-down orientation and curved stroke, add both thicker and thin alternating lines of Rose, Peach, and White to give each bloom its own unique look. Use your Dr. Ph. Martin's Bleedproof White for the bolder white lines or Chinese White for the more blended white look.

continues on next page

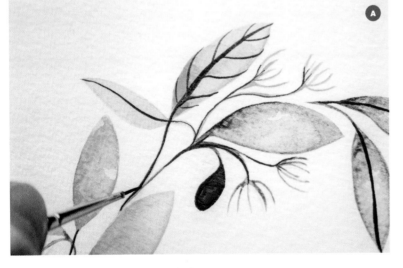

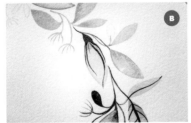

8 I suggest adding the white accents last, as they provide the most "pop" for your piece. [C–F]

9 Keep in mind that overusing Chinese White can begin to muddy up all of your lines, blending the defined Payne's Gray lines into your peach tones. If this happens, use the waterdrop blotting technique to bring clear water to your muddy colors, use your brush to scrub the area lightly, and blot with your paper towel to soak up the water and paint. [G]

10 Then, once the boundary is dry, repaint your wet-on-dry lines as needed.

DETAIL WORK

As you prepare to add wet-on-dry layering as detail lines to your piece, consider what patterns you would like to create on your leaves. Do you prefer those lines to be straight or curved? Angle toward the points of the leaves, or head straight to the edges?

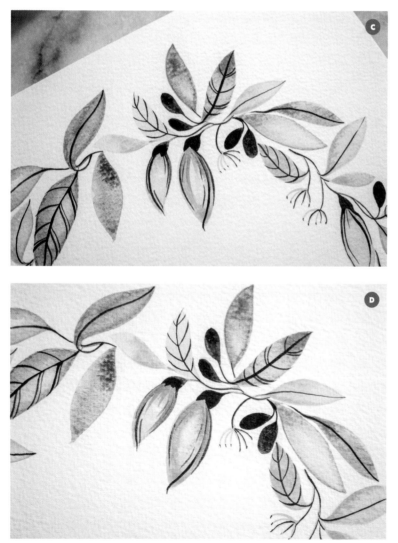

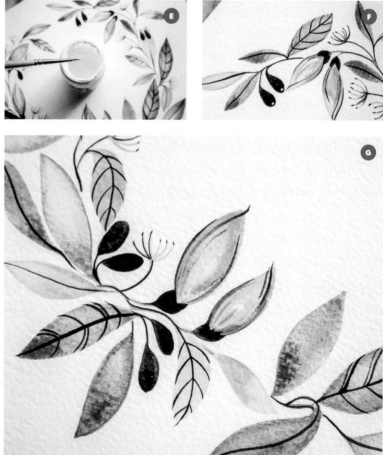

MINDFULNESS WITH WATERCOLOR

EXTENSIVELY EXPLORED AND RESEARCHED, THE DEFI- nition of Mindfulness may include paying attention, living in the present moment, and finding contentment in a nonjudgmental awareness of yourself and your environment.

While we can practice mindfulness in a myriad of ways (gardening, yoga, meditation, dancing, and more) it is my watercolor practice that has taught me—and continues to reveal to me—the benefits of slowing down and being mindful. The rhythmic, repetitive motions are comforting, therapeutic even, and the required concentration evokes a feeling of calm. As I paint, worries tend to melt away as I focus solely on the task in front of me. The opposite of multitasking, this unique kind of focus can even reduce stress and anxiety.

Perhaps I'm biased, but I believe in the magic of painting. When my paintbrush moves just right and creates a beautiful image on the paper, it is as though I grab hold of a dream and bring it to life. When the paint flows and my hands create things beyond what my mind can imagine, it's as though I can make time stand still. When I'm fully engaged and present in my artwork, painting can whisk me away into a creative space that is all my own.

With any endeavor, strength develops through repeated practice. If you regularly practice this type of calm focus on a single task, you will create a habit of peacefulness. You can rewire your brain through patterns of mindful activity. Ask yourself, "What do I want to strengthen in my life?"

Of course, how you practice makes a difference, too. As you learn to paint—or to learn any new skill—you must give yourself grace. When practiced, lines and shapes that present a challenge today will feel fluid and natural in a month. Learn with intention; be kind to yourself and embrace the ups and downs in your journey. Celebrate that you are on the path of a lifelong learner, using your means and abilities to acquire new skills and knowledge. Rejoice in stretching your creative muscles to see the world in a new way. Delight in the sense of satisfaction that comes with each new technique or completed lesson. Grant your spirit love, care, and encouragement in this new journey.

What a gift to be able to experience the world through new eyes with watercolor, and in turn become alive to new sensations and experiences. You're on your way to becoming an artist—and a happier, more grounded person, too, as you experience the profound effects of mindfulness in art. Pretty cool, right? ●

DRAPING BOTANICALS
INK, PENCIL,
WATERCOLOR & GOUACHE

LESSON 15

CREATING AN ARTISTIC PIECE THAT'S INSPIRED BY A REAL-LIFE bouquet of flowers is the best way to preserve your favorite flowers, and to enjoy them forever. In this lesson, we are going to look at the bouquet I arranged with some of my favorite seasonal flowers, including an "Itoh" tree peony and some very delicate arugula flowers. Both of these flowers bloom in my garden for only a week or so every year, so it is pure joy to capture their shape and movement on paper—and savor their beauty! Real-life bouquets can be complex and layered, and can feel intimidating at first glance. We are going to cover how to identify the key elements of a bouquet (the Thrill, the Spill, and the Fill) and translate a three-dimensional arrangement onto a two-dimensional surface (watercolor paper), so you can recreate any of your favorite flower arrangements in a painted masterpiece of your own.

TOOLS

- Round watercolor brushes, sizes 4 and 1
- 140-lb. watercolor paper
- HB pencil
- Micron pens, sizes 005, 01, and 02
- Traceable "Draping Botanical" worksheet, beginner or advanced (page 215)
- Tape (washi or drafting)
- Light source for tracing (a well-lit window or a light box)
- Artgum Eraser
- Paper towel
- 2 Mason jars of water

PAINT PALETTE

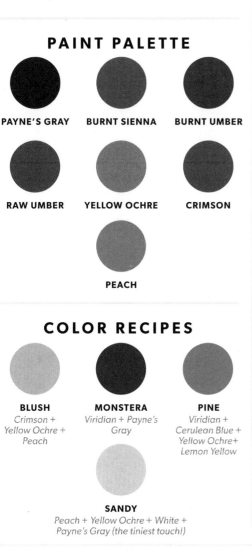

PAYNE'S GRAY **BURNT SIENNA** **BURNT UMBER**

RAW UMBER **YELLOW OCHRE** **CRIMSON**

PEACH

COLOR RECIPES

BLUSH
Crimson + Yellow Ochre + Peach

MONSTERA
Viridian + Payne's Gray

PINE
Viridian + Cerulean Blue + Yellow Ochre + Lemon Yellow

SANDY
Peach + Yellow Ochre + White + Payne's Gray (the tiniest touch!)

TECHNIQUES

Fine-line ink work Wet-in-wet

Washes Blotting

TIPS FOR THIS PROJECT

- When you trace the design in pencil, and then in ink, begin by tracing all of the leaves first before moving on to the flowers. Working with repetitive shapes will give you the best results. You will discover that your hand movement finds a flow. You will also build up muscle memory, which can help with your freeform drawing down the road.

- You will have the most control over your lines when you pull your pen or brush down toward you. Reorient your paper so you can continue to pull lines, marks, and strokes toward yourself.

PENCIL & INK

- Tape your papers together to secure your watercolor paper to your tracing sheet. This way, you can move and reorient your paper while tracing without having to realign the marks every time.

- Trace over your pencil lines with your Micron pens. Use the 01 or 02 for the petals and leaf outlines, and the 005 or 01 for the finer lines of the stems, arugula petals and pods, and the inside of the peony.

BEGINNER

- Feel free to trace a simpler version by just focusing on one of the larger peony flowers and a grouping of leaves. As you feel more confident with these elements, add more of the other botanicals, working up to the entire tracing and following all of the Intermediate steps laid out in the lesson.

ADVANCED

- Study the pictures of the flower bouquet, and perhaps you can add in an iris. By adding in the element of a deep purple flower to complete the color scheme, your bouquet will only increase in complexity and beauty. This is also a wonderful opportunity to rearrange this bouquet differently. Trace elements in a different design, or perhaps your artistic eye sees that this bouquet just needs a ___ (you fill in the blank) . . . it's your turn! Another way to challenge yourself: introduce gouache as your waterdrop into the Monstera leaves. Watch and see how gouache bleeds into watercolor, instead of clear water.

- Once all of your art is inked, begin erasing where the ink is driest, which will be where you began tracing. Go slow.

PAINTING FLORALS:
THE THRILL, THE FILL & THE SPILL

Often used as a design rule in floral arranging or container gardening, the saying, "The thrill, the fill, and the spill" is also a great way to think about how to arrange a botanical watercolor. It's simply a creative way to create multiple layers of interest within a piece.

The Thrill: What flower or color inspires you? That will become the main attraction of your painting. In this floral arrangement, the Itoh tree peony is by far my favorite element of the design. Often, I will recreate the flower in pencil on my page, just from observing it in the garden or a picture. Since I own this photo (taken by the incredible Erin Schedler), I have permission to use it to create a flower tracing. (Be sure to ask permission whenever you paint or trace from photos!) By tracing its lines onto watercolor paper, we begin to understand flower structure and movement and build up muscle memory to train our hands.

Once you have decided on your thrill, it's time to add the supporting balance of the spill.

The Spill: These are the elements that provide the overall outer shape to your piece—top, bottom, and both sides. In this example, the clematis and lace-leaf hydrangea, as well as the ferns and arugula flowers, seem to "spill" over the piece and give it its full shape. Rarely do flowers, leaves, and berries in nature grow perfectly upward. Leaves often face down and angle themselves like solar panels in order to soak in that sunshine. You want these wild, supporting elements in your arrangement to complement your main attraction or "thrill." When you "spill" leaves and blooms, your bouquet begins to take shape. Here, the arugula branches and flowers provide the asymmetrical balance that characterizes most of my watercolor pieces.

Once you have a focal point and some balance, it's time to add your fill.

The Fill: These are the elements of your piece that fill in the shape of an arrangement or painting. To give a bit more width to this piece, I added a rose. Also, since I have a peony and arugula flowers, a third flower provides a nice rhythm to my drawing, repeating the floral patterning. Adding a few more leaves tucked in and around the arrangement for more "fill" finalizes the drawing.

Once I create a pencil arrangement like this, I often hang it on my wall for a few hours (or days!) before I commit to it. I like the fresh eyes of a new morning or coming upon it without overthinking its design. Often, those fresh eyes give me the insight into just what the piece needs to make her complete.

I've provided a traceable for this project, but once you're ready to start with your own pencil drawing, I highly recommend using The Thrill, The Spill, and The Fill!

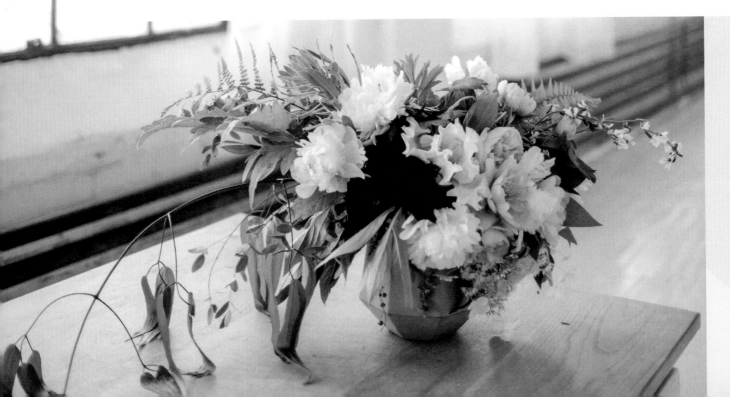

BRUSH: Round 4, Round 1

PAINT CONSISTENCY: 80w/20p "soy sauce with wasabi," moving toward a 50w/50p "heavy cream" consistency for the wet-in-wet application

Prime your Round 4 brush with water and use your brush to bring water from your Mason jar over to your palette to create the 80w/20p consistency of your Monstera color recipe. Dip your brush in water and bring it back to your palette to create an 50w/50p consistency of Payne's Gray. We will be using Payne's Gray very minimally and in small concentrations.

LARGE MONSTERA LEAVES

1 After you have primed your colors on your palette, clear your brush in the Mason jar. You will start with a clear wash, so load up the bristles with water and bring your brush to your watercolor paper.

2 Wash your first large leaf, working from left to right and using your paintbrush to lightly "scrub" the paper in a side-to-side motion.

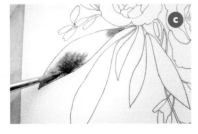

Once your first leaf has a nice sheen, it's time to add your paint. [A]

3 Bring your brush to your palette and load the bristles with your 80w/20p Monstera green mixture.

4 Take your brush to your wet leaf and use the wet-in-wet method to drop in Monstera at the points of the leaf, both at the tip and where the stem connects to the leaf shape. Let the color bleed, creating its own masterpiece within your leaf shape. [B, C]

5 As you watch the paint move and bleed within your wet leaf boundary, pick up your Round 1 brush, prime it with water, and pick up your 50w/50p "heavy cream" consistency of Payne's Gray. Bring your brush to your leaf and drop in the smallest amount of the Payne's Gray mixture at the tips of the leaf, just as you did with the Monstera—but since the Payne's Gray mixture has less water, it will not spread as

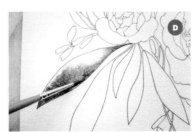

quickly or fully as the Monstera, allowing for very dark concentrations of color in those points. [D]

6 A lighter point will naturally form in your leaf, usually near the large center area, depending on how much Monstera and Payne's Gray you've dropped in. While your leaf boundary is still wet, use the waterdrop method to drop in clear water. If your boundary is still very wet, the clear waterdrop will simply diffuse the paint in the area where you drop it in. If your leaf has begun to dry, the waterdrop will create a watercolor bloom as the water encounters the drying Monstera paint. [E]

7 Use your brush to bring your wash to the leaf's edge to cover

the entire boundary. Using a Round 1 allows you to have a bit more control and stay within the lines better. As you can see in this photo, I washed the entire leaf with a Round 4 and dropped in color, and then I used a Round 1 to bring the wet boundary to the pen edge, all while the leaf boundary was still wet. [F]

8 Repeat this process for all of the Monstera leaves.

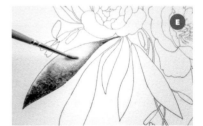

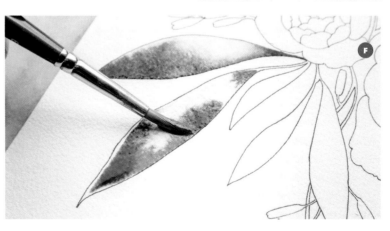

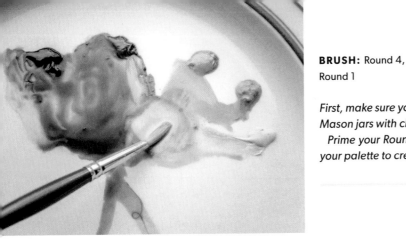

BRUSH: Round 4, Round 1 **PAINT CONSISTENCY:** 80w/20p "soy sauce with wasabi"

First, make sure your brushes are rinsed with cool, clear water to remove all of the paint tones. Refill your Mason jars with clear water.

Prime your Round 4 brush with water and use your brush to bring water from your Mason jar over to your palette to create the 80w/20p consistency of your Blush color recipe.

SMALL PINE LEAVES

1 In order to achieve a high-low contrast in the small leaves, contrary to what we just did for the larger leaves, you will begin with a wash and use the blotting method to remove the light space. When your boundary is this small, pulling color out is the best method to create contrast.

2 Load your brush with your Pine mixture and bring your brush to your watercolor paper. Wash your first small leaf, filling the entire boundary with Pine green. **[A]**

3 Once your leaf has a nice sheen of paint and water, bring your paper towel to your paint and gently pull out the pigment from an area where you would like the light to shine out. **[B]**

4 If that doesn't pick up enough color, feel free to drop in a clear waterdrop, and use your paper towel and a clean, damp brush to push the paint away from the light spot as the wash begins to dry. **[C]**

5 If you'd like a bit more contrasting Pine green within your leaf, you can dip your brush back in your Pine green and drop in color at the corners of the leaf while the boundary is still wet. I love creating each leaf as a unique painting. Take your time and enjoy every leaf! **[D]**

6 Repeat this process for all of your Pine-green leaves.

7 Learning the balance of when to walk away and move on to the next leaf, and when to revisit a drying leaf that needs a water bloom or a little paper-towel blotting takes practice and repetition. Sometimes you need to let a leaf just dry and do its thing; other times, a few touches with your brush or a paper towel completes the look of the leaf. You'll hone your eye over time, and you don't want to fuss too much! **[E]**

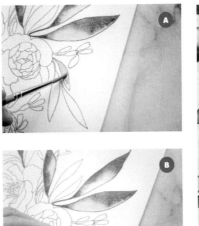

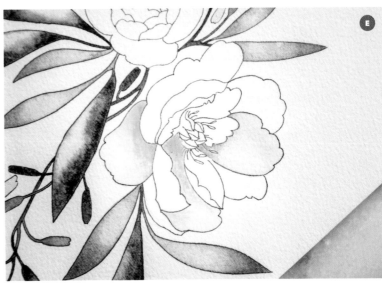

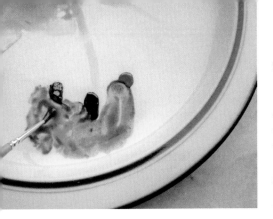

BRUSH: Round 1

PAINT CONSISTENCY: 50w/50p "heavy cream," moving toward 80w/20p "soy sauce with wasabi"

Prime your brush with water and use your brush to bring water from your Mason jar over to your palette to create the 50w/50p-moving-toward-20w/80p consistency of a triad of color dabs: Burnt Sienna, Burnt Umber, and Raw Umber.

Painting these stems and pods is very similar to painting the multicolored leaves in the Lesson 12 (see page 147).

ARUGULA FLOWERS, PODS & STEMS

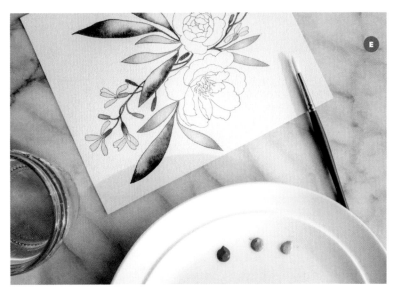

1 Fill your brush with your new mixture of Burnt Sienna and bring your brush to your watercolor paper to begin painting the brown stem parts of the arugula flowers. You will work your way down into your piece, rotating your page so you can access the sections you need.

2 Begin with the base of the arugula flower petals, what I'm calling the 'pod.' Apply a wash of Burnt Sienna. As you make your way down, painting stem and pod, alternate between the three colors of your "heavy cream" consistency of Burnt Sienna, Burnt Umber, and Raw Umber. This adds variety and gives the desired "painterly" effect of gradual gradation within the piece. **[A, B, C]**

3 Once your pods and stems are complete, it's time to paint in your arugula petals.

4 Prime your brush with water and use your brush to bring water from your Mason jar over to your palette to create a 50w/50p-moving-toward-80w/20p consistency of your Sandy color recipe. Load your brush with your Sandy color and bring it to your watercolor paper to paint in the arugula petals, as you have the arugula pods. Use very light pressure to only access the point of your brush, as these boundaries are relatively small, and you don't want to overfill or flood them with your paint-and-water sauce mixture. **[D]**

5 Now all of the "spill" and "fill" have been painted—it's time for the "thrill!" **[E]**

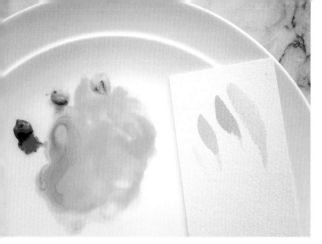

BRUSH: Round 4, Round 1

PAINT CONSISTENCY: 80w/20p "soy sauce with wasabi"

First, make sure your brushes are rinsed with cool, clear water to remove all of the paint tones. Refill your Mason jars with clear water.

Take a moment to observe the rose and peony boundaries that you'll be painting. Notice that some petal boundaries are large and others are quite small. You will paint the larger petal boundaries much like you did the larger leaves, and the smaller petals much like the smaller leaves.

Prime your Round 4 brush with water and use your brush to bring water from your Mason jar over to your palette to create the 80w/20p consistency of your Blush color recipe.

ROSE & PEONY, LARGE PETALS

1 Because you will be following your black ink lines as your boundaries, you want to be extra conscious of your water-to-paint ratio. When you're trying to stay within the lines, it is truly an art to find the perfect wash balance—not too much water to flood the smaller boundary, but enough water to allow the paint to move and bleed, creating the lovely watercolor effect.

2 Dip your brush in your clear water Mason jar and bring it to your watercolor paper. You'll begin with a clear wash on the larger petals of the peony.

3 Wash your first large petal boundary, working from left to right and using your paintbrush to "scrub" the paper texture in a back-and-forth motion, simultaneously lifting the paper fibers and bringing water to your paper surface. As you work, add this clear wash to the stamens and inner details where they overlap with your petals. You will add color to their points at the end. [A]

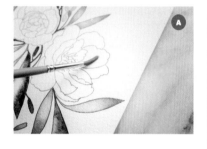

4 Once your first petal has a nice clear sheen, it's time to add paint.

5 Prime your Round 1 brush with water and bring it to your palette to pick up your Blush color mixture. Take your fully loaded brush to your watercolor paper to your wet petal boundary and use the wet-in-wet method to drop in the Blush color at a spot near the center of the flower. Flowers like the Itoh tree peony are usually the boldest in color near the center of the flower, so dropping in your color here with the wet-in-wet method will ensure this part of the petal is the most saturated, mimicking nature. Let the color bleed into the petal, moving itself and creating its own masterpiece. [B]

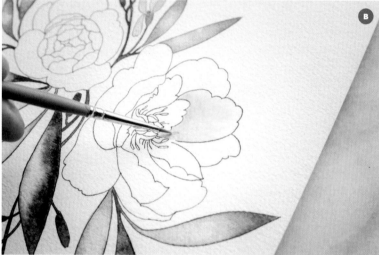

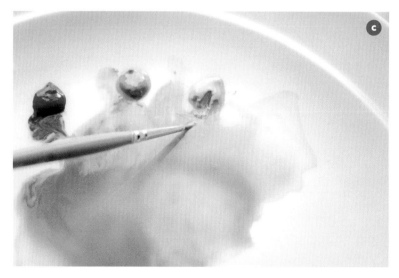

6 As you watch the paint move within your watery petal boundary, pick up your Round 1 brush, prime it with water, and bring some water over to your palette to animate your Peach paint, aiming for a 50w/50p consistency. Load your brush with your new Peach mixture and bring it to your wet petal boundary. Drop in the smallest amount at the edges and centers of your petals. **[C]**

7 While your petal boundary is still wet, use the waterdrop technique to drop in clear water. If your boundary is still very wet, the clear waterdrop will simply diffuse the paint in the area where you drop it in. If your petal has begun to dry, the waterdrop will create a watercolor bloom as the water encounters the drying Blush paint.

8 Identify the larger petal boundaries of the peony and the rose, and paint each of them following this same process. Add pops of colors once the petal boundaries are wet, and use the waterdrop technique to make each petal look unique. **[D–H]**

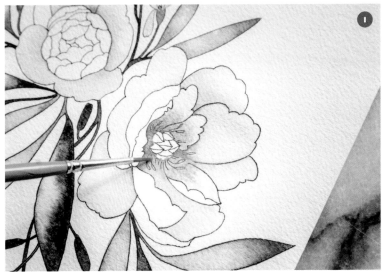

9 If you want, you can make a few unique choices for each of the larger petals as they dry. If you can still see a shine on a wet boundary within the petals, add color by dropping in the Peach again at the point in the petal where you want the highest concentration of color. You can be bold and drop in Crimson or Yellow Ochre (making sure you're working with a 50w/50p "heavy cream" consistency of each on your palette), but drop them in lightly and build slowly in color so they don't overpower the petals. **[I]**

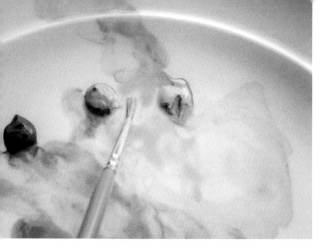

BRUSH: Round 1 **PAINT CONSISTENCY:** 50w/50p "heavy cream"

Now it's time to adjust our method and paint the smaller petal boundaries.

Prime your brush with water and use your brush to bring water from your Mason jar over to your palette. Make sure you have a 50w/50p consistency of your Blush color recipe.

Many of these petal boundaries are so small that they actually look good in a concentrated color, creating an almost stained-glass effect.

ROSE & PEONY, SMALL PETALS

1 Load your brush with your 50w/50p consistency of Blush and bring it to your watercolor paper. Beginning with the smaller boundaries on the peony, create your base wash in Blush. From there, you can drop in Peach and a more concentrated (10w/90p) Blush color using the wet-in-wet method.

2 Once your petal has a nice sheen of paint and water, you can use your paper towel to blot out the pigment in a spot you would like some light to shine. If that doesn't pick up enough color, drop in a clear waterdrop and use your paper towel

and a clean, damp brush to push the paint away from the light spot as the wash begins to dry. **[A, B, C]**

3 As your small petals begin to dry, you will see that the slight differentiation in the water-to-paint ratio allows for subtle color variety, adding interest to the flower as a whole.

4 Next you will paint the small petals of the rose. To add variety, alternate the colors you use to wash each boundary—some in Peach, some in Blush, some with just the wash water (these are the

lightest!). **[D, E]**

5 Be aware of which small boundaries are still wet, being careful not to cross wet boundaries.

6 If you happen to paint a small petal on the same boundary of

another small petal that is still wet, they will bleed together. But don't worry—since you are working in a very limited palette within these petals, it's an easy fix. **[F]**

6 To fix bleeding boundaries, blot both petals with a paper towel and pull out all the deposed pigment. Wait until they both dry and become separate boundaries again. Then you can rewash them separately, in analogous colors.

7 Follow this process for all of the small rose petals.

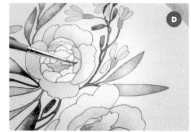

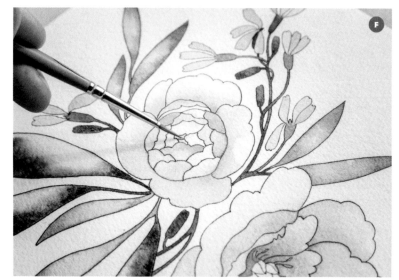

BRUSH: Round 1 **PAINT CONSISTENCY:** 90w/10p "soy sauce" (Pine), 10w/90p "mustard" (Yellow Ochre for stamen points)

For the very center of the peony, prime your brush with water and use your brush to bring water from your Mason jar over to your palette to reanimate your Pine color recipe, aiming for a 90w/10p "soy sauce" consistency. You want the very lightest tinge of a green tone for the center of your flower.

PEONY CENTER

1 Load your brush with your light Pine color mixture and bring it to your watercolor paper to lightly wash the center of your peony, giving it the slightest tinge of green. You can test your color on scrap paper first, or simply paint it right onto the center of your peony and use your paper towel to blot any excess in color or water.

2 To add color to the stamen tips of the peony center, prime your brush with water and use your brush to bring water from your Mason jar to your palette to reanimate your Yellow Ochre paint, aiming for a 10w/90p "mustard" consistency.

3 Load your brush with the 10w/90p "mustard" consistency of Yellow Ochre and gently dab in the color. [A]

For those of you who would love to paint the art on the cover of my book, there is a traceable for it on page 217. Using this tracing would be an Advanced way to approach this lesson, as the steps for incorporating Micron pen, watercolor, and gouache are the same for both of these beautiful floral bouquets.

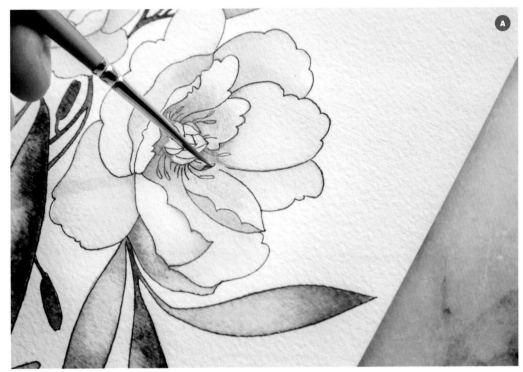

HOW TO FIND YOUR VOICE

ONE OF THE MOST FASCINATING THINGS THAT I'VE WITNESSED IN CLASS IS the way each student receives a lesson through their own unique filter, and likewise, creates strikingly individual pieces of art.

We may all sit at a table together, look at the same examples, hear the same teaching, animate the same paint colors, and often work from the very same drawings. Yet, each person creates something that is unique. I love exploring what is happening here.

Even when we imitate, as many of us do as we learn a new skill, a person's creative fingerprint is stamped onto their piece. Some kind of filtering, an interpretation, occurs inside the self, and what comes out is one's own work. This is Art. I may have composed all of our lessons in this book, but I promise you: yours will be one of a kind.

As you follow along, painting and learning new techniques, feel freedom to move in your intuitive choices. Do you prefer a darker, more vibrant burgundy color? Does it feel more balanced to you to add a few more leaves, or a few less? Try it! Listen to yourself and see where it takes you.

We are born makers. Creating with our hands allows us to take our teaching—what we've learned through education and experience—move it through our heart and mind, and then out through our hands. These unique expressions of color and shape are refreshing to a community because they often resonate with the unexpressed ideas of others and have a way of bringing individuals together. At its best, Art unites people. It reminds us that we are not alone.

I create so I can be myself and be in community with others.

I create to escape from the monotony of daily life and to engage in life more deeply, with the full force of my creative self.

It may not feel like you have your own "style" yet, and that is ok. Use these lessons to hone your eye, train your hand, identify with techniques that help express that intuitive driving force in your own mind. And use these lessons as a springboard. The only way to find your own style is to keep creating.

Recently I was asked to be one of the six Watercolor Instructors to teach a worldwide online Watercolor Summit (what an honor!). I eagerly accepted and set upon the task of designing a piece that would teach technique in a simple, approachable way, but also provide an exciting challenge to those who were familiar with the process but wanted to push themselves to

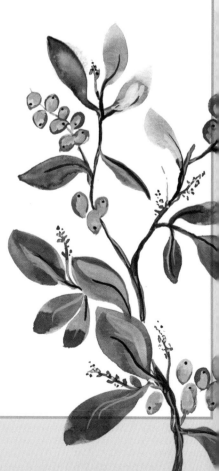

create something new—with their own voice. My lesson provided the lines and I took them through the creation process of a piece similar to the one in this book for Lesson 15. Pencil to ink, then watercolor.

I cannot fully express the joy I felt the morning my lesson went live, when I opened my Instagram and artists from India were sharing what they'd already learned from my teaching session. It was a joyful feeling beyond my wildest dreams to see artists from all over the world, from Mumbai to Mexico City; St. Petersburg, Russia; Busan, South Korea; Abu Dhabi, UAE; Kuala Lumpur, Malaysia; Jönköping, Sweden . . . over seventy-three countries represented, all downloading the recorded videos and creating a beautiful piece together. We encouraged everyone to share photos of their process and their final piece. I cannot put into words the beauty that began to flood in or the happiness I experienced as people were using their new techniques and creating their own stunning art. They may have learned by tracing my lines and using my color palette, but then many found their own flowers to inspire new and original lines and compositions and mixed their own individual combinations of colors to create a piece of art that was distinct and beautiful.

As I sit here thinking about the excitement I experienced during the Summit, I can barely contain myself thinking about what you will create with the lessons in this book. I cannot wait to see your process pictures and your final pieces! And just like the Summit, my hope and dream for you is that you will apply the instruction but also play and explore, and eventually emerge with your own style.

As you travel through the lessons, creating at the Beginner or Intermediate level, my hope is that you will revisit the lessons again and again, gleaning new wisdom as your understanding of technique increases. You can restart at the beginning using the Advanced prompts (and even come up with some of your own!) to challenge yourself and see what you're capable of. Believe me, your Lesson 7 wreath will look very different if you return to it again after completing all the lessons. You will be amazed at your growth; that potential is in you right now.

And the more you create and mature in your skills, the more your distinct voice will emerge. Every artist has something to say— the challenge is translating the image in our minds onto the page, especially as the vision continues to grow, pushing us to greater skills and demanding a higher level of technique. Build slowly and steadily, be gentle with yourself. Feeling clumsy with the slight resistance to growth in a new area is normal. Allow yourself the space to feel this way, push through the uncomfortable. You are on the path to becoming an artist and this is where you begin to define yourself. Soak in the shapes and colors of bouquets at your local market, filter them through your Self, and use your new skills to translate them onto paper, in paint and water.

Please share your process by tagging @TheMintGardener on Instagram, and using the hashtag #modernwatercolorbotanicals. I truly cannot wait to see what you create and encourage you on your journey. Your learning process inspires me! And it inspires others who need to see—who need that little spark to go ahead and create. ●

WILDFLOWERS
LAYERING
WITH GOUACHE

WHILE YOU WILL BE PAINTING ANOTHER FLORAL ARRANGEMENT here, inspired by the same beautiful bouquet we have used throughout the book as our inspiration, the bouquet in this last lesson looks different. The bouquet in Lesson 15 was about incorporating ink to create precise lines, and the joy and beauty of movement that comes in transparent watercolor. It has a stained-glass beauty to it, with all the dark inked lines and subtle color shifts. By contrast, this lesson has a wilder feel and is all about abstract botanical shaping and creating movement in watercolor with texture and layers. You will use gouache in a more intentional way, unleashing its opaque beauty and bringing more depth to your watercolor art.

TOOLS

- Round watercolor brushes, sizes 4 and 1 (and, if you have them: 0, 00, 5/0, 10/0)
- 140-lb. watercolor paper
- HB pencil
- Colored pencil, white (optional)
- Traceable "Wildflowers" worksheet (see page 203)
- Tape (washi or drafting)
- Light source for tracing (a well-lit window or a light box)
- 2 Mason jars of water
- Artgum Eraser
- Paper towel
- Scrap paper

PAINT PALETTE

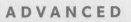

PAYNE'S GRAY **YELLOW OCHRE** **RAW UMBER**

CHINESE WHITE OR DR. PH. MARTIN'S BLEEDPROOF WHITE

COLOR RECIPES

SAGE
Viridian + Cerulean Blue + Yellow Ochre

PINE
Viridian + Cerulean Blue + Yellow Ochre + Lemon Yellow

STORM
Payne's Gray + Ultramarine

APRICOT
Crimson + Chinese White + Peach

RASPBERRY
Magenta + Crimson White + a touch of Payne's Gray

IRIS
Magenta + Crimson + Chinese White + Payne's Gray

MONSTERA
Viridian + Payne's Gray

TECHNIQUES

Washes Wet-on-dry

Wet-in-wet Gouache

TIPS FOR THIS PROJECT

- You will paint this piece in three different layers. The first layer will be considered the backdrop of your piece and will be made up of the "spill" and "fill" (see page 170). This first layer is made of a wet wash with movement and shine, with wet-in-wet pops of deeper color dropped in. Once this first layer is complete and dry, you will add the second layer, and the beginnings of the "thrill." And once this second layer is dry, you will be ready to add the third layer, complete with all of the details and dimension that make up a stunning wildflower bouquet for your final arrangement.

- Pieces like this are one of my favorite reasons for working in an open palette. Colors will blend and change as you work, often mixing to create tones somewhere between the recipes. If you spy a fantastic shade on your palette that is the result of your colors blending and playing, then by all means, use it! This is part of the magic of watercolor!

- Keep scrap paper nearby to test your small brushstrokes as you work. You want to make sure your details are made of fine, delicate marks that will not suddenly unleash a huge supply of water into surrounding boundaries.

- As always, remember to continually pull two to three feet back from your piece as you are painting, gaining perspective as you create.

PENCIL WORK

- Tape your papers together to secure your watercolor paper to your tracing sheet. This way, you can move and reorient your paper while tracing without having to realign the marks every time.

- Use a light source, such as a window or a light box, to view your traceable design through your watercolor paper as you trace.

- Using your HB pencil, lightly trace the lines of the background onto your watercolor paper. This will provide all the fine lines of the ferns, the clematis, and all of the supporting fill-and-spill elements. Because all of the background tracing will be covered in a very dark wash, you do not have to worry too much about your lines.

ARTICHOKE

FERN

IRIS

ARUG
FLOW

PEONIES & ROSE

HYDRANGEA

PEPPER BERRIES

CLEMATIS

BRUSH: Round 4 **PAINT CONSISTENCY:** 80w/20p "soy sauce with wasabi," moving toward 90w/10p "soy sauce"

Prime your brush with water and use your brush to bring water from your Mason jar to your palette to create the 80w/20p-moving-toward-90w/10p consistency of your Storm, Monstera, Pine, and Sage color recipes. This is for the large oval boundary. Because it is the backdrop to the piece, you'll want to add interest and dimension by giving it gradation in many colors and tones of green.

FIRST LAYER: BACKDROP

1 Clear your brush in your Mason jar and bring your water-filled bristles to your watercolor paper to start with a clear-water wash.

2 Wash your oval boundary, working from left to right, using your paintbrush to lightly "scrub" the paper in a back-and-forth motion, bringing clear water to your paper surface. **[A]**

3 Once your oval shape has a nice clear, shiny sheen with movement, it's time to add your paint.

4 Bring your brush to your palette and load it with the 80w/20p Pine color recipe. Take your fully loaded brush to your wet boundary, using the wet-in-wet method to drop in the Pine color at different points: both of the edges and parts in the center. Work quickly as you fill the boundary with color. **[B]**

5 Now, bring your brush back to your palette to access the 80w/20p Storm and Sage recipes, as well the pure Payne's Gray, Raw Umber, and Yellow Ochre, and bring them individually to your wet boundary. Use the wet-in-wet method to drop in these different colors throughout the wet boundary, adding interest and points of color within your wash. **[C–E]**

6 If you notice a significant puddle forming on your watercolor paper, feel free to use your paper towel as "vacuum." Remember, we want movement and shine, but a "biodome" effect threatens boundary overflow and unpredictable drying lines. **[F, H]**

Keep going! This boundary needs to stay wet for the backdrop details which you start learning on the next page.

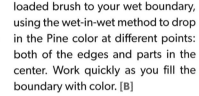

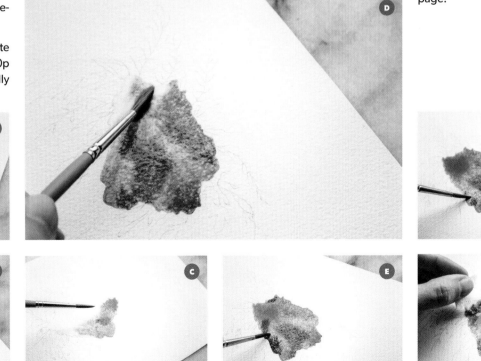

BRUSH: Round 1 (or smaller 0, 5/0, or 10/0) **PAINT CONSISTENCY:** 50w/50p "heavy cream"

Next you will practice fine-line brush-detail work by painting in the shapes of your ferns, artichoke leaf, clematis vine, and little bits and bobs around the wet oval boundary. To fill in these wild details of the background, switch to a smaller brush or, better yet, a variety of small brushes. When working with fine details, be sure to test on scrap paper before you make the final marks on your piece.

You will want to try to complete as many of these detail strokes as possible while the large oval boundary is still wet, in order to ensure continuity in the piece.

You will be accessing some color recipes with your brush from your palette, but you will also use your brush to pull the wet color mixture OUT from your large wet oval boundary. (Much like you did in previous lessons, as you continued a vine or a stem.) Be sure to keep your palette wet with water, to keep that movement and shine in your sauce, before you bring your paintbrush to your paper. While painting, consistently check the water on your palette, making sure the colors you want to use are wet and ready to be added to your piece.

FIRST LAYER: BACKDROP DETAILS

1 Prime your Round 1 brush with water, scoop up your 50w/50p "heavy cream" Sage mixture and bring your brush to the wet boundary of your bouquet. Use your PPP motion to pull the Sage-colored leaf out from the wet boundary of your large wet oval, causing the boundaries to mix in color, but still maintaining the delicate new stroke marks of the small leaf shapes. You should be able to create most of these leaf shapes with one to three strokes of your small paintbrush. **[A–D]**

2 Because each boundary is so small, you don't need to worry about creating a wet-in-wet effect in them. Aim to use just enough water and paint within each to enable the paint to flow, but not so much water that you flood the small boundary. Watch out for the biodome effect and if it happens, use the blotting method with your paper towel to gently "vacuum out" any section where the water seems to be puddling, or is about to run over.

3 Alternate your colors by pulling different paint mixtures out of

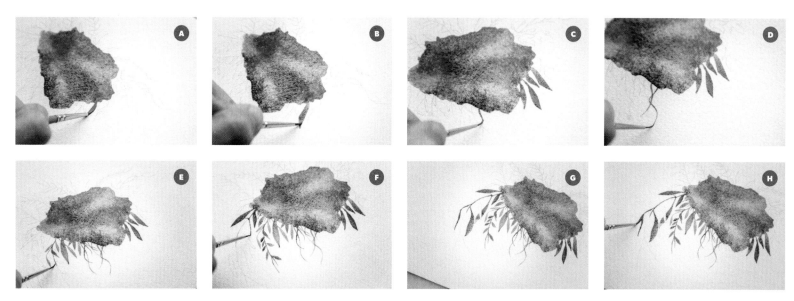

the oval and bringing different colors from the 50w/50p consistency mixtures on your palette to provide slight color gradations as you paint your small lines, tracing along your pre-drawn pencil lines. Different variations of the green recipes we have created together work beautifully here, and you can see from the photos that I've used Sage and Pine. I've also kept a few of the pure tube colors on my palette animated as well, Burnt Umber and Yellow Ochre, to use in creating these fine detail lines. [E]

4 As you bring colors from your palette to your fine "spill" details, slowly shaping the outline of this wildflower bouquet, you are letting the boundaries and colors combine with one another, and essentially letting them watercolor themselves. I don't brush or paper-towel blot these too much. Just keep moving, because your large oval wash is on its way to drying. [F]

5 If you encounter overlapping leaves, paint one and leave the other one white until the first boundary is dry. This will give you more

control. Beware small boundaries with overlap! [G]

6 Use the PPP method for the leaves, switching between small brush sizes (if you have them), depending on the size of the boundary—use the smallest brush size for the smallest boundaries. [H–L]

7 Try using a few different colors as you paint the multiple PPP strokes to complete a leaf. Because all of the boundaries are shiny with wet movement, you can introduce variances in color as you work. They will dry together without creating any hard lines. [M]

8 Keep switching brushes if you can. The Round 10/0 will give you the best control for the smallest boundaries. [N]

9 You may find there is enough movement even in these small boundaries to use the wet-in-wet method to drop some dark accents into the fern leaf, and also connect the fern to the larger oval boundary, as I did here. Remember, these movements can be made only when the boundaries are still wet. [O]

10 If you're finding that your large oval is beginning to dry as you work your way around your piece, leading to some hard lines, don't worry! You will use gouache to add some layers after the

background is complete. Gouache covers up hard lines because it is not transparent . . . so you will be able to deal with these lines later on. [P–S]

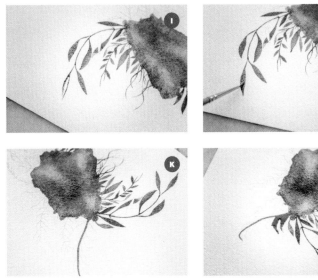

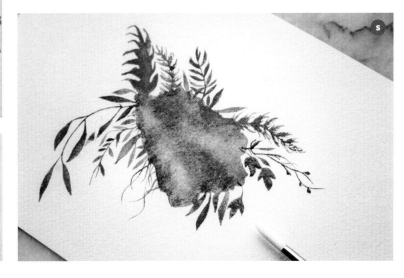

BRUSH: Round 1 (or Round 0, if you have it)

PAINT CONSISTENCY: 50w/50p "heavy cream," moving toward 10w/90p "mustard"

Before you paint a second layer, make sure that the first layer is completely dry. In this case, you WANT hard flower lines to be differentiated from the moody, green-toned background you just created. This is when a dry boundary becomes your best friend, to create drama and high contrast. Ideally, you'll leave the piece overnight to dry. If you'd rather not wait that long, an hour is probably fine, but this depends on the humidity where you live, how much water was in your first wash, and your paper and paint types. Remember the hovering hand trick? Wait until the shine and movement is gone from the boundary. Hold your hand a quarter inch above the area and feel for the coldness that seems to emanate from your watercolor paper when it's wet. If it's dry enough to no longer be cold, you should be able to add the second layer.

SECOND LAYER: WHITE GOUACHE

1 Once your first layer is dry, you're ready to paint the base layers of your flowers. If you traced the lines with pencil beforehand, and can you see them well enough, you'll use those to guide your painting now. If not, use a light source to trace and add them now, using your white colored pencil. [A, B]

2 You will use white paint for these shapes. Whatever you have in your tool kit that's white, use it! Chinese White, white gouache, or Dr. Ph. Martin's Bleedproof White all work well. With both white watercolor and white gouache, you often need to apply a few layers to get a nice bold white. Wait for each layer to dry between applications.

3 My favorite combination for the flowers is to do a first layer in white watercolor and then, once that's drying, add a few strokes of Dr. Ph. Martin's Bleedproof White to really make the petals "pop."

4 Add a fresh squeeze of white watercolor or gouache to your palette. Dip your brush in your water and use it to bring water from your Mason jar to your palette to create a 10w/90p consistency.

5 Load your brush with white and bring it to your watercolor paper. Recall the short, curved PPP motions you practiced in Lesson 6 (see page 96). Start from the center of the petal and pull down to make these short, interesting petals. [C]

6 Leave interesting space between the petals and the flower shapes—only this time it's not interesting white space you're leaving; it's interesting *green* space! It's the

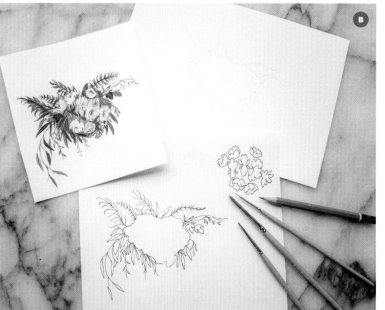
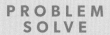

PROBLEM SOLVE

If you're using Dr. Ph. Martin's Bleedproof White, you may have noticed it can get a gritty texture (and tends to crumble a bit in the jar if you leave the cap off for too long). If this happens, add a little water directly into the jar. Use an old brush or spoon to mix it well. Remember, a little bit of water goes a long way. This should get rid of the grit and ensure that you have a smooth paint texture to work with for your flowers.

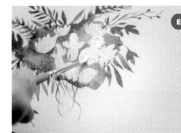

negative space that allows the eye to rest in between shapes and identify the petals from the lush green background. [D, E]

7 Next, use your smallest brush to paint in the tiny dots of the hydrangea. [F]

8 Once your first layer of white has been painted and dried, feel free to add another layer of Dr. Ph. Martin's Bleedproof White to add extra boldness. [G, H]

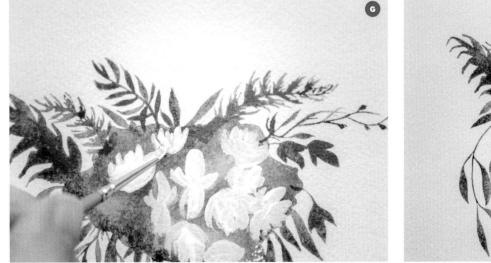

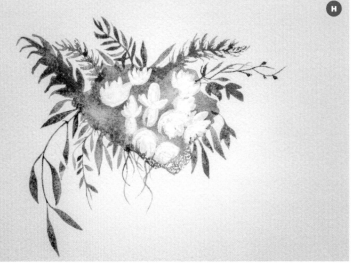

BRUSH: Round 4 (to reanimate color recipes), Round 1 (or smaller 0, 00, 5/0, or 10/0)

PAINT CONSISTENCY: 50w/50p "heavy cream," moving toward 10w/90p "mustard"

Now it's time for the detail layer! You will add contrasting petals, tiny berries, leaf veins, and petal centers, and fill in some of the leafy foliage so your flowers aren't just swimming in a large oval of green.

Unlike the second layer, you don't have to wait until the whites of the flowers are dry. In fact, it often makes the abstract flowers more interesting if this gouache layering blends a bit with the whites you just laid down.

THIRD LAYER: GOUACHE DETAILS

1 First, reanimate your Apricot color recipe. Dip your brush in your water and use your brush to bring water from your Mason jar to your palette to get that 10w/90p "mustard" consistency of Apricot. You can add a bit more tube paint, if needed, to get the recipe to the thicker texture.

2 Bring your brush to your scrap paper to practice a few short, curved PPP petal strokes. Once you feel ready, bring your loaded brush

to your watercolor paper and add your Apricot PPP strokes to your florals. **[A]**

3 As you paint, don't cover up ALL of the white petals you created in the second layer. Let some flowers stay completely white, and let others have interesting white centers or accents. You're aiming for abstract flower shapes. The painter Henri Matisse is an incredible inspiration on the subject of abstract flower shaping, so if you're looking

for some beautiful flower inspiration in this style, look up his work for some ideas.

4 As you can see in this photo, I have mixed more white into my Apricot recipe to lighten the color, which enables you to add even more interest for the eye as you build and layer your wet-on-dry coloring. **[B]**

5 Once you're happy with your layer of Apricot-colored petals, you can mix the color recipe for Iris, and paint in those flower details,

aiming for the thicker 10w/90p "mustard" consistency to give it a textured, layered look. **(C–E)**

6 Use your Round 4 brush to reanimate some of the green color recipes on your palette, such as Monstera (that deep, dark green mixture of Viridian and Payne's Gray), aiming for a 50w/50p consistency. I like to use a larger round when I'm animating my palette, as it protects the bristles of my smaller brushes, and also brings more water to the palette

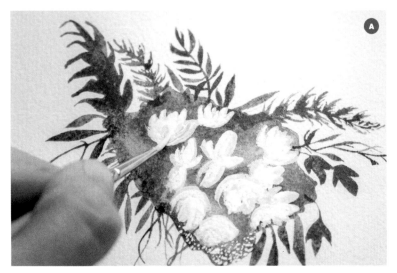

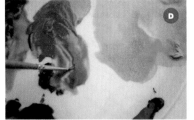

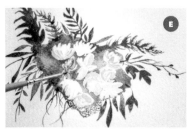

more quickly. Then switch back to your Round 1.

7 Load your Round 1 brush with your 50w/50p consistency of the green tone of your choice and bring your brush to your watercolor paper. You will use your PPP motion to add some leaves to the open spaces in your wildflower bouquet. This additional "fill" will anchor your flowers and bring the wild feel of layers and layers of delicious greenery gathered together, to make a beautiful whole. Rotate your paper as you add in slender leaves and small marks in varying green tones to add interest and make your piece unique. [F, G]

8 Is your overlapping clematis leaf still the white of your paper? This is a great time to complete that final spilling leaf. Make sure you choose a differently toned green so it stands out from the leaf it's in front of. As you can see in the picture, the back leaf is a deeper Viridian in color, so I used a lighter Pine to color the top leaf in. The color difference allows the top leaf to "pop" off the page and remain unique in form, in contrast to the leaf that appears behind it. Use your PPP motion to fill in the leaf. [H]

9 Dip your Round 1 (or smaller—your smallest brush will work best here) in a clean water jar to switch from the greens you've been painting with to a nice Raspberry color recipe. Load your brush with your 50w/50p consistency of Raspberry and bring it to your scrap paper to practice your strokes. When you're ready, bring it to your watercolor paper and use light pressure to add these detail marks to the flower centers and petals. [I, J]

10 Use the same small brush and Raspberry consistency to complete the pepper berries. [K]

11 Using the same small brush and your 20w/80p Apricot color recipe, complete the arugula flowers. [L]

continues on next page

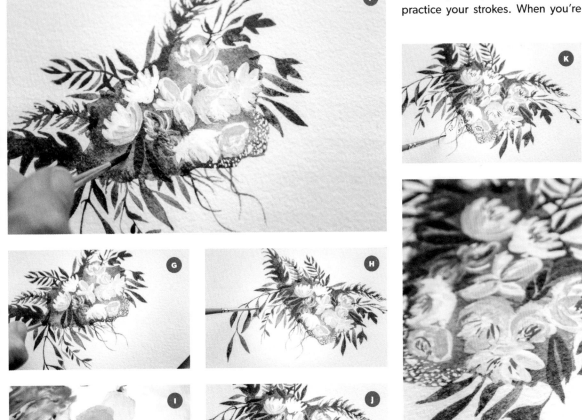

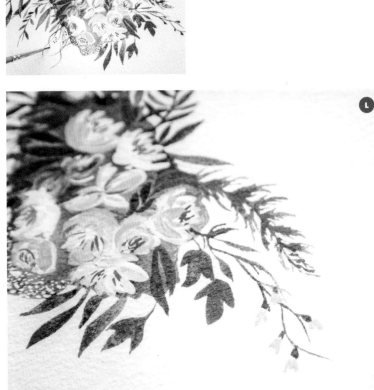

12 I mix my Raspberry with my Peach and use this color to accent more petals. [M–O]

13 You can also revisit the areas of Dr. Ph. Martin's Bleedproof White or use a thicker consistency of your white watercolor or gouache paint now, to add more white accent details to your flowers and leaves. [P]

14 Once you're happy with your petals, it's time to add their centers. Use your Round 4 brush to dab a bit of white watercolor (or white gouache) paint into your Yellow Ochre, aiming for a 10w/90p consistency. Pick up this tacky mixture with your smallest brush and bring it to your watercolor paper to make tiny marks in the centers of your petals and on some of your leaves to add some final contrasting interest. [Q–S]

15 Now, I like to add a fresh dab of Payne's Gray to my palette. I enjoy working with tube paint

freshly squeezed, especially for tiny little marks of details, like you see in this picture. You can reanimate a dab of Payne's Gray already on your palette, but just the act of reanimating adds water to dilute the potent color and texture of this paint—that's why it's fun to sometimes work straight from the tube. [T]

16 Use your brush to add tiny little Payne's Gray dots in the flower centers and in the green background keep the viewer's eye moving around your piece, soaking in all of the tiny paint strokes and marvelous detail you have created in this piece! [U–W]

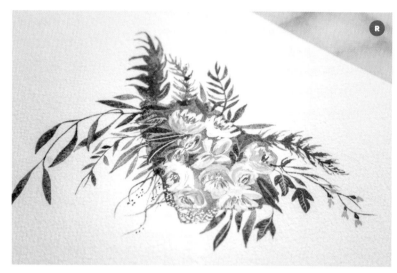

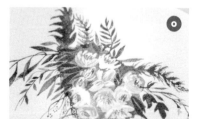

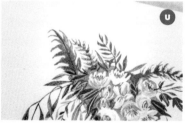

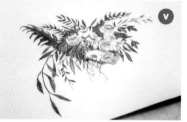

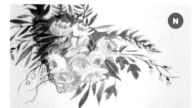

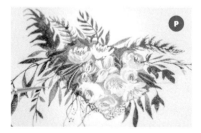

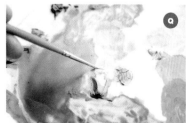

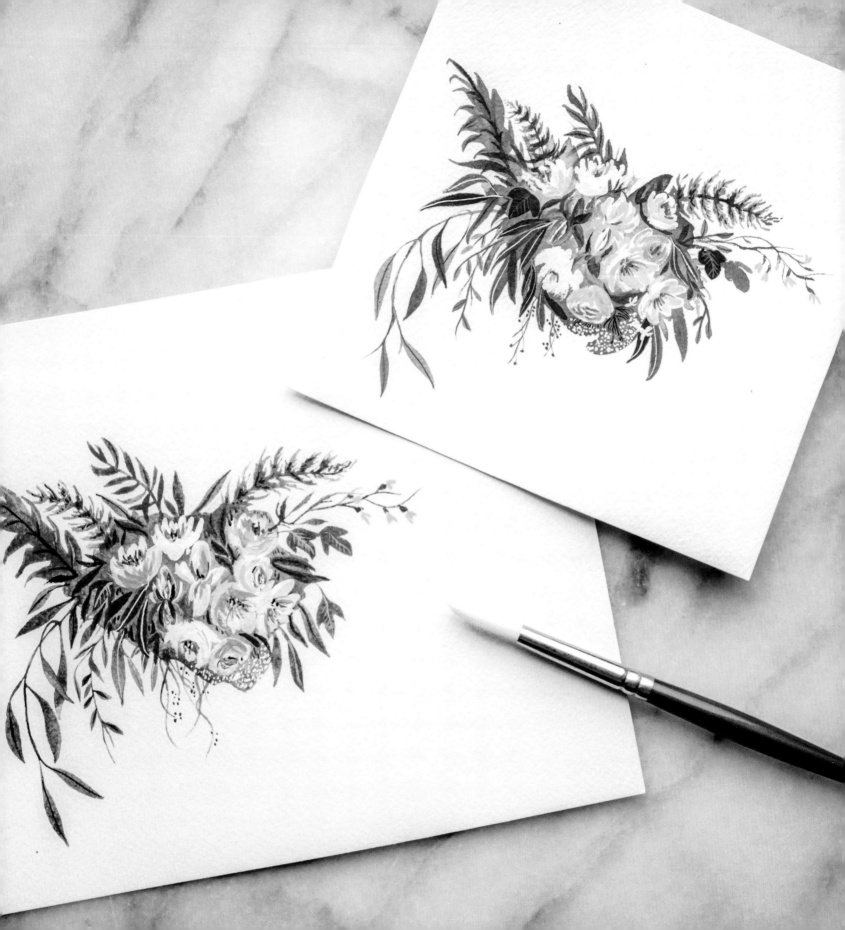

LIFE IN THE GARDEN

I LIKE TO SAY: PAINT ON MY HANDS AND EARTH UNDER MY NAILS GIVES ME JOY.
One of my favorite places to connect with my family and friends is in our garden. We once lived in a 600-square-foot apartment, every table, shelf, and windowsill occupied by plants. We now live in a home on a quarter-acre in the heart of the city. Over the years, we have transformed every inch of our outdoor space into a thriving jungle of an urban garden.

Each member of our little tribe has a place and a role in our garden. My husband loves to grow things to eat—kale, corn, collard greens, snap peas, and beets—and he loves to roll up his sleeves and shift dirt, paint the chicken coop, turn the compost pile, and pull weeds; it's how he relaxes and recharges after long days at work. I love to find heirloom flowers to fill our garden beds: sunflowers, roses, peonies, bearded irises, lilies, and dahlias. Our two small daughters go to the garden in search of snacks and they help to select what to plant, with seasonal seed catalogs as their bedtime stories of choice. For all of us, the garden is a source of wonder; a place where our imaginations can run wild. We see magical things emerge from the ground that started as the tiniest seeds, then grow, thrive, and begin the cyclical process all over again.

The garden is a renewable source of inspiration. It is physically refreshing, emotionally grounding, and spiritually encouraging. When the walls of the house or the pace of the city get to be too confining, I can sit outside, soak in the sunshine, listen to the bees hum, and watch my daughters run barefoot and collect fallen flower petals. I breathe in deeply of dark earth and feel like I've just inhaled my weeks' worth of vitamins.

There is so much marvelous detail happening on each little plant. I love observing them and studying their movement and then trying to translate them to paper: the shape of the olive tree's leaves or the beautiful mess of the sage and lavender branches all entangled with one another. Sometimes I bring my sketch pad outside and draw the shapes

I see with my daughters; other times these images wait in my mind and come out of my paintbrush during the girls' naptime.

Every time I dig in the earth, I feel like the dirt sets my mind buzzing with thoughts and ideas. I just planted five Café au Lait Dahlia tubers yesterday; I love how ugly they are when you bury them in the dirt. If you haven't seen a dahlia tuber, just imagine an extra knobby brown potato, with brown wart-like knots near the top, which are called the tuber's "eyes." It's hard to believe the exquisite future that's hidden inside them, but it's a metaphor that never fails to inspire me. Every time you plant a tuber, or a seed, you are seeing Hope in its purest form. There is so much potential in these utilitarian compact beings, and when you tuck them into their dark beds, the magic starts to happen. The mystery of the deep soil, sun, and rain activates the explosive power within those small unassuming bodies – tiny green shoots begin to surface, leaves stretch and grow. Every time I see a new leaf or blossom, I marvel at the journey that has all taken place underground, beyond our comprehension.

After the seed has done its work, the beautiful flowers—the crowning glory of any plant—follow the sun and receive our praise. And yet they fade so quickly! We have poppies blooming right now, and one tiny bud will unfurl in the early dawn, wrinkled and trembling, shine and dance for a day, and then lose all her petals as the dusk approaches. Just one day of glory, but the pollen she offered to the bees for her day in the sun, and the seeds she will shed from her drying body—those gifts echo and ensure her return, in a new form, next spring.

Nothing is wasted or without meaning in the garden.

The cyclical process of every season, the hidden things waiting patiently to bloom, life and death being a necessary part of growth and expansion—those lessons continue to inspire me every time I get my hands in the dirt.

Our green space has become a place where each of us finds rest and feeds a creative urge. When the day is through and we come inside, the leaves and bits of dirt that fall from my daughters' hair at bath time are the mark of a day well spent. And it's not so different for me: hands full of earth, heart full of love. ●

RESOURCES

TO CONTINUE BUILDING YOUR SKILLSET IN THE FOLLOWING AREAS, CHECK OUT THE RECOMMENDED BOOKS!

Drawing Florals: Alli Koch (@allikdesign), *How to Draw Modern Florals* and *Florals by Hand*

Fundamental Watercolor Skills: Michael Crespo, *Watercolor Class*

Color Theory: Josef Albers, *Interaction of Color* and Stephen Quiller, *Color Choices*

BOOKS I READ FOR INSPIRATION:

Steven Pressfield, *The War of Art*

Madeleine L'Engle, *And it was Good*, *A Stone for a Pillow*, and *Sold into Egypt*

SOME OF MY FAVORITE SUPPLIES AND BRANDS INCLUDE:

Brushes: Princeton, Arteza, Grumbacher, Winsor & Newton

Watercolor Paints: Reeves, Winsor & Newton, Van Gogh, Daniel Smith

Gouache Paints: Reeves, Arteza

Paper: 140-lb weight, cold press or rough preferred. Hot press works as well, but its lack of surface texture leads to different drying effects.

Student-Grade: Canson or Strathmore // Professional Grade: Hahnemühle, Arches

Waterproof Black Pens: Sakura of America Pigma Micron Pens

Water-soluble Colored Pencils: Arteza, Prismacolor

Drawing Pencils & Sharpener: Staedtler Mars HB Pencils

Eraser: Prismacolor Artgum Eraser

WOULD YOU LIKE TO LEARN MORE FROM SARAH?

Sarah has worked with several collaborators to bring her unique style in video classes. Sarah is on Skillshare, as well as these other wonderful online options. Be sure to check out:

Sarah's Watercolor, Gouache & Ink Class at The Crafter's Box
The Crafter's Box is an education resource that collaborates with artists to build thoughtfully sourced tools & materials kits to accompany detailed, digital workshops in a variety of making techniques. In a workshop collaboration with Sarah Simon, participants dive into the wonderful world of watercolor to explore florals and Sarah's iconic flower girl, The Plant Lady, Florence. Find out more at thecraftersbox.com.

Sarah's Watercolor & Botanical Illustration Course at the Art Summit
Join Sarah, and six other art industry professionals from around the world, to dive into an in-depth Watercolor Summit workshop with over 15 hours of online downloadable classes exploring everything from fundamental techniques, color mixing, how to create depth in landscapes, pet portraits, loose florals, and realistic botanical illustrations. Find out more, and download a free mini-series at artsummits.com/sarahs.

Be sure to follow her Instagram @themintgardener for the latest updates.

Page 26
Johnstone, Ainslie. "The amazing phenomenon of muscle memory." *Medium* (2017). https://medium.com/oxford-university/the-amazing-phenomenon-of-muscle-memory-fb1cc4c4726.

PAGE 34
Crespo, Michael. *Watercolor Class*. 6th ed. New York: Watson-Guptill, 1994.

Page 38
Crespo, Michael. *Watercolor Class*. 6th ed. New York: Watson-Guptill, 1994.

ACKNOWLEDGMENTS

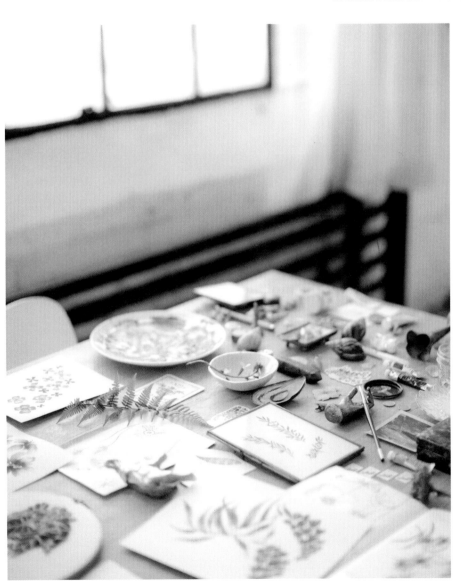

I would like to thank the following people who were instrumental in creating this book:

For Adriel & Britney—for translating the breathings of my heart into eloquent, clear, and thoughtful words. And for taking my words and making them say what I wanted them to say, so much better than I ever could.

For Sandy, who has encouraged me more than she knew, and was the first to believe that this could happen, years ago.

For my Mom, who had so many dance parties and playdates with my daughters so I could paint and write.

For my daughters, who help me to see more clearly, every day.

For Colin, who always encourages me to keep reaching for the stars.

For my Tribe: Colin, Adriel, Britney, Josh, Victory, Jenny W., Kristin, Kristen, Ellen R., Erin D., Adair, Jocelyn, Ellen S., Ashley, Amy, Julie, Deborah, Sara, Mindy Lee, Andrea W., Sarah Z., Violet, Brett, Juston, Erin S., Holly, Alli, Colleen, Elizabeth D., Kristi, Brooke, Jenna, Christie, Matt, Al, Mom, Dad, Sandra Lea, Gary, Hillary, Tim, Alexandra, Nana, Grandmother Veronica, Grandpa Ubu, Pat, Laura, Pam, Peggy, Walt, Leigh-Anne, Barb, Scott, Christopher, the Melissa C's, Aaron, Kevin, Maria, Hanley, Leighton and Angus.

You prayed for me, encouraged me, laughed with me and cheered me on, month after month. I felt and heard every good thing from you. Thank you.

I want to thank everyone on the Blue Star team: Clare (your attention to detail and cheerful thoroughness), Alicia, Laura Lee and Stephanie (your patience and ability to understand me and all my words), Amy, Brenna, and Peter. For the pep talks, the organization, the details, the mad skills. For believing in me, supporting all of my crazy ideas, and teaching me along the way. And for giving me the creative freedom to dream, play, and bring this book to life.

The Recipe Testers: Jenna, Aurelie, Elizabeth, Sara, Ellen, Amy. Thank you for taking the time to try all of these lessons before we published. Seeing the work you created was the best encouragement.

ABOUT THE AUTHOR

SARAH SIMON IS THE FOUNDER, ARTIST, AND AUTHOR behind The Mint Gardener. Finding inspiration in the ever-blooming variety of textures and colors in her urban garden of the Pacific Northwest, Sarah creates lush watercolor paintings in a unique artistic style that has captured an international following.

With a continually blooming audience of art and garden lovers alike, Sarah shares her designs, as well as her teaching talents, which have received international attention in her online painting courses and are now captured here in *Modern Watercolor Botanicals*.

Sarah's work has been featured in multiple publications and blogs worldwide and has been celebrated in the form of commercial product design at Target and as stationery, textiles, wholesale, and private commissions.

Sarah enjoys creating an experience as she teaches her audience to watercolor. She invites them to engage in her artistic world, with peaceful blues, serene greens, and small pops of complementary accents in blush and coral. Using her relatable and effective teaching analogies, Sarah invites her audience into a world of coloring and unique inspiration, teaching watercolor unlike anyone else has.

She lives in Seattle with her family.

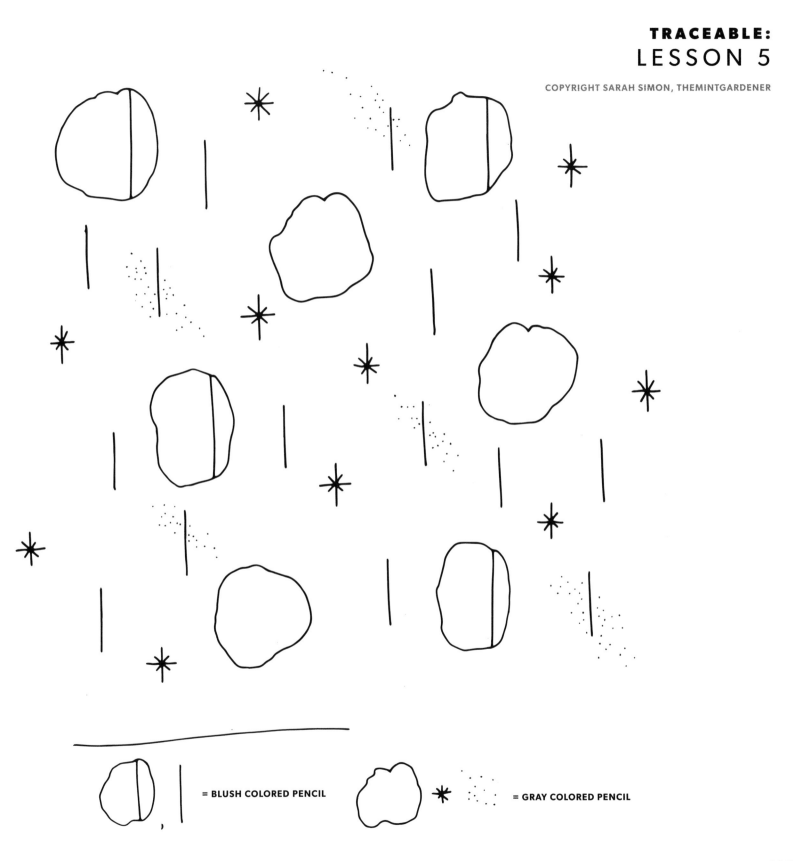

= BLUSH COLORED PENCIL = GRAY COLORED PENCIL

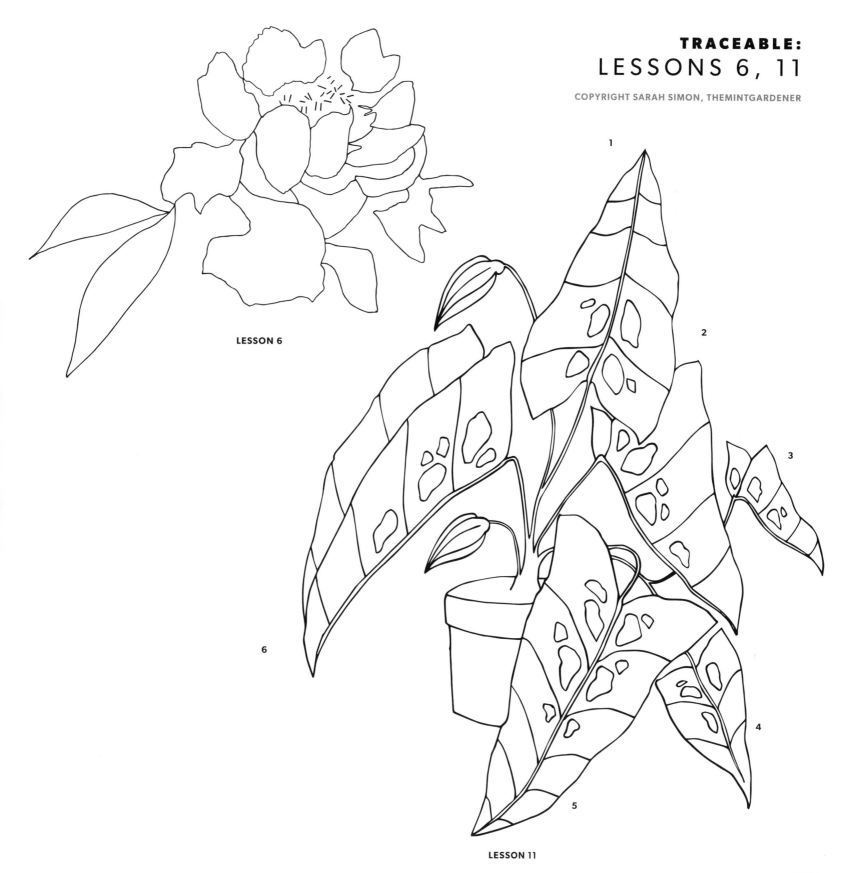

LESSON 6

1

2

3

6

4

5

LESSON 11

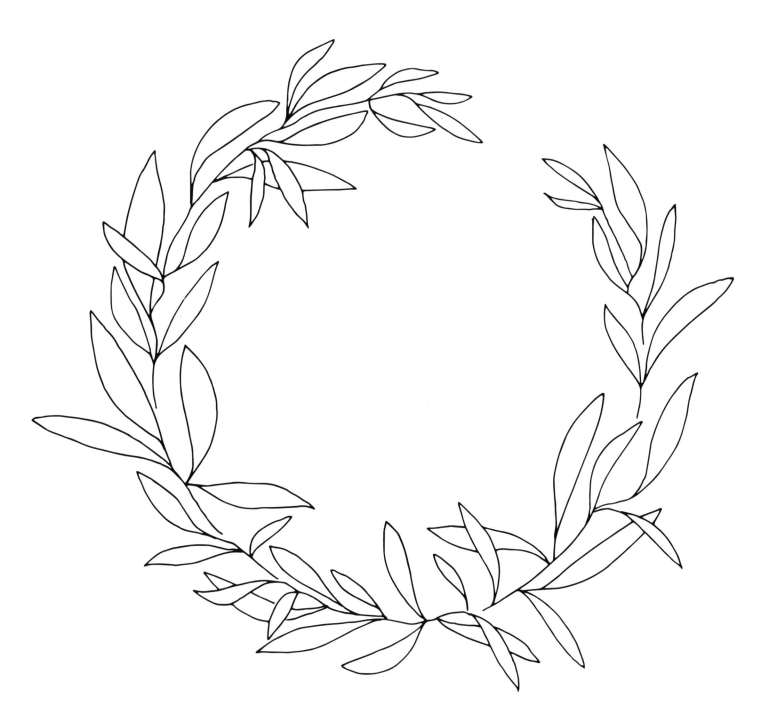

COPYRIGHT SARAH SIMON,
THEMINTGARDENER

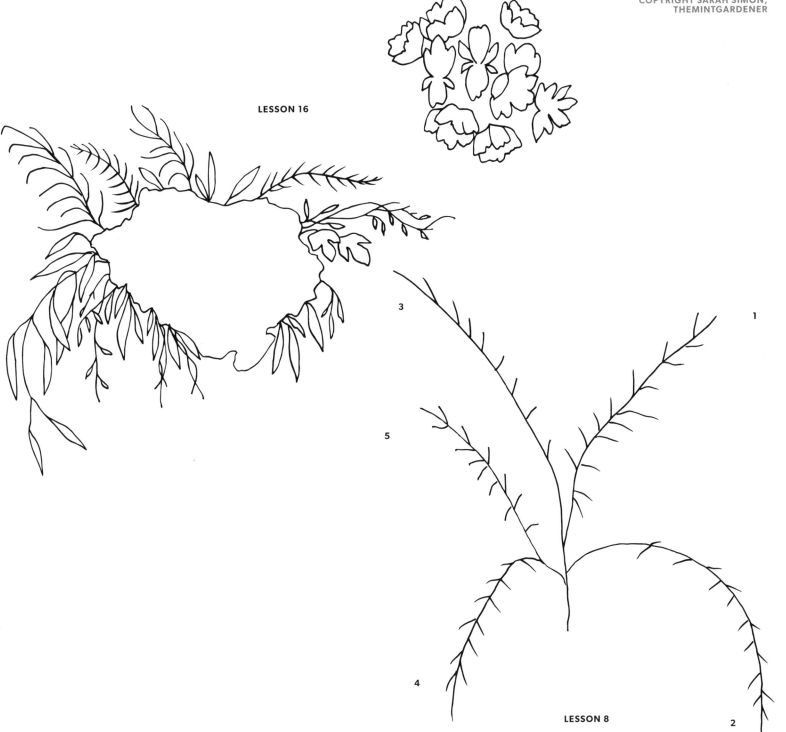

LESSON 16

3

5

1

4

LESSON 8

2

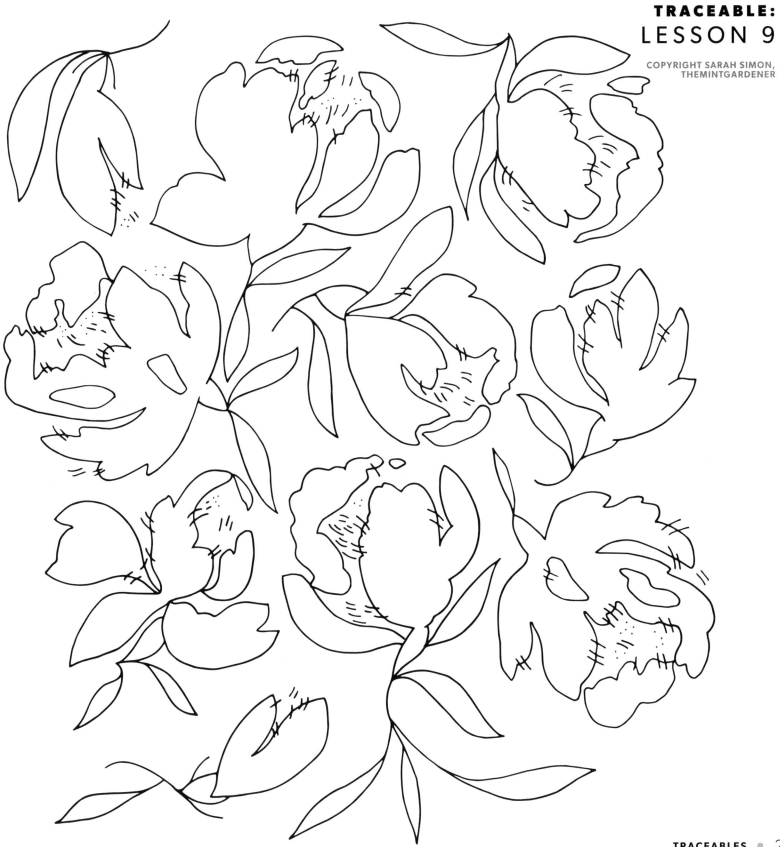

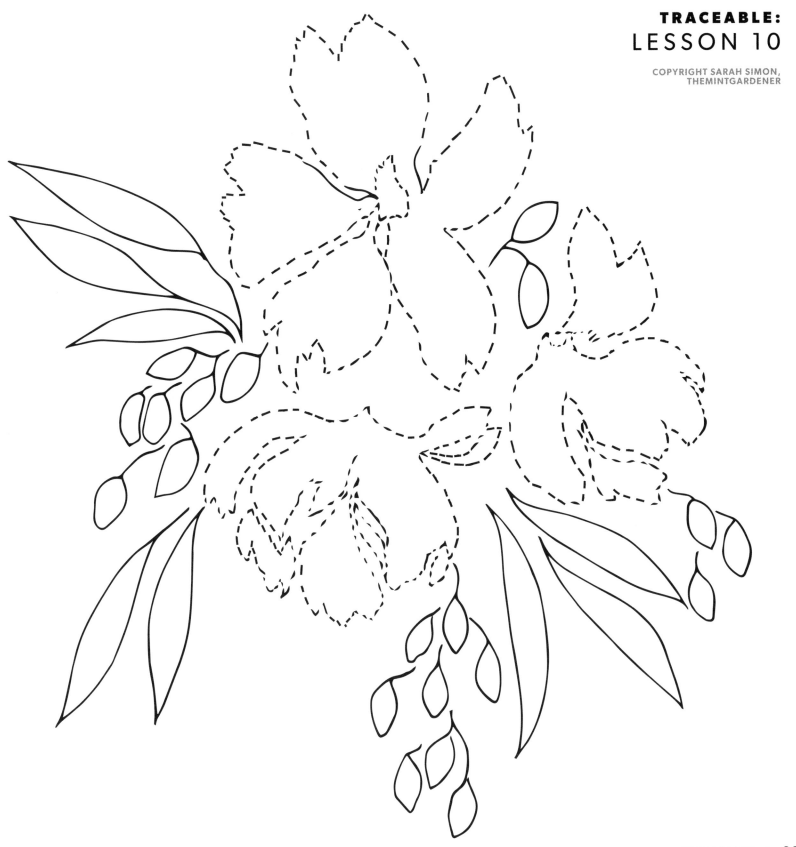

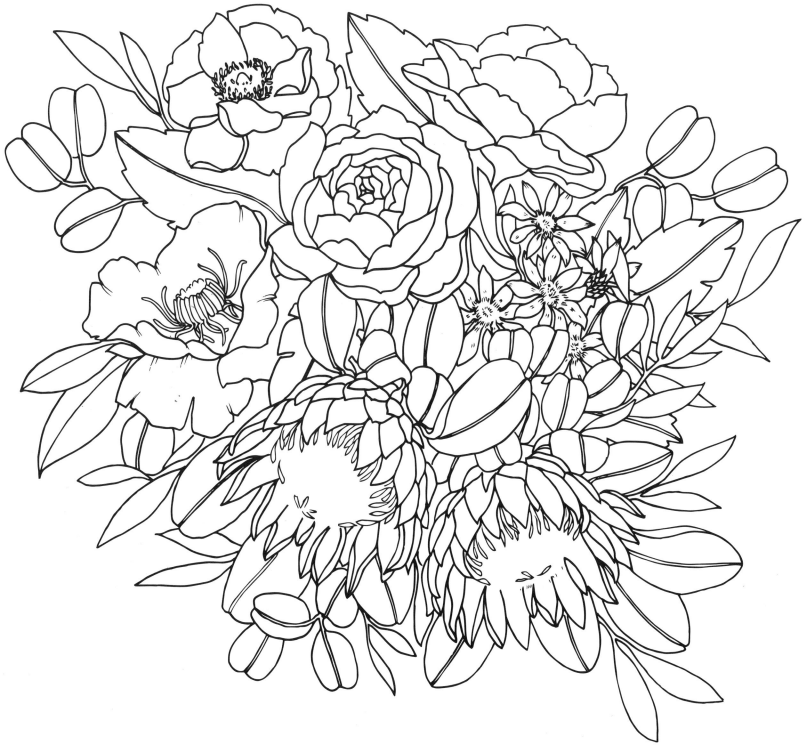